CÉZANNE'S CARD PLAYERS

Organised by

THE COURTAULD GALLERY, LONDON and
THE METROPOLITAN MUSEUM OF ART, NEW YORK

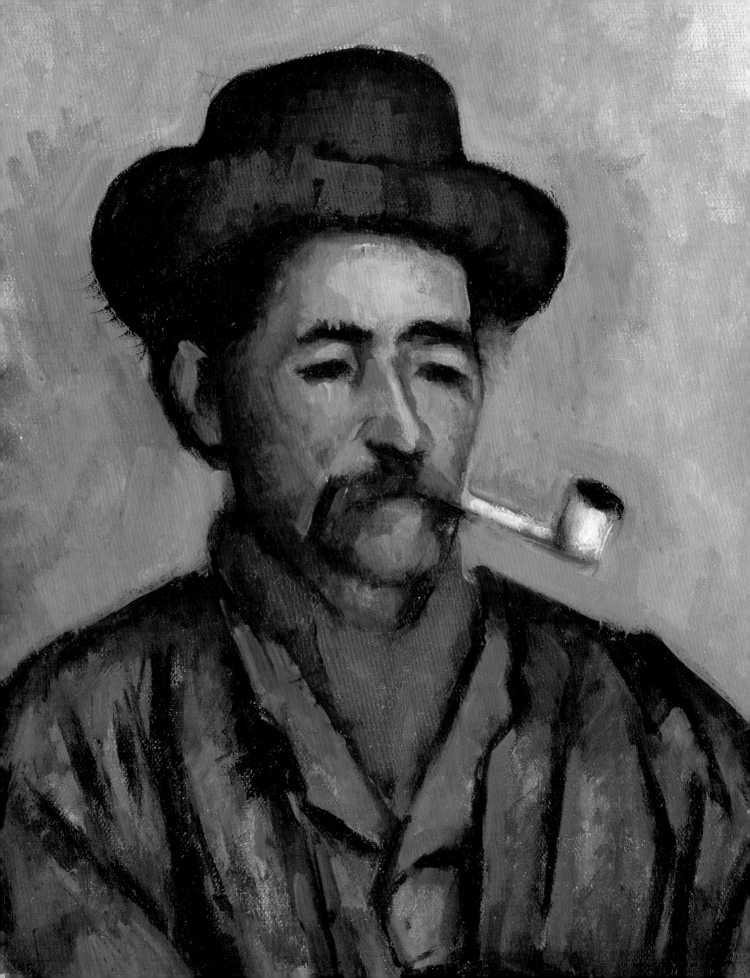

CÉZANNE'S CARD PLAYERS

Edited by Nancy Ireson and Barnaby Wright

ESSAYS BY

Nancy Ireson and Barnaby Wright
Aviva Burnstock, Charlotte Hale, Caroline Campbell
and Gabriella Macaro
John House
Richard Shiff

CATALOGUE BY

Nancy Ireson and Barnaby Wright

with contributions from
Laure-Caroline Semmer

THE COURTAULD GALLERY
IN ASSOCIATION WITH
PAUL HOLBERTON PUBLISHING
LONDON

First published 2010 to accompany the exhibition

CÉZANNE'S CARD PLAYERS

The Courtauld Gallery, London
21 October 2010 – 16 January 2011

The Metropolitan Museum of Art, New York
9 February 2011 – 8 May 2011

The Courtauld Gallery is supported by
the Higher Education Funding Council
for England (HEFCE)

ISBN 9-781907-372117 pb

British Library Cataloguing in Publication Data
A catalogue record for this book is available from
the British Library

Produced by Paul Holberton publishing,
89 Borough High Street, London SE1 1NL
www.paul-holberton.net

Designed by Philip Lewis

Origination and printing by e-graphic, Verona, Italy

COVER IMAGE: Detail, Paul Cézanne, *The Card Players*, cat. 13
BACK COVER: Paul Cézanne, *The Card Players*, cat. 1
FRONTISPIECE: Detail, Paul Cézanne, *Man with a Pipe*, cat. 3
PAGE 9: Detail, Paul Cézanne, *The Card Players*, cat. 14
PAGE 10: Detail, Paul Cézanne, *Peasant*, cat. 19
PAGES 12–13: Detail, Paul Cézanne, *The Card Players*, cat. 1
PAGES 92–93: Detail, Paul Cézanne, *The Card Players*, cat. 13
PAGES 152–153: Detail, Paul Cézanne, *The Card Players*, cat. 2

CONTENTS

DIRECTORS' FOREWORD

THIS EXHIBITION, the first to be organised jointly by our two institutions, is also the first to look in detail at the celebrated paintings of card players which Paul Cézanne produced in Aix-en-Provence in the 1890s. It examines the *Card Players* compositions in the context of portraits of the peasants who modelled for them and directly related preparatory studies. The Courtauld Gallery and The Metropolitan Museum of Art each own two major paintings from this group, making us ideal partners in this project. Both institutions also share a long history of engagement with Cézanne and their collections were at the forefront of the reception of the artist's work in Britain and America.

At the Courtauld Institute of Art, one of the world's leading specialist institutions for the study of art history, this relationship has been expressed through teaching and research and, above all, through The Courtauld Gallery, which holds the most extensive collection of Cézanne's works in the United Kingdom. The majority of these were assembled in the 1920s by the Institute's principal founder, Samuel Courtauld, who collected the artist's work in the face of significant critical hostility. The small band of advocates for Cézanne's importance was eloquently led by Roger Fry, the painter and critic who had briefly been a curator at The Metropolitan Museum of Art and was later to become an important advocate for The Courtauld Institute of Art.

Several of the pictures which were to adorn Samuel Courtauld's collection were shown in New York in the 1910s. Although the debates about the merits of Cézanne's work were also played out in America, they were concluded earlier and with greater aplomb than in Britain. Here too it is pioneering private collectors who deserve much of the credit, alongside progressive critics and artists. Mr. and Mrs. H.O. Havemeyer, for example,

had assembled an exceptional collection of Cézanne's paintings in New York during the artist's lifetime. Admirably, The Metropolitan Museum of Art became the first public institution in America to acquire a painting by the artist when it purchased *View of the Domaine Saint-Joseph* from the Armory exhibition in 1913. Cézanne's works no longer look as strange to us as they did to his first audiences. However, they still communicate the sincerity and singular vision which so gripped his admirers both in Britain and America.

This exhibition investigating Cézanne's *Card Players* is tightly focused in character and scale. It aims to offer a very different experience from that of a large survey exhibition. We hope that visitors will slow their pace, engage deeply with individual works, and explore the relationships between them. The accompanying catalogue offers new insights into the series from a number of perspectives. They include the findings of a technical research project, conducted by The Courtauld and the Metropolitan, which has thrown fresh light upon Cézanne's production of the paintings and the much-debated question of their sequence.

We would like to thank supporters of our two institutions whose generosity and encouragement have made this project possible. In London, we would especially like to acknowledge the important assistance provided by the Friends of The Courtauld, which supports numerous programmes at The Courtauld Institute of Art, including exhibitions and scholarships. The Courtauld would also like to thank Mr Robert Stoppenbach for his donation to the exhibition in memory of Dewitt and Katherine Buchanan. Both The Courtauld and the Metropolitan extend their warmest thanks to The Pierre and Tana Matisse Foundation for so generously funding the publication of this handsome catalogue.

DEBORAH SWALLOW
Märit Rausing Director
The Courtauld Institute of Art
London

THOMAS P. CAMPBELL
Director
The Metropolitan Museum of Art
New York

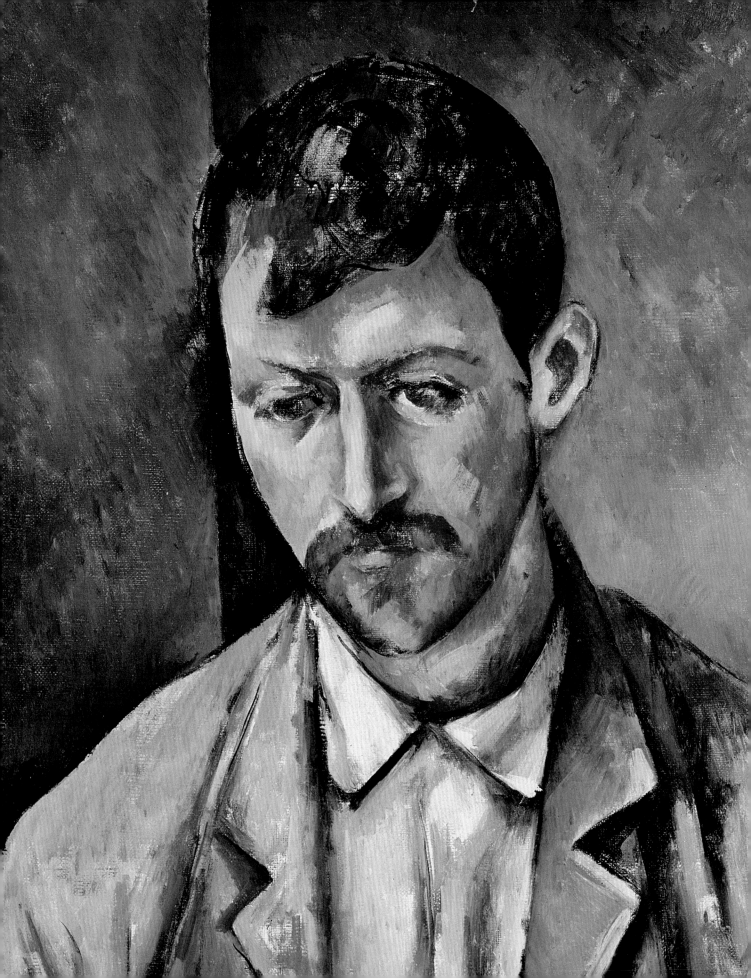

EXHIBITION SUPPORTERS

The Friends of The Courtauld
The Pierre and Tana Matisse Foundation

We would like to thank most warmly the Schroder
Foundation and Daniel Katz for supporting the posts
of the exhibition's curators at The Courtauld: Nancy Ireson,
Schroder Foundation Curator of Paintings, and Barnaby
Wright, Daniel Katz Curator of 20th Century Art.

ACKNOWLEDGEMENTS

The realisation of this exhibition and its catalogue would
not have been possible without the generosity and support
of many institutions and individuals. We would like to
extend our warmest thanks to those who have lent works
to the exhibition or facilitated loans, thus enabling us to
present this rich and detailed account of one of Cézanne's
greatest achievements: The Honolulu Academy of Fine Arts,
Honolulu; The Collection of Marion and Henry Bloch,
courtesy of The Nelson-Atkins Museum of Art, Kansas City;
The Museum Boijmans Van Beuningen, Rotterdam; The Art
Institute of Chicago; The Kimbell Art Museum, Fort Worth,
Texas; Musée d'Orsay, Paris; The Museum of Art, Rhode
Island School of Design; The National Gallery of Art,
Washington, DC; The Philadelphia Museum of Art; The
Pierpont Morgan Library, New York; The State Hermitage
Museum, St Petersburg; The State Pushkin Museum,
Moscow; Städtische Kunsthalle, Mannheim; Thomas Gibson
Fine Art, London; The Worcester Art Museum, Worcester,
Massachusetts; and the private owners who wish to remain
anonymous.

The exhibition would not have been possible without the
support, expertise and enthusiasm of many individuals
and we would like to thank especially: Rita Albertson; Rachel
Billinge; Barbara Buckley; Silvia Centeno; Anna Corsay;
Walter Feilchenfeldt; Michel Fraisset; Albert Kostenevich;
Elsa Lambert; Martha Lucy; Daniella Luxembourg;
Bruno Mottin; Winnie Murray; the Paulet family; Sylvie
Patry; Theodore Reff; Elisabeth Reissner; Joseph Rishel;
Anne Roquebert; Johanna Salvant; Stephanie Schleiffer;
Jennifer Tonkovich; Jayne Warman; Christiane Zemb.
We would also like to thank Christie's for their support.

At The Courtauld we would like to thank the following
members of staff for their exceptional contributions to the
project: Graeme Barraclough; Julia Blanks; Stephanie Buck;
Mary-Ellen Cetra; Ron Cobb; Kerstin Glasow; Karin Kyburz;
Katharine Lockett; Chloe Le Tissier. We would like to thank
Aurica Garcia Schaible for her research assistance in the
preparation of the catalogue.

At The Metropolitan Museum of Art first thanks go to Gary
Tinterow, assisted by Nykia Omphroy, for coordinating every
aspect of the presentation at the Metropolitan. We thank
Susan Stein and Charlotte Hale for their contributions to the
catalogue and presentation; to Jennifer Russell, Martha Deese,
Nina Maruca and Kirstie Howard in the Exhibitions, Registrar
and Councel's Offices; to Linda Sylling, Sophia Geronimus,
Michael Langley and Taylor Miller for the handsome exhibition
design; to Cynthia Iavarone and Anthony Askin, Sandie Peters,
Jeff Elliott, Rachel Robinson, and Brooks Shaver for the
installation; and special thanks to Vincent Pomarède,
George Wachter, Mahrukh Tarapor and William Acquavella
for their much appreciated assistance.

SAMUEL COURTAULD SOCIETY

The Courtauld is grateful for the significant annual support that
it receives from the members of the Samuel Courtauld Society.

DIRECTOR'S CIRCLE

Anonymous
Andrew and Maya Adcock
Farah and Hassan Alaghband
Apax Partners
Christie's
Nicholas and Jane Ferguson
Sir Nicholas and Lady Goodison
James Hughes-Hallett
Daniella Luxembourg, London
Madeleine and Timothy Plaut
Paul and Jill Ruddock
The Worshipful Company of Mercers

PATRONS' CIRCLE

Anonymous
Agnew's
Lord and Lady Aldington
Jean-Luc Baroni Ltd
Philip and Cassie Bassett
The Lord Browne of Madingley
Mr Damon Buffini
David and Jane Butter
Julian and Jenny Cazalet
Mr Colin Clark
Mark and Cathy Corbett
Mr Eric and Mrs Michèle Coutts
Samantha Darell
David Dutton
Mr. and Mrs. Thomas J. Edelman
Roger and Rebecca Emery
Mr Sam Fogg
Lucía V. Halpern and John Davies
Mr and Mrs Schuyler Henderson
Nick Hoffman
Philip Hudson

Nicholas Jones
Daniel Katz Ltd
James Kelly
Norman A. Kurland and Deborah A. David
Helen Lee and David Warren
Gerard and Anne Lloyd
Stuart Lochhead and Sophie Richard
Dr Chris Mallinson
Janet Martin
Mr Jay Massey
Clare Maurice
The Honourable Christopher McLaren
Norma and Selwyn Midgen
Cornelia S. Edelman Moss & James Moss
John and Jenny Murray
Mr Morton Neal CBE
Mrs Carmen Oguz
Mr Michael Palin
Catherine Petitgas
Lord and Lady Phillimore
Mr Richard Philp
Marie-Christine Poulain and Read Gomm
Leslie Powell
Derek and Inks Raphael
Pam Scholes
Richard and Susan Shoylekov
William Slee and Dr Heidi Bürklin-Slee
Hugh and Catherine Stevenson
Marjorie Stimmel
Sir Angus Stirling
Johnny Van Haeften
Mrs Elke von Brentano
Haunch of Venison Gallery
Erik and Kimie Vynckier
The Rt. Hon. Nicholas & Lavinia Wallop
George and Patricia White

ASSOCIATES

Anonymous
Lord Jeffrey Archer
Rupert and Alexandra Asquith
The Hon Nicholas Assheton CVO, FSA
Mrs James Beery
Dame Diana Brittan
Peter Brooks
Henry and Maria Cobbe
Mr Oliver Colman
Prisca and Andrew Cox
Emma Davidson
Derek Johns Ltd
Hester Diamond
Simon C. Dickinson Ltd
Mr Andrew P Duffy
Ben Elwes Fine Art
David and Diana Frank
Mrs Judy Freshwater
The Rev. Robin Griffith-Jones
Mrs Katherine Gyngell
Celia Johhnson
Annick Lapôtre
Mark and Liza Loveday
Philip Mould Ltd
Michina Ponzone-Pope
The Lady Ridley of Liddesdale
Charles Rose
Anna Somers Cocks
Dr and Mrs Joseph Spence
Rex De Lisle Stanbridge
Mr Robert Stoppenbach
Professor Deborah Swallow
Dr John Sweetman
Yvonne Tan Bunzl
John and Diana Uff
The Ulrich Family
The Weiss Gallery
Katherine Woodward Mellon

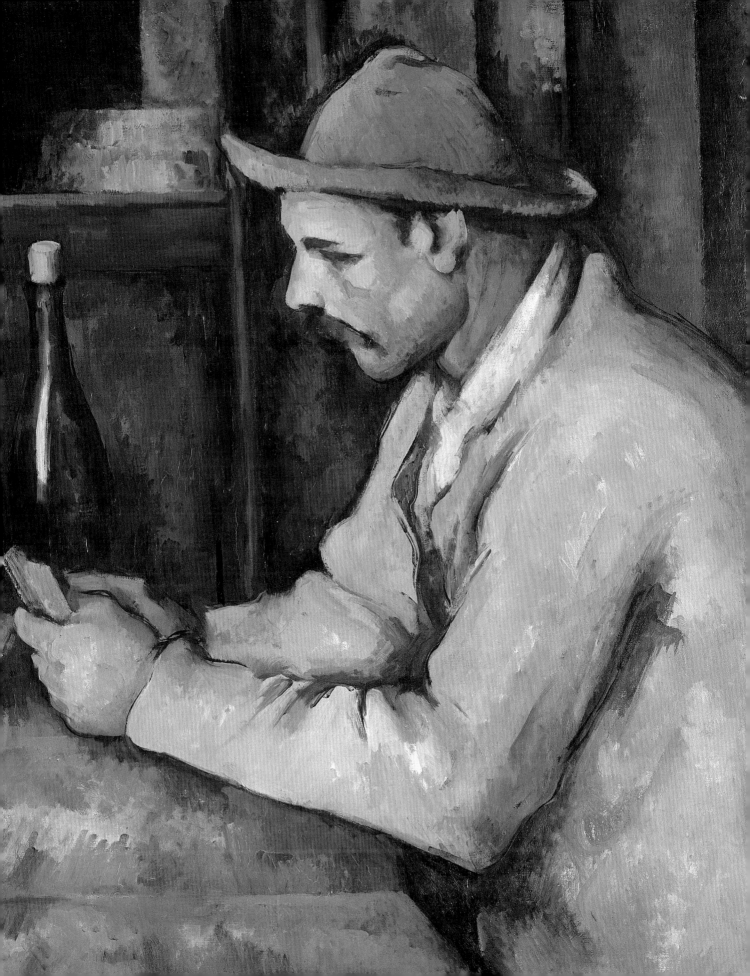

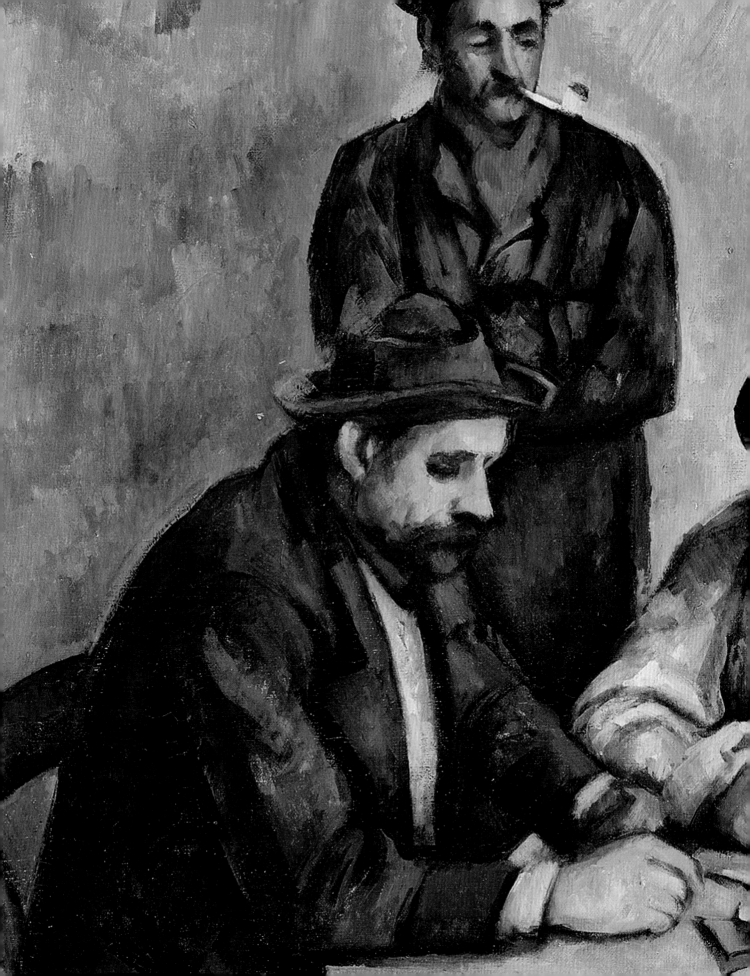

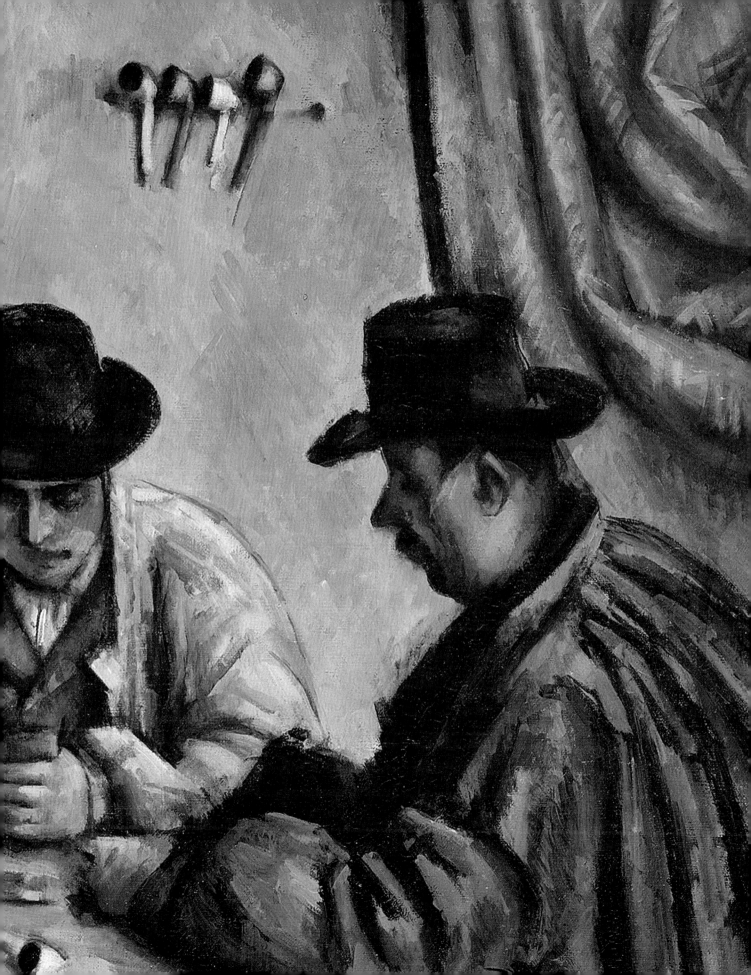

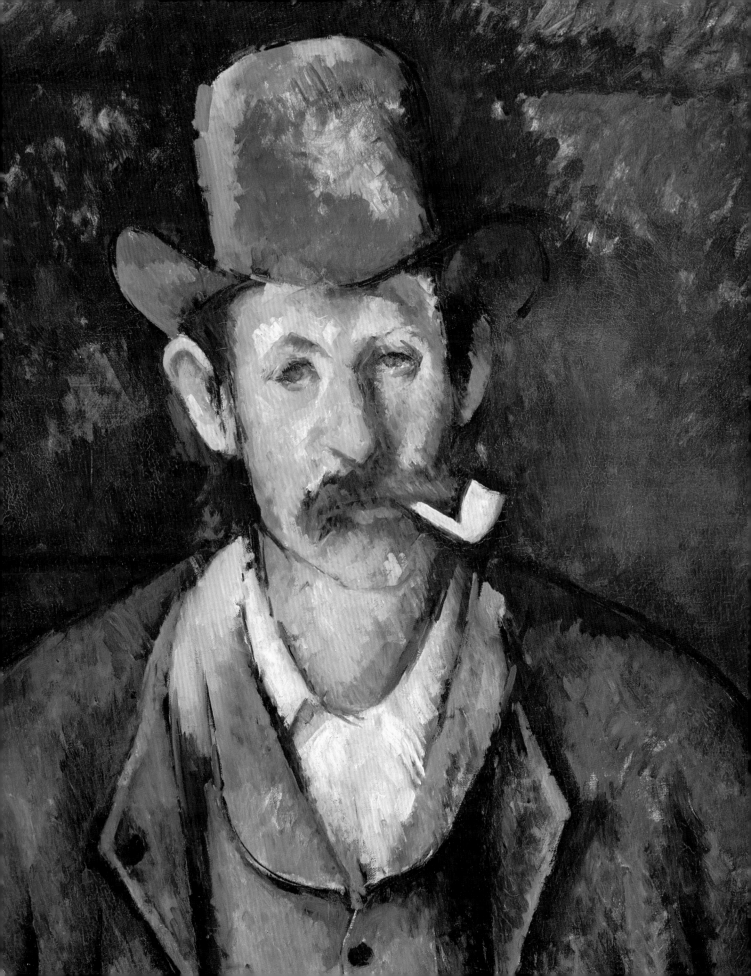

Cézanne's *Card Players*
An Introduction

NANCY IRESON AND BARNABY WRIGHT

In 1891 the writer Paul Alexis spent some time with Paul Cézanne in Aix-en-Provence. He wrote to Émile Zola, who was keen for news of his estranged friend; "During the day, he [Cézanne] paints at the 'Jas de Bouffan' where a worker serves as his model, and where one of these days I'll go to see what he's doing."[1] This snippet of information is the first and only contemporaneous record of the artist at work on his paintings of peasants in the early 1890s.[2] It indicates that Cézanne adopted the motif at this time, although as Alexis had yet to see the canvases, its use has limitations. The subject was new for the artist as a major theme and it occupied him intensely for several years, resulting in a substantial group of related canvases.[3] It consists of his five – now famous – *Card Players* compositions (cat. 1, 2, 12–14), a larger number of paintings of individual peasants (see, for example, fig. 1 and cat. 18–24), and a number of related studies in oil, pencil and watercolour (see, for example, cat. 3–11 and 15–17).

The group has a distinctive place within Cézanne's oeuvre. The *Card Players* paintings are his only significant engagement with what would conventionally be called a genre subject. His considerable investment in the theme, combined with the fact that two of the canvases are among the largest he ever painted, suggest that he considered the project to be a major artistic statement. In this regard, the *Card Players* are comparable to his *Bathers* series from this same decade; yet, as is so often the case with Cézanne, precious little is known about the specific circumstances of their production, let alone their intended meaning. The *Card Players* and peasant 'portraits' alike have proved remarkably impervious to conclusive critical explanation. Few people saw the works during his lifetime and contemporary responses to them are scarce. But these mysteries have only added to their fascination. The series has often been celebrated as being at the pinnacle of his achievements – "equal to the most beautiful works of art in the world" in the words of one early biographer, Gustave Coquiot.[4] Just as importantly, however, the paintings have long played a role in shaping Cézanne's post-humous reputation. Their legacy lived on – both visually and philosophically – in various quarters of early twentieth-century art, in interpretations that have shaped (and continue to shape) critical readings of the works.

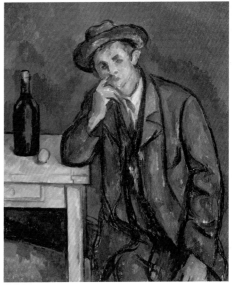

Fig. 1
Paul Cézanne
Seated Peasant, c. 1898
Oil on canvas, 45.7 × 37.5 cm
The Barnes Foundation, Merion, Pennsylvania

This project is the first to focus specifically on the series of paintings and their related works. Although small selections of them have been included in previous monographic exhibitions, this show offers the most comprehensive account of the group to date. Its catalogue discusses them with the further inclusion of the two large *Card Players* canvases, which, regrettably, could not be displayed. Although the *Card Players* and peasant works are often discussed in the literature on Cézanne, they have received surprisingly little detailed scholarly attention. Notable exceptions include Theodore Reff's important article addressing possible sources for the works and Nina Maria Athanassoglou-Kallmyer's more recent illuminating account of the social and cultural context of 1890s Provence.[5] A number of aims have been at the core of the current project: to assess the state of scholarship on the group; to enhance understanding of their production and significance; and to provide a basis for further academic exploration. The essays in this volume address a number of important concerns, from the making and sequence of the *Card Players* paintings, to consideration of their place among artistic and literary approaches to rural subject-matter in the nineteenth century and on to broader questions of the paintings' resonance within early Modernist discourse. Firstly, however, this essay introduces something of the context in which the works were produced. It relates this to the ways in which the paintings have been received and it considers how these depictions of card players and peasants have facilitated readings of the artist, which, though absorbing, often reveal more of their authors than they do of Cézanne.

Creating the Card Players

If Alexis's 1891 letter is taken as a reliable point of reference, it seems safe to assume that Cézanne began work on peasant themes no sooner than the late autumn of the previous year. The artist had spent much of the latter half of 1890 in Switzerland with his wife and son – a stay that seems to have pained him – and he returned to Aix only in November.[6] He then re-established himself in the house on his family estate, the Jas de Bouffan, where he could easily use farm workers from the estate as sitters. We know from an interview conducted in the 1950s with a certain Léontine Paulet, that in 1890 (or thereabouts) her father Paulin Paulet, a gardener at the Jas, was paid five francs by Cézanne to sit for his *Card Players* paintings. She iden-tified Paulin as the figure seated on the left of the Metropolitan Museum (cat. 1) and Barnes Foundation (cat. 2) canvases and, in the latter painting, Léontine herself recalled having posed as the young girl.[7] A later family photograph of Paulin (fig. 2) gives a sense of his appearance (despite his more advanced years), and accords broadly with Cézanne's many depictions

of him. Paulin may also have been the model for the figure on the right in the other three *Card Players* compositions, now in the Musée d'Orsay (cat. 12), the Courtauld Gallery (cat. 13) and a private collection (cat. 14), in addition to being the sitter for a number of other related works (for example cat. 20 and 21).[8] A further name has also come down to us, that of *père* Alexandre, again a farmworker from the Jas, who is identified by Georges Rivière as being the onlooker wearing a blue smock and red neckerchief in the two multi-figure paintings; he also appears in an oil sketch and is the subject of one of the most complex of the peasant portraits (cat. 2 and 23).[9]

It is impossible to know how far Cézanne had progressed with the paintings at the time of Alexis's letter. He is likely to have been working on some of the individual peasant portraits, as *The Smoker* (cat. 20) is probably one of the works that the artist gave to Alexis during his 1891 stay.[10] It has been assumed that Cézanne also embarked upon the two multi-figure *Card Players* compositions at around the same time. The series of three *Card Players* canvases of different sizes, each a repetition of a remarkably similar composition, are usually thought to have been started slightly later (perhaps around 1892). These paintings are in many ways much simpler. They show two men, facing each other, playing cards across a wooden table. Yet it is important to recognise that there is no firm evidence to confirm these hypotheses, nor any indication of how long Cézanne took to complete the two groups, and so past conclusions have been reached largely on stylistic grounds. Equally, in the absence of clear evidence, such a strict division between the multi-figure and two-figure groups may be inaccurate. In his 1923 monograph, which was in part based upon the recollections of Cézanne's son, Rivière listed the sequence of five paintings as being more intertwined than is generally thought today. However, since it is broadly accepted that Cézanne finished the two multi-figure canvases between 1890 and 1892 before embarking upon the two-figure works, which John Rewald places at various points between 1892 and 1896, this project has used the now-conventional version of events as its starting point.[11]

Debates about the sequence in which Cézanne painted the series have been central to the critical history of the *Card Players* pictures, not least because the order in which the works were made might reveal something of his practice. Cézanne's friend, the Provençal poet and writer Joachim Gasquet, seemed certain that the artist worked towards the Barnes canvas, viewing the smaller versions of the compositions as stages in its development. Indeed, Gasquet went as far as to say that the others were "only preparatory studies" for this work, which he described as being "one of his [Cézanne's] most beautiful canvases, in which he came closest to his elusive 'formula'".[12] In his more detailed account of their chronology, Rivière dated the version now in the Metropolitan to 1890, therefore placing it first in the

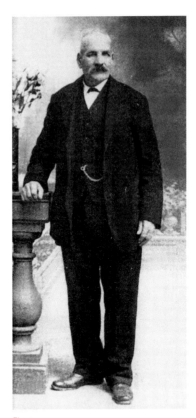

Fig. 2
Paulin Paulet, c. 1920–25
Photograph courtesy of the Paulet family

series, the Orsay and Courtauld canvases following in 1891 and the private collection and Barnes paintings bringing the series to culmination in 1892.[13] Yet later writers were to challenge these assumptions. The art historian Bernard Dorival gave a very different account of the series in 1948, in which he maintained that the artist began with the largest canvases and gradually refined his compositions until he arrived at the smallest. This view of Cézanne's process has since held considerable sway and is maintained in Rewald's catalogue raisonné.[14]

The implications of this interpretation were considerable. Effectively, Dorival suggested that Cézanne had worked against conventional nineteenth-century artistic practice, where gradual increases in scale and compositional complexity were the norm. Instead, by this logic, the artist engaged in an exercise of distillation and refinement, eliminating extraneous details (such as the young girl, picture and shelf which appear in the Barnes version) and moving beyond mimetic concerns (note, for instance, the difference between the left-hand figure in the private collection version and that in the Orsay work). Building on this notion, later writers have sometimes singled out the Orsay painting, the smallest in the whole group, as the finest of all. For the art historian Meyer Shapiro in particular, its combination of 'contemplativeness' and formal 'purity' – coupled with the excitement of Cézanne's lively broken brushwork – set it apart from the rest of the series.[15] Indeed the technique seen in the Orsay canvas – which could be seen to anticipate the painter's celebrated late style – has prompted some to argue that it might date to the mid 1890s.[16] But the technical research conducted for this exhibition has found little to support such ideas. New evidence suggests that Cézanne worked more conventionally, scaling up instead of down, and somewhat more in line with the assumptions made by earlier writers. This research is discussed in detail in the technical essay by Aviva Burnstock, Charlotte Hale, Caroline Campbell and Gabriella Macaro in this volume. Elaborating on the established *Card Players* dating, then, we have assigned each of the two-figure paintings as c. 1892–96, in order to reflect the ongoing nature of the debate.

To establish a chronology for the individual peasant paintings is perhaps even more difficult, since Cézanne's interest in the theme never fully abated. Though typically put within the broad timeframe of 1890–96, varied depictions of peasant sitters remained an intermittent feature of his work until the end of his life.[17] Gasquet recalled seeing certain canvases in the artist's studio in 1898, probably including *Man in a Blue Smock* (cat. 23).[18] In his final years Cézanne embarked upon his famous series of portraits of the gardener Vallier (see, for example, fig. 3) and, according to tradition, an unfinished canvas of Vallier was on his easel when he died in 1906.[19] For this exhibition, we have chosen to focus upon those peasant 'portraits' which link

most closely with the *Card Players* paintings themselves, those that depict the same models or that share a similar setting, attitude and handling.

The surviving preparatory works for the *Card Players*, which unusually for the artist include both drawings and oil studies, strongly suggest that Cézanne posed his peasant models individually in a studio rather than arranging actual groups of card players around a table. Having made these individual studies – many of which are highly refined and worked-up – he would then have devised the larger compositions on the actual canvases. In some instances this seems quite clear. The two multi-figure works announce

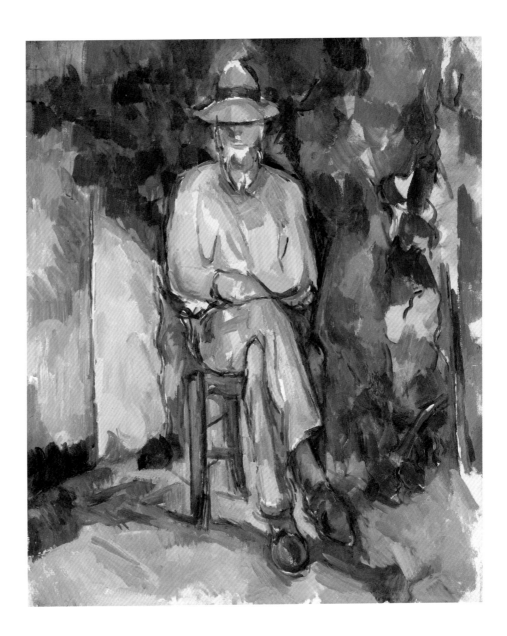

Fig. 3
Paul Cézanne
The Gardener Vallier, c. 1905–06
Oil on canvas, 65.4 × 54.9 cm
Tate, London

themselves rather explicitly as being staged rather than observed from local life, with artfully arranged props that include a curtain and pipe-rack. However, even if the other three pictures might more plausibly be thought to represent an actual rural setting (as some commentators have believed), this seems very unlikely.[20] Cézanne preferred to work alone and he relied heavily on studies made in the studio. Though he would have undoubtedly seen local peasants playing cards in Aix, even the few rapid, tiny sketches he made of seated men (see cat. 10 and 11) could have been made in the studio as easily as they might have been jotted down from a scene observed elsewhere.

The location of the studio in which the works were produced has also been a subject of debate. At the Jas de Bouffan, Cézanne had a customised studio on the top floor, in a well-lit corner room in the eves. But he was also known to have worked in the principal salon downstairs – a grand space turned over to him early on in his career, by his stern if sometimes indulgent father – though he no doubt worked in other parts of the house when it suited his needs.[21] The Jas estate also included a farmhouse, a far simpler space, where several writers have suggested that Cézanne chose to work when he painted the Card Players canvases. Even within the artist's lifetime, in 1898, Gasquet described seeing canvases in the Jas de Bouffan that showed peasant figures "in a farm room, playing cards, while smoking".[22] In his 1921 Cézanne monograph, he expanded this description to tell how the artist sat his "card players ... huge, solid and living" in his "bright farm kitchen", adding in a 1926 version of the text that one of the painter's most important projects had been to sit "a few rough card players", on country chairs and around a bottle, at "a farm at the Jas, beneath the mantelpiece of a communal chimney All the humble glory of the Jas, all of the painter's Virgilian soul, there in one never-ending dialogue".[23] These accounts, though slightly confused, were understandably persuasive. Rewald believed that the Barnes and Metropolitan canvases were indeed set in one of the farmhouse's ground floor rooms.[24] Sadly, however, that space as it stands today can offer no confirmation of this, beyond its inclusion of a fireplace, which could possibly be the one mentioned by Gasquet. Robert Ratcliffe, by contrast, suggested that the two multi-figure works may have been set in one of rooms of the main house and that the other three, with their more rustic-looking settings, were perhaps based in the farmhouse.[25] Again, there are no distinguishing architectural features still in existence to confirm this, though the bluish wall that forms the backdrop of the two multi-figure works (and the hint of a red painted decorative line at skirting board height) might support the theory. These appear in a number of other Cézanne paintings, ranging from peasant works (see for example cat. 24) to still lifes, which could suggest that this room was a regular studio space.[26] Given the numerous formal and intellectual issues raised by the works,

the enduring interest in setting may seem relatively unimportant.
But it has been prominent in the history of the works and it is as well
to question why.

Painters and peasants

The wish to know where Cézanne painted must lie, at least in part, with
the ways that writers have sought to align Cézanne with Aix and its people.
If the painter worked in a farmhouse, or in an upstairs studio near the
servants' quarters, the implication was surely that he was closer to his
subjects. Gasquet in particular courted the idea of such shared affinities,
for it suited his politicized regionalist agenda. He even speculated that the
contemplative girl in the Barnes canvas might represent the artist's youth,
offering a direct correlation between the artist and his peasant sitters.[27]
For Gasquet and others Cézanne was far more than an observer of rural
life. He was an artist who lived and worked among the people he painted
and, in a sense, he was of them. It was not enough that the banker's son
rejected a career in the legal profession to devote himself to art; a sense
of his affinity with the land and people of Provence became crucial to
a sympathetic reading of his art. Gasquet explained that Cézanne was
meticulous about finding the right location in which to paint. "He would
set himself up, with peasants more often than not. And the great work
began."[28] But it is important to recognise that, socially, the artist was far
removed from the card player subjects of his paintings.

 This is not to say that he did not feel sympathy or affection for those
who worked on the land. It is often quoted that the painter told of how he
loved "above all else the appearance of people who have grown old without
breaking with old customs":[29] a phrase that supports the idea of his
Card Players and peasant paintings as human equivalents of his beloved
Montaigne Sainte-Victoire – reassuringly steadfast in the face of a rapidly
changing modern world. They exude monumentality, gravitas and stillness;
"something that has found its centre and can never be moved" in the
words of the English critic Roger Fry.[30] But it is important to recognise
that nineteenth-century sympathy for peasants did not equate to a wish
for social progression. If respect for country-folk was common among
the middle and upper classes in nineteenth-century France, it carried
with it an integral wish for the maintenance of existing hierarchies.
For contemporary historians and sociologists, France functioned well
because each had his or her role, and aspirations to climb the ranks were
discouraged. The Republican Jules Michelet, the most famous of France's
historians, set out the roles and responsibilities of the different sections
of French society in his widely disseminated study Le Peuple.[31] He explained

that each group had a part to play in the service of the homeland, and he outlined their duties, from the peasant to the aristocrat. Catholic conservatives were even more reluctant to contemplate peasants rising above their station. A volume by one right-wing author declared the inequality of the classes to have been ordained by God, and called for good relations between the *ferme* and the *château*.[32] Seen from a variety of political standpoints, in Cézanne's lifetime, the artist could have been somehow at one with the workers on his estate, while remaining their social superior. In seeing his works contemporary viewers could have enjoyed that same theoretical relationship with the peasants depicted.

Consequently, we should remember that though the *Card Players* pictures have been interpreted as evidence of the painter's deep affinity with his subjects, there is little to suggest that Cézanne actually identified with his peasant sitters directly.[33] True, the artist had a strong work ethic but he had never held a conventional job and, even as an artist, his

Fig. 4
Paul Cézanne
Portrait of Ambroise Vollard, 1899
Oil on canvas, 100 × 81 cm
Musée du Petit-Palais, Paris

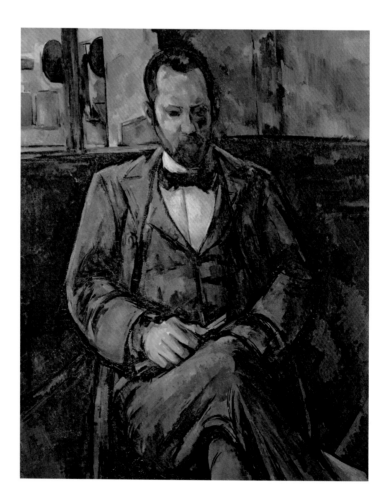

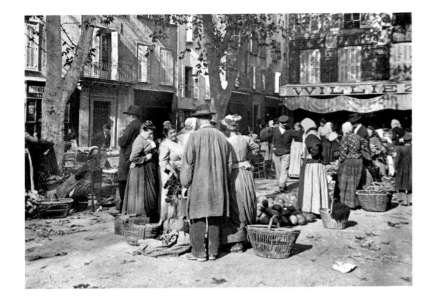

Fig. 5
A market, Aix-en-Provence, c. 1895
Photograph by Henry Ely

professional approach was idiosyncratic. This painter was a landowner
with a private income and the men that he painted were his employees.
Though he depicted these sitters with the same care and consideration
he brought to all his subjects, there is no indication that he had any kind
of personal connection with them. Their names do not appear in his
correspondence and, as mentioned previously, he paid them to pose on
at least one occasion, setting them apart from the likes of the art dealer
Ambroise Vollard (fig. 4), or of close family members who sat for him.

Many writers have highlighted how Cézanne's dress and accent
distanced him from the sophisticated Paris art world. In her important
study that focuses on the artist in the context of Provence, Athanassoglou-
Kallmyer provides a detailed analysis of the artist's manners and appearance;
she gathers examples of how Cézanne shocked his peers with his grubby
clothes and unkempt beard, and she broadens this to a more general
discussion of how provincials could never match the standards of fashion
and etiquette set by their metropolitan counterparts.[34] However, even if
the Provençal middle-classes may have seemed parochial to Parisian eyes,
within Aix itself, class codes were still at play. (As Michelet recounted, to
the peasant, even the skilled labourer seemed bourgeois).[35] A picture of a
market in Aix taken by Henry Ely – a photographer in the town at the end
of the nineteenth century – makes such distinctions between peasants and
their bourgeois neighbours clear (fig. 5). Though people from all social
categories tended to dress well for the camera in the late nineteenth century,
even informal photographs of Cézanne (see fig. 6) show him wearing clothes
that are proper, if worn. Even in adulthood, he was surely the rebellious

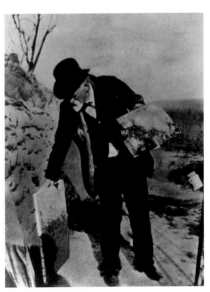

Fig. 6
Paul Cézanne, 1906
Photograph by Ker-Xavier Roussel

son of a banker, rather than a son of the earth. If he shocked society it was precisely because he was part of that world in which 'common' traits could cause offence. And as such, the artist was something of an embarrass-ment to his hometown. When Vollard visited Provence to buy works by Cézanne in the 1890s, the locals met him with a cool reception. "I see what it is," said one; "they buy [these paintings] in Paris to make fun of people from Aix!"[36] In a rather romanticised account, another early writer signalled how strange the painter appeared to the townsfolk, who he avoided for fear of insult: ". . . almost all of them know his name, very few know his voice".[37]

The idea of Cézanne as a man with an affinity with the peasant developed in the early twentieth century, encouraging understandings of the artist as a rural outsider to the modern urban world. The influential writings of the painter and theoretician Maurice Denis, and of Fry, helped to establish Cézanne as one whose achievements were the result of relentless and instinctive hard work in the natural environment, rather than of a preconceived intellectual programme.[38] Others perpetuated the reading; "to ascribe literary intentions to him . . . is more than to misunderstand Cézanne, it's to blaspheme him", penned the writer Octave Mirbeau in 1914.[39] In idealistic terms, this connected an 'authentic' painter to the virtues of 'authentic' peasant labour.

Though widespread, arguably, this vision reached its peak in the teachings of the Marxist art historian Max Raphaël, who lectured at the Volkhochschule in Berlin in the 1920s. His classes – which he described as being addressed especially "to young people who must work for a living", and which were published posthumously in translation as *The Demands of Art* – would impact on the image of Cézanne well into the latter part of the century.[40] Raphaël described Cézanne's block-like brushstrokes as "a peasant's footprints impressed into the soil, like the furrow made by a plow".[41] He concluded that the artist's palette, too, was that of a peasant, but one specifically in an age of nascent industrial capitalism, where manual labour was forced to give way to machines. He decided that the radical compositions that Cézanne created were the natural result of this struggle. For "Cézanne the peasant . . . the act of painting, to the very extent that it was instinctively and unconsciously pursued, inevitably transformed – even against the artist's will and to his own surprise – an intended harmony into a disharmony, whose inner contradictions, at least in their artistic quality, would have destroyed one another had Cézanne not deliberately staved off destruction by creating transitions and connections through analyzing nature and integrating the results of his analysis into a compositional whole."[42] Raphaël acknowledged that Cézanne was a banker's son at the outset of his text, but was at pains to stress in his conclusion that the artist has a 'passionate affection' for the

common-folk: workers, peasants and hired hands. It did not matter that such people had not understood him. Proximity would have hindered his overarching vision.

Cézanne the modern master

Alongside this desire to align Cézanne with his peasant subject-matter has been a need to celebrate him as a modern heir to masters of past art. The Card Players canvases have played a crucial part in this exercise. Less than two decades after the painter's death, the works had become iconic. In a study entitled Au chevet de l'art moderne, Guillaume Janneau described the Orsay Card Players as a work that "the painters of tomorrow consult as a reliable advisor".[43] But already, in 1905 and 1907, Denis had developed an image of a 'classic' Cézanne, dubbing him a modern Poussin.[44] Drawing upon Denis's work, Fry later linked the Card Players canvases back to the "designs of the Italian Primitives".[45] Others created yet more challenging historical genealogies. In 1913, in an important article for the journal Montjoie!, the painter Albert Gleizes had praised Cézanne as one who linked contemporary art and great French painting of the past, citing the Les Nains amongst the leaders of the tradition.[46] By 1925, in their La peinture moderne, Amédée Ozenfant and Charles-Édouard Jeanneret felt confident enough to place an image of the Barnes Card Players in an art-historical line up that included everything from Assyrian reliefs and African sculpture to paintings by Jean Fouquet and Georges Seurat's Young Woman Powdering Herself (The Courtauld Gallery).[47] More specifically, beyond a general sense of art historical genealogy, for some French artists and writers in the early twentieth century a connection between Cézanne and the Old Masters became a nationalist issue, one linked to ideas of a particularly 'Latin' culture and tradition.[48] Visually, of course, there was surely no better image to articulate the idea than his Provençal Card Players and peasant paintings. It is little wonder that Jacques Guenne, writing for L'Art Vivant in 1938, decided that "at the far reaches of a rotting civilisation" Cézanne's Peasant (cat. 19) could connect with the "rugged [and essentially French] health of the Le Nains".[49]

But did Cézanne's Card Players connect with the past in any tangible way? Card playing was an age-old pastime, with a special legacy in Provence, one of the oldest regions of playing card manufacture in France. The works themselves project a sense of unending hands, played and replayed in the ongoing ritual of an everlasting game, inviting associations of timelessness, and the subject certainly had its precedents in painting. But importantly, as John House explores in his essay in this catalogue, this was not how peasant card games were typically depicted in the art of the

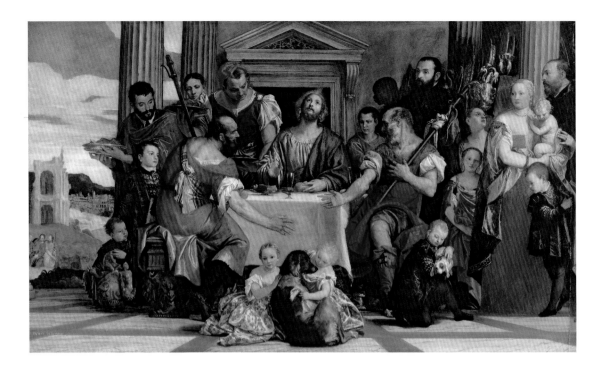

Fig. 7
Paolo Veronese
The Supper at Emmaus, c. 1559
Oil on canvas, 241 × 415 cm
Musée du Louvre, Paris

past or indeed during Cézanne's own time.[50] The game of cards was more usually deployed to convey a moralizing lesson, reflecting on the associated vices of gambling and drinking, or else its fleeting character could convey themes of *vanitas*. None of this could be further from Cézanne's novel treatment of the genre. Indeed, the fact that they deny such conventions enhances the monumentality and solidity of these *Card Players* paintings. There is no sense of rowdiness here. Cézanne stills and silences any potential intrusion into his dignified scenes. His is more a game of "collective solitaire", to quote Schapiro's memorable phrase.[51]

Yet Cézanne's *Card Players* are certainly not a rejection of the art of the past. There has been much discussion of potential historical precedents, especially those from the Louvre – from Paolo Veronese's *Supper at Emmaus* (fig. 7) to David Teniers the Younger's numerous peasant genre scenes (see, for example, fig. 34) and Jean-Baptiste-Siméon Chardin's *House of Cards* (fig. 36), which may have shaped the artist's efforts and the reception of the works.[52] Particularly compelling and enduring are connections between the series and the work of the *frères* Le Nain. The painter and writer Émile Bernard recalled in a footnote to his recollections of the artist that Cézanne spoke often of the Le Nains,[53] and he visited the Musée Granet in Aix on many occasions, where he saw Mathieu Le Nain's *Card Players* (see fig. 8). This includes a small figure standing in the background, rather like the child onlooker in the Barnes composition.[54] Gasquet claimed that Cézanne

thought the picture exemplary – a model of the way in which one should paint – and Antony Valabrègue, a childhood friend of the painter and later biographer of the Le Nains, had asked to photograph the canvas in the 1870s.[55] Perhaps he even discussed the work with Cézanne.[56] Curiously, the tones in which Valabrègue would write about the brothers some years later could well have prompted readers to associate Cézanne with the seventeenth-century French masters. "If one notices very obvious failings in the paintings of the Le Nains," he declared, "on a different note, one finds qualities that are rare and completely instinctive, faultless observation, a singular naïveté, a surprising frankness".[57] These artists were sincere if a little rough; their work "offers itself with a character that is profoundly personal".[58] But this material should also be tempered. Though the 1860s and 1870s saw a spate of publishing on the Le Nains, and in 1874 the Louvre acquired another Le Nain card-playing scene, The Little Card Players (fig. 9) – in which the standing figure also bears resemblance to the peasant to the rear of the Barnes and Metropolitan compositions – there is little to suggest that these events caused a surge of artistic interest in the Le Nains more generally. Records of copyists in the Louvre are fragmentary, but the lists for the French schools (complete for the years 1893–1906) reveal only a smattering of interest for the Le Nains. No copies are recorded as having been made of The Little Card Players,[59] and works such as Chardin's House of

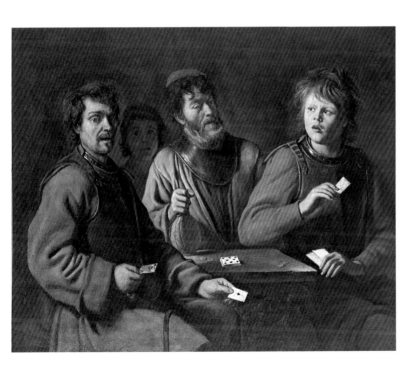

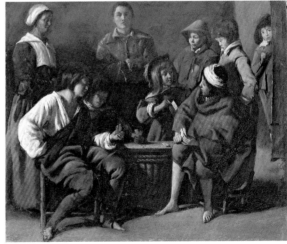

Fig. 8
Mathieu Le Nain
The Card Players (Les Joueurs de cartes), c. 1635–40
Oil on canvas, 61.4 × 76.2 cm
Musée Granet, Aix-en-Provence

Fig. 9
Antoine Le Nain
The Little Card Players (Les Petits Joueurs de cartes), c. 1635–40
Oil on copper, 15 × 17 cm
Musée du Louvre, Paris

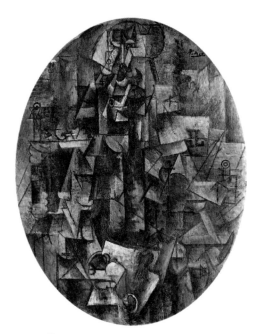

Fig. 10
Pablo Picasso
Man with a Pipe, 1911
Oil on canvas, 90.7 × 71 cm
Kimbell Art Museum,
Fort Worth

Cards, or *The Smoker* by Teniers the Younger, attracted scant attention.[60] There is evidence that Cézanne was a frequent visitor to the Louvre – himself registering to make copies in his early career – but there is no evidence that he sought out card-playing scenes in particular.[61]

For artists, perhaps, it was easier to resolve the paradoxes of Cézanne's *Card Players*. Their potential contradictions were secondary to how they suggested new ways of seeing. The legacy of Cézanne in the art of the twentieth century has, of course, been extensively charted and discussed, most recently in Philadelphia Museum of Art's exhibition, *Cézanne and Beyond*.[62] However, the impact of the *Card Players* group upon the next generation of artists exposes, particularly clearly, a divergence within that legacy. We can find numerous examples of twentieth-century works that can be related, directly or indirectly, back to Cézanne's peasants, but two of the most striking and contrasting are Pablo Picasso's *Man with a Pipe*, 1913 (fig. 10) and Theo van Doesburg's *Card Players*, 1916–17 (fig. 11).

It is unclear which of Cézanne's pipe smokers Picasso saw in Paris during the first decade of the twentieth century, but he would have had opportunities to see a number of them. Purposefully or not, a number of Picasso's Cubist portraits from this period seem to draw from the example of the Courtauld, Mannheim and Hermitage *Smokers* (cat. 18, 20, 21) in particular. In Picasso's *Man with a Pipe* the radical faceting of the picture plane pushes to an extreme Cézanne's 'patchwork' rendering of his peasants through a series of short brushstrokes, resolved to varying degrees. What Picasso seems to take from Cézanne is not so much the robust and steadfast monumentality of his peasants, but the fugitive nature of their construction. Moreover, in the Hermitage painting, Cézanne complicates the space of the picture explicitly, by setting his peasant against one of his still-life canvases, in a play of artifice and reality that would surely have appealed to the pioneers of Cubism.

By contrast, Van Doesburg's work is a direct *homage* to, and re-interpretation of, Cézanne's multi-figure scenes (cat. 1 and 2). It builds on those qualities of solidity and sure construction that Picasso's painting seems to challenge. Van Doesburg consolidates and simplifies Cézanne's composition considerably, but he does so by enhancing the pyramidal arrangement of the players that underpins the Barnes and Metropolitan paintings. Intentionally or not, his use of the arch to accentuate this also imbues the work with ecclesiastical associations, and the image as a whole is clearly akin to the stained-glass window designs Van Doesburg produced at around the same time.[63] If the monumentality and contemplativeness of Cézanne's *Card Players* borders on the spiritual, and invited comparisons with religious art of the past, this work in tempera courts similar readings.

Interestingly, it was precisely these qualities of solidity that Fernand Léger (who would later paint his own *hommage* to the *Card Players*) found

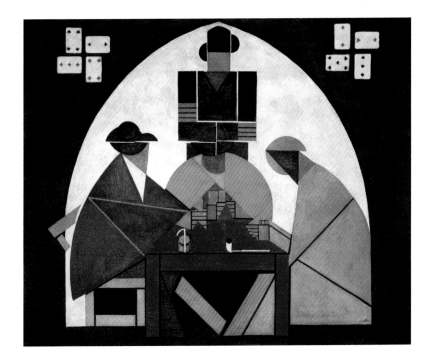

Fig. 11
Theo van Doesburg
The Card Players, 1916–17
Oil and tempera on canvas,
117 × 147.5 cm
Gemeentemuseum,
The Hague

in the large two-figure *Card Players* at the 1907 Cézanne retrospective
at the Salon d'Automne. He singled it out as one of the most "stunning
things" among "incomplete things", one which "cries out with truth and
completeness".[64]

In these instances, too, we might argue that these divergent responses
say more about the different agendas of early twentieth-century art than
they do about Cézanne's and his *Card Players* group. Yet if the *Card Players*
and peasant paintings remain compelling for us today, it is not only for
their intrinsic merits but also for their role in mythologies of Cézanne
the artist. We are not in a position to draw definitive conclusions about
the series (and perhaps that will never be possible) but it is hoped that this
project will contribute to a re-evaluation of the works and their histories.
Over a century later, it is both for their clarity and for their complexity
that the *Card Players* group remains an enduring focus of creative and
intellectual fascination.

NOTES

Our thanks to Paul Smith for his helpful suggestions and to Ernst Vegelin for his comments on the first draft of the essay.

1 "*Les journées, il peint au Jas de Bouffan, où un ouvrier lui sert de modèle, et où j'irai un de ces jours voir ce qu'il fait*": Paul Alexis, letter to Émile Zola, February 1891, *Paul Cézanne, Correspondance*, ed. John Rewald, Paris: Grasset, 1978, p. 235.

2 The term 'peasant' is used for convenience in this catalogue, since the figures have since been read as such in the Cézanne literature. But it is important to recognise the nuances of such terminology in the period and the complexities of French society in the years of the Third Republic. The "*ouvrier*" to whom Alexis referred, for instance, was certain to have been an employee of the artist, whereas the term '*paysan*' might feasibly refer to a small-holder. For an overview see Jean-Marie Mayeur and Madeline Rebérioux, 'Economy and Society', *The Third Republic from its Origins to the Great War*, trans. J.R. Foster, Cambridge, 1973, pp. 42–72.

3 It should be noted that a few isolated examples of peasants appear in Cézanne's work before this time, for example *La Moisson*, c. 1877, oil on canvas, 45.7 × 55.2 cm, private collection, Rewald: 301, and *Le Jardinier*, c. 1885 (?), oil on canvas, 63.5 × 53.5 cm, Barnes Foundation, which Rewald notes may be of a later date: John Rewald with Walter Feilchenfeldt and Jayne Warman, *The Paintings of Paul Cézanne: A Catalogue Raisonné*, New York: Harry N. Abrams, and London: Thames and Hudson, 1996, no. 525.

4 Gustave Coquiot, *Paul Cézanne*, Paris: Ollendorf, 1919, pp. 223–24.

5 Theodore Reff, 'Cézanne's "Cardplayers" and Their Sources', *Arts Magazine*, November 1980, pp. 104–17, and Nina Maria Athanassoglou-Kallmyer, *Cézanne and Provence: The Painter in His Culture*, Chicago: Chicago University Press, 2003, pp. 207–20.

6 Alexis reported that Cézanne's wife, Hortense, had "inflicted" the five-month holiday on her husband: Paul Alexis, letter to Émile Zola, February 1891, *Correspondance* 1978, p. 234.

7 Cited in Robert Ratcliffe, 'Cézanne's Working Methods and their Theoretical Background', PhD, The Courtauld Institute of Art, 1961, pp. 19–20. The whereabouts of the transcript of the original interview, listed in Ratcliffe's footnote as in the M. Provence archive, is unknown; our thanks to Michel Fraisset of the Atelier Cézanne for his efforts to locate the text.

8 This image was located by Michel Fraisset and first published in Michel Fraisset, *L'Atelier Cézanne*, Aix-en-Provence, 2006, p. 37.

9 Georges Rivière, *Le Maître Paul Cézanne*, Paris: Floury, 1923, p. 217. Although Rivière is unequivocal in his identification of cat. 3 as being a "*Portrait du père Alexandre*", there has been some subsequent confusion over this identification. This stems in part from Douglas Cooper's mistaken assertion that Rivière was referring to cat. 18. See Douglas Cooper, *The Courtauld Collection. A Catalogue and Introduction*, London, 1954, p. 89.

10 See Rewald 1996, no. 756.

11 See Rivière 1923, pp. 217–19, and Rewald 1996, nos. 710, 713, 714.

12 "*C'est une de ses plus belles toiles, celle où il a serré de plus près cette 'formule' qui lui fuyait*". He adds in a footnote: "*Qu'est-elle devenue? Les jouers de cartes au Louvre, ceux de la collection Pellerin et ceux de la collection Bernheim-Jeune n'en étaient que la préparation*": Joachim Gasquet, *Cézanne*, Paris: Bernheim-Jeune, 1926, p. 16. Interestingly, this note is absent from the 1921 version of his text.

13 See Rivière 1923, pp. 217–19.

14 See Bernard Dorival, *Cézanne*, New York: Continental Book Center, 1948, p. 63, and Rewald 1996, nos. 706, 707, 710, 713, 714.

15 Meyer Schapiro, *Cézanne*, New York: Abrams, 1952, p. 16.

16 Rewald gives a date of *c.* 1893–96: see Rewald 1996, no. 714.

17 For example, one of the works sometimes associated with the *Card Players* group is a watercolour (Rewald watercolours: 542) which shows a peasant seated at a table in an attitude comparable to some of the *Card Players* studies. However, certain points of difference, notably Cézanne's looser handling of the watercolour medium and the different table at which the man is seated, make a later date seem more probable, as Rewald suggests: see John Rewald, *Paul Cézanne: The Watercolours. A Catalogue Raisonné*, Boston: Little, Brown, 1983, no. 542.

18 Joachim Gasquet, 'Le Sang provençal', *Les Mois Dorés*, March–April 1898, p. 379.

19 For a discussion of these works see Rewald 1996, no. 954.

20 For example, Roger Fry suggested that Cézanne must have studied his card players "in some humble café in Aix": see Roger Fry, *Cézanne: A Study of His Development*, London: Leonard and Virginia Woolf at the Hogarth Press, 1927, p. 71.

21 For a summary of the artist's decoration of this room see Walter Feilchenfeldt, 'Cézanne's murals at the Jas de Bouffan: Cézanne', in *Jas de Bouffan: Cézanne*, Aix-en-Provence: Société Paul Cézanne, 2004, pp. 95–97. For Cézanne's relationship to his father, as it relates to the house, see Bruno Ely, 'Pater Omnipotens Aeterne Deus: The purchase and sale of the Jas de Bouffan by the Cézanne family', *ibid.*, pp. 23–47.

22 *"D'autres, dans une salle de ferme, jouent aux cartes, en fumant"*: Gasquet 1898, p. 379.

23 *". . . lui qui avait assis, dans sa claire cuisine de ferme, des joueurs de cartes . . . massifs, solides et vivants"*: Joachim Gasquet, *Cézanne*, Paris: Bernheim-Jeune, 1921, p. 18; *"Un de ce projets . . . ce fut, dans une ferme du Jas, sous le manteau de la cheminé commune, d'asseoir autour d'une bouteille, sur des chaises campagnardes, quelques frustres joueurs de cartes Toute l'humble gloire du Jas, tout l'âme virgilienne du peintre y dialoguent à jamais"*: Gasquet 1926, p. 16.

24 Recalled to Nancy Ireson by Anna Corsy at the farmhouse at the Jas de Bouffan, Aix-en-Provençe, 4 May 2010. Corsy grew up at the Jas and became a good friend of the art historian through his many visits to the estate. See also John Rewald, *Cézanne, A Biography*, New York: Abrams, 1986, pp. 192–93.

25 Ratcliffe discussed the matter of setting in an extended footnote: Ratcliffe 1961, pp. 401–02.

26 Jayne Warman has used this feature to link certain Cézanne still lifes to the Jas itself:

Jayne Warman, 'Les natures mortes au Jas de Bouffan', in *Jas de Bouffan* 2004, pp. 15–20.

27 Gasquet 1926, p. 16.

28 Gasquet, 'Le Printemps d'un art', Bibliothèque Méjanes, Aix-en-Provence, MS 1864, p. 30.

29 *"J'aime sur toutes choses l'aspect des gens qui ont vieilli sans faire violence aux usages"*: quoted in Jules Borély's account of a visit to Cézanne's studio, dated 1902 but not published until 1926; reprinted in Michael Doran, ed., *Conversations avec Cézanne*, Paris: Macula, 1978, p. 21.

30 Fry 1927, p. 72.

31 Michelet at once awarded France to the peasants – *"La terre de France appartient à quinze ou vingt millions de paysans qui la cultivent ; la terre d'Angleterre a une aristocratie de trente-deux mille personnes qui la font cultiver"* – and characterised their lives as hard and anxiety-ridden: Jules Michelet, *Le Peuple* [1846], Paris: Flammarion, 1974, p. 80.

32 Le Comte de Fleurance, *Les Campagnards: étude sur les paysans de France*, Paris, 1877, pp. 240–46.

33 See John House's essay in this catalogue, pp. 50–67.

34 Athanassoglou-Kallmyer 2003, esp. pp. 50–51.

35 Michelet 1974, p. 93.

36 *"Je vois ce que c'est, me dit il ; on achète ça à Paris pour se moquer de ceux d'Aix !'"*: Ambroise Vollard, *En écoutant Cézanne, Dégas, Renoir* [1938], Paris, 2008: Grasset, p. 83.

37 *"A peu près tous savaient son nom, très peu connaissaient sa voix"*: Elie Faure, *P. Cézanne*, Paris: Crès, 1926, p. 7.

38 See, for example, Maurice Denis, 'Cézanne', *L'Occident*, 1907, and Fry 1927.

39 *"Lui prêter des intentions littéraires . . . c'est plus qu'ignorer Cézanne, c'est le blasphémer"*: Octave Mirbeau, *Cézanne*, Paris: Bernheim-Jeune, 1914, preface, n. p.

40 Notably, the influential art historian Herbert Read wrote the introduction for the English edition of *The Demands of Art*: Herbert Read, Preface, Max Raphaël, *The Demands of Art*, Princeton University Press, 1968.

41 *Ibid.*, p. 18.

42 *Ibid.*, pp. 16–17.

43 *"Les joueurs de cartes . . . que le Louvre a reçus de Monsieur Camondo et que les peintres de demain consulter comme un sûr conseiller"*: Guillaume Janneau, *Au chevet de l'art moderne*, Paris: Alcan, 1923, p. 85.

44 Denis's various characterisations of Cézanne, their potential meanings and comparable concurrent readings of the

artist, are discussed in Richard Shiff, 'The Cézanne legend', in *Cézanne and the End of Impressionism: A Study of the Theory, Technique, and Critical Evaluation of Modern Art*, Chicago and London: University of Chicago Press, 1986, pp. 162–74.

45 Fry 1927, p. 72.

46 Albert Gleizes, 'Le cubisme et la tradition', *Montjoie!,* Paris, 10 February 1913. The wider significance of these Modernist lineages is discussed in Christopher Green, 'Tradition and the Progress of Styles', *Cubism and its Enemies*, New Haven and London: Yale University Press, 1987, pp. 187–202.

47 Amédée Ozenfant and Charles-Édouard Jeanneret, *La peinture moderne*, Paris: Crès, 1925. The Barnes canvas is illustrated as no. 31, p. 33.

48 Laure-Caroline Semmer, 'Cézanne au XXe siècle, une histoire de la reception critique de Paul Cézanne', PhD, Université Paris 1, Panthéon-Sorbonne, 2004, pp. 222–41.

49 "...*celles où son rêve 'de refaire Poussin sur nature' s'aille à la cadence des sentiments humain, où son paysan bleu rejoint, à l'extrême pointe d'une civilisation pourrissante, la rude santé des compagnons le Nain*": Jacques Guenne, 'La peinture française en suisse', *L'Art Vivant*, June 1938, p. 31.

50 See John House's essay in this catalogue, pp. 50–67.

51 Schapiro 1952.

52 The most comprehensive overview is that outlined in Reff 1980. See also John House's essay in this catalogue, pp. 50–67.

53 Émile Bernard, *Souvenirs sur Paul Cézanne*, 3rd edn, Paris: La Rénovation Esthétique, 1921, p. 50. Bernard mentions that the painter showed him an Ostade engraving *"qui était pour lui l'ideal des désirs".* He then adds, in a note, "*Il me parlait aussi beaucoup des frères lenain* [*sic*]".

54 Other canvases from the collection that may have had an influence are discussed in Denis Coutagne and Bruno Ely, *Cézanne au Musée d'Aix*, exh. cat., Musée Granet, Aix-en-Provence, 1984, pp. 124–25.

55 Gasquet 1921, p. 18; for Valabrègue's request, see Bruno Ely, 'Cézanne's youth and the intellectual and artistic milieu in Aix', in *Cézanne in Provence*, exh. cat., Musée Granet, Aix-en-Provence, and National Gallery of Art, Washington, 2006, p. 41.

56 Nina Maria Athanassoglou-Kallmyer, 'Cézanne and his friends at the Jas de Bouffan', in *Jas de Bouffan* 2004, p. 55.

57 "*Mais si l'on remarque, dans les toiles des Le Nain, des défauts très apparents, on y reconnaît, d'autre part, des qualités très rares et toutes de premier jet, une observation exacte, une singulière naïveté, une surprenante franchise*": Antony Valabrègue, *Les Frères Le Nain*, Paris: Librairie de l'art ancien et moderne, 1904, p. 3.

58 "*L'œuvre le Nain s'offre à nous avec un caractère profondément personnel*": *ibid.*, p. 1.

59 List of copyists for the French School, 1893–1906, Archives des Musées Nationaux, Musée du Louvre, pp. 577–82.

60 List of copyists for the French School, 1893–1906, *ibid.*, pp. 123–68 ; List of copyists for the Flemish Schools, 1882–1893, *ibid.*, LL23, pp. 266–79.

61 Theodore Reff, 'Copyists in the Louvre, 1850–1870', *The Art Bulletin*, vol. 46, no. 4, December 1964, pp. 552–59.

62 *Cézanne and Beyond*, Philadelphia Museum of Art, 2009.

63 For the place of the picture in Van Doesburg's oeuvre, and for the artist's comments on its first exhibition, see *Theo van Doesburg: oeuvre catalogue*, ed. Elks Hoek, Utrecht and Otterlo, 2003, pp. 177–78.

64 This quotation is cited by Christopher Green in his essay 'Cézanne and Léger: Realizing New Sensations', in *Cézanne and Beyond*, exh. cat., Philadelphia Museum of Art, 2009. This essay has been particularly instructive for our thinking about the legacy of Cézanne's *Card Players*.

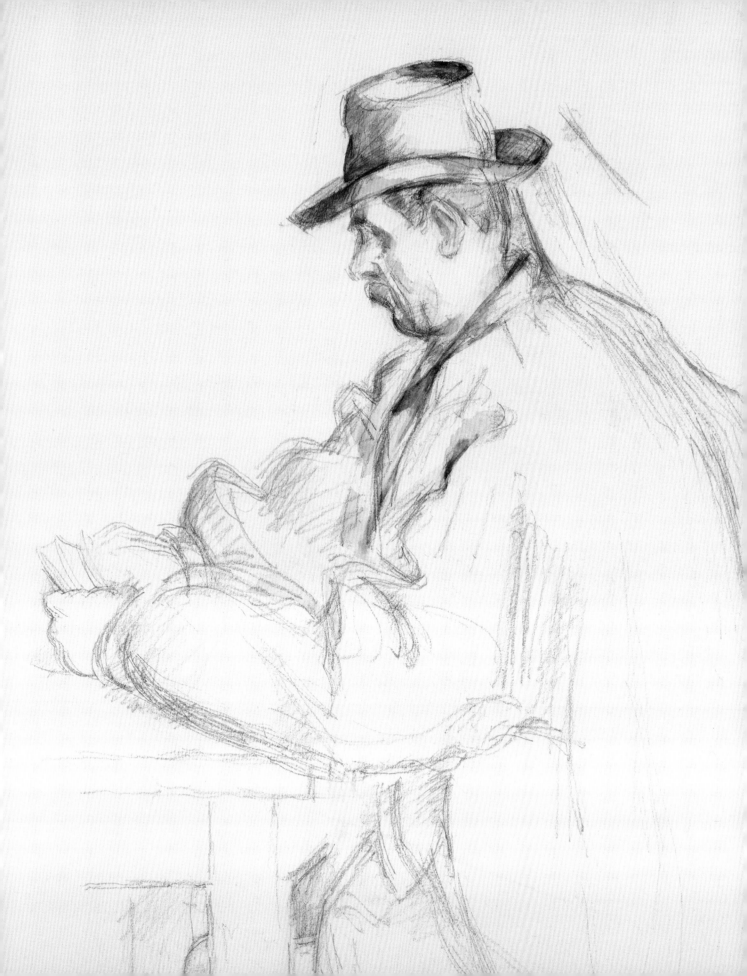

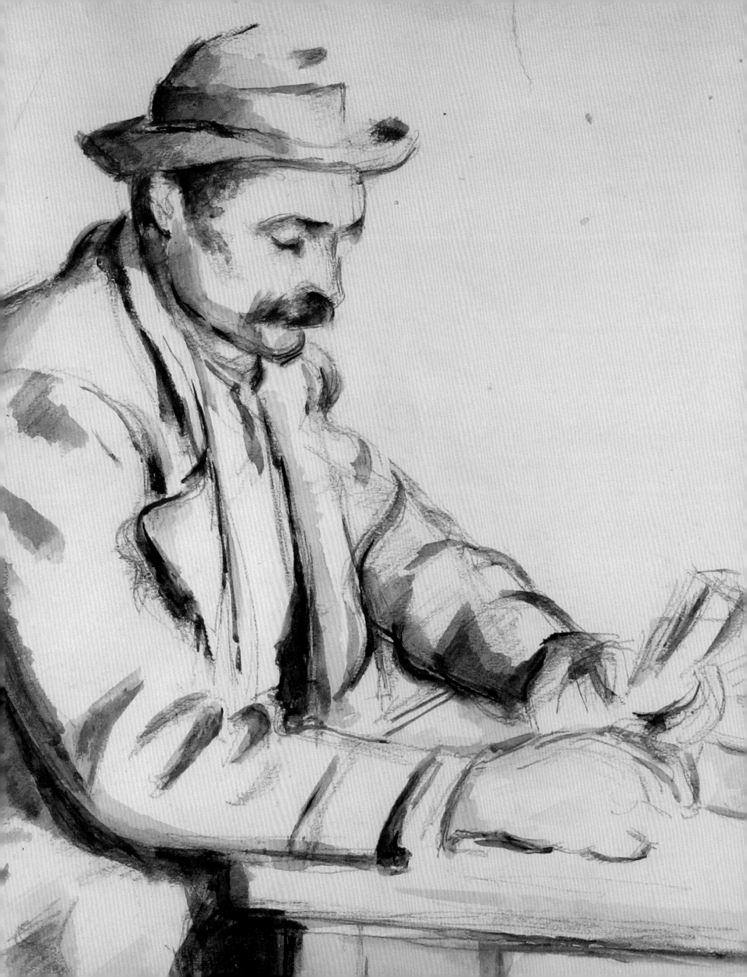

Cézanne's Development of the *Card Players*

AVIVA BURNSTOCK, CHARLOTTE HALE
CAROLINE CAMPBELL AND GABRIELLA MACARO

Cézanne's five *Card Players* paintings (The Metropolitan Museum of Art, The Barnes Foundation, Musée d'Orsay, The Courtauld Gallery and private collection; cat. 1, 2, 12, 13 and 14) are among the most impressive groups of works he ever undertook. The largest of the paintings are surpassed in scale, but not in complexity, only by the three monumental *Bathers* of his final years.[1] Like the *Bathers*, they have long been accorded a major role in Cézanne scholarship. For many writers, their silent monumentality has exemplified the profound and interlocking significance for Cézanne of the art of the past and the traditions of Provençal life. Certainly, the *Card Players* represent Cézanne's engagement with a familiar subject of genre painting, potentially known to him from various sources, including the work of Jean-Baptiste-Siméon Chardin and Adriaen van Ostade (figs. 36 and 58), whom he admired, and in particular from a painting now attributed to the Mathieu Le Nain in the Musée Granet in Aix-en-Provence (fig. 8).[2] The use of peasant sitters from Cézanne's family estate for the *Card Players* paintings, and their placement in spaces that might evoke the cafés or spartan farmhouses of the region, have also been read as articulating a sense of specifically Provençal identity, albeit one firmly within the European 'grand manner'.[3]

Most scholars of Cézanne would agree with Lionello Venturi's 1936 assessment of this group of compositions as a series of masterpieces.[4] Yet our knowledge of the *Card Players* is very fragmentary, and there are few contemporary references to them. What documentary evidence there is has served to place the production of all five *Card Players* between the autumn or winter of 1890 and the end of the decade, and to connect them to Cézanne's images of peasants and pipe-smokers of this period (including cat. 18–24). Léontine Paulet, who served as the model for the child in the Barnes Foundation *Card Players*, later recalled sitting for Cézanne with her father in 1890.[5] Paul Alexis's letter to Émile Zola of 11 February 1891 recounts that "a worker serves him [Cézanne] as a model", quite possibly for these paintings.[6] Joachim Gasquet, in 1898, commented, "There are at the Jas de Bouffan some canvases where robust peasants rest from their work Others, in a farmhouse room, play at cards, while smoking",[7] and

so the works were seemingly completed by this time. By 1899 *The Card Players* (cat. 14) was with the dealer Ambroise Vollard. But none of the paintings or studies for the *Card Players* has been dated more definitively.

Thus discussions concerning the dating and chronological order of the *Card Players* have been based almost exclusively on the material provided by the surviving paintings and drawings themselves, and from other works in the artist's oeuvre. They have been subjected to extensive connoisseurial and stylistic analysis, and from this derives the assumption that they were produced as a series, unquestioned since it was made by Georges Rivière (Paul Cézanne the younger's father-in-law) in 1923.[8] Rivière assigned them a clear chronological order, claiming that the painting now in the Metropolitan Museum came first, and was executed in 1890. He placed the Orsay and the Courtauld pictures a year later, while he assigned the Barnes Foundation and private collection paintings to 1892.[9] In 1926, Gasquet re-ordered this chronology slightly, placing the Barnes canvas last in the sequence.[10] Writing in the 1930s, Lionello Venturi and Albert Barnes followed Rivière's opinion that the pictures were executed in this two-year period, although they disagreed over their relative chronology.[11] Scholars have since debated for and against the proposition that Cézanne worked on the pictures and related figure studies over a longer time-span. Today there is widespread agreement that the five paintings are closely connected, and were probably executed between 1890 and 1896.[12] Most commentators concur that the two multi-figure paintings (cat. 1 and 2) came first.[13]

However, within this broad consensus there has been considerable discussion and debate. For some, like Joseph Rishel, one cannot propose a "chronological relationship" between the Metropolitan and Barnes paintings in the absence of any substantive evidence to determine the date and order of their execution.[14] Others have not been so circumspect. In 1948 Bernard Dorival proposed that their sequence of creation began with the largest *Card Players*, the Barnes Foundation painting (cat. 2), from which Cézanne then developed a "better centred and more stable" version of the pyramidal composition, the canvas now in the Metropolitan Museum (cat. 1). Cézanne then further simplified and harmonised this composition in the three two-figure *Card Players* (cat. 12–14), the final version of the subject being the painting in the Musée d'Orsay (cat. 12).[15] With some variations, this hypothetical order has been followed by most subsequent critics,[16] many of whom have considered the Orsay picture to be, as Meyer Schapiro remarked, "the last and undoubtedly the best".[17] The majority have seen the two larger paintings (cat. 2 and 14) as the first of each sub-group. In general, there has been little dissent from the view that, as Cezanne reworked and refined his compositions, he reduced their scale.[18]

The date of the three two-figure *Card Players* has provoked more disagreement. For some they date from the early 1890s, together with the

Barnes and Metropolitan Museum pictures.[19] For others, notably Douglas Cooper, Theodore Reff, John Rewald and Joseph Rishel, stylistic similarities with other works by Cézanne and, most significantly, a portrait of Gustave Geffroy from 1895–96 (one of the few securely dated paintings by the artist; fig. 44),[20] suggested a dating c. 1893–96 for the two-figure compositions.[21] Kurt Badt pointed out the further possibility that Cézanne "abandoned the subject for a while, and then took it up a second time when the original models were no longer available to him".[22] He argued that while "the earliest versions the figures have that 'classical' clarity which Cézanne evolved in the 1880s, the later representations of the theme, on the other hand, are akin to the male portraits of Cézanne's very late period",[23] such as those of the gardener Vallier that he made between 1904 and 1906 (see, for example, fig. 3).[24] In these works, as in the Card Players, paint has been applied in broad brushstrokes, and passages beside highly worked areas have deliberately been left bare, or covered with a very thin and insubstantial wash. However, these same characteristics have been noted in Cézanne's paintings of at least a decade earlier.[25] Essentially, there is no firm evidence on which to base a purely stylistic dating of the Card Players compositions.

Although the paintings themselves have provided the main basis for these arguments, they have not been studied from every point of view. In particular, they have not been subjected to concerted technical analysis, using techniques such as X-radiography, infrared reflectography and photography, sampling, and non-invasive analysis of materials. The undertaking of such a study for four of the five Card Players (cat. 1, 2, 12 and 13) in preparation for this exhibition, in conjunction with the close examination of several of the surviving drawings, has provided new material for consideration. The drawings appear to have been used extensively in the production of the paintings, since those parts of the painted compositions for which drawings exist reveal little evidence of reworking. In addition, technical study has supported the argument that Cézanne's Card Players can be divided into two compositional groups, but challenges the current consensus established for the order of their production. This essay asserts that the multi-figure compositions seem likely to have started with the smaller painting from the Metropolitan Museum (cat. 1) and moved outwards to the large Barnes canvas (cat. 2). The two-figure Card Players series seems to have begun with the Orsay canvas (cat. 12) and may have continued with the larger work (cat. 14), which was perhaps further refined in the smaller, Courtauld picture with a different emphasis (cat. 13). However, the relationship between these last two remains somewhat speculative and it is also possible to argue that the largest of the three was in fact the final work of the group.

Cézanne's working practice for the *Card Players* series

A starting point for Cézanne's *Card Players* series may have been several sketches in the small-format sketchbooks now in the Philadelphia Museum of Art. These include tiny graphite studies (cat. 10 and 11) that seem to relate to the central figure (cat. 10) in the Barnes and Metropolitan Museum pictures and to the man on the left (cat. 11) in the multi-figure paintings or to the right in the two-figure paintings. The sketches have an unfinished appearance, as if made in seconds or minutes, interrupted by the movement of the sitter. It is tempting to imagine that these sketches were made swiftly and discreetly in a local café where perhaps men were playing cards. However, one must acknowledge that it is equally plausible that they were made in the studio, either as initial sketches of his sitters or even at a later stage.

Whether or not Cézanne sketched in an actual café, the setting of the three two-figure paintings has often been thought to evoke such an interior. Evident in the Orsay version, for example, are the curved profile of the left sitter's back and the cork of the bottle echoed in the area behind the figures, a feature that suggests these are reflections in a mirror (fig. 12), such as one might expect to find in a café.[26] The three works on paper (cat. 16, 17 and fig. 59) and the oil study (cat. 15) which relate to these compositions all include elements of the horizontal architrave below the mirror. This suggests that this feature was intended to evoke a specific

Fig. 12
Detail of the bottle in cat. 12

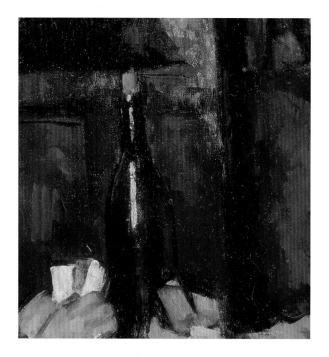

architectural locale; its height has been altered in relation to the heads
of the sitters in the paintings and in the studies.

Although Cézanne was surely inspired by first-hand experience of
observing the local practice of card playing, and even if the background
setting of the two-figure compositions might be an evocation of an actual
café, all his *Card Players* pictures were evidently executed in the studio.[27]
This has long been assumed, and it remains highly likely in the context
of his general practice. Evidence that he made use of studies of particular
sitters and objects for the *Card Players* compositions is plentiful. The
table in the Metropolitan picture, for instance, appears in other works by
Cézanne, including painted still lifes.[28] And while the simple covered table
in the two-figure versions is more generic, the same yellow-tan tablecloth
is used in other paintings which were clearly made in the studio, including
The Smoker (cat. 21). This work also includes the swathe of curtain evident
in the background of both the Barnes and the Metropolitan *Card Players*,
which was probably based on a studio prop.

Contemporary accounts of Cézanne's working practice provide
evidence that he used models for his portraits and figurative compositions.
Émile Bernard, after spending time with Cézanne between 1904 and 1906,
asserted that Cézanne's "imagination was poor: he only had a very refined
sense of composition He could not draw without a model."[29] It seems
clear that the larger and more detailed preparatory sketches and paintings
of the *Card Players* were made using several local models who posed for
Cézanne in his studio. The left-hand figure in the Metropolitan and Barnes
canvases is thought to be Paulin Paulet, a gardener at the Jas de Bouffan,
who sat for studies, with his daughter Léontine, for which they were paid
5 and 3 francs respectively. Paulet may also be the right-hand player in the
three two-figure compositions. Another farmworker, *père* Alexandre, is
thought to be the standing man in a blue smock in the multi-figure works.[30]
In addition, Cézanne owned a plaster head (fig. 13) – a studio prop which
has since been lost – which bore a striking resemblance to the head of the
left-hand player in the two-figure works. This may have been used when
his model was not available to him, as a convenient and malleable point
of reference.[31]

While a number of sketches of single figures in different media exist,
there are no extant preparatory drawings or sketches for the whole
composition of any of the *Card Players*. This has led to the consensus that
Cézanne sketched his models separately, and only later arranged them in
a determined composition. Although all five versions of the *Card Players*
exhibit different levels of reworking and application of paint, none appear
to be unfinished.

Infrared technologies identified carbon-based underdrawing in all four
painted versions of the *Card Players* examined for this study, invisible to the

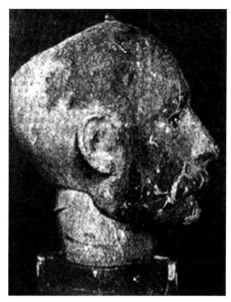

Fig. 13
Plaster head of a life-size artist's
dummy formerly belonging to Cézanne

Fig. 14
Paul Cézanne
*Madame Cézanne in the
Conservatory*, 1891
Oil on canvas, 92.1 × 73 cm
The Metropolitan Museum of Art,
New York, Bequest of
Stephen C. Clark, 1960

Fig. 15
Detail of fig. 14, showing the
sitter's hands

eye.[32] It is clear that, in these instances, Cézanne began with a free graphite sketch that provided a guide, or frame of reference, for the subsequent development of the subject in paint. The apparent modification of the figures between the initial sketches and the completed paintings no doubt indicates the extent to which he had rehearsed their form and placement in pencil or paint previously.

In general, Cézanne used both graphite and paint for drawing in the initial stages of working, as can be seen in the unfinished portrait of *Madame Cézanne in the Conservatory* (fig. 14), studied as a comparative for this project. This illustrates Cézanne's method of roughly sketching the composition in graphite and then loosely marking out contours with ultramarine blue linear brushstrokes (fig. 15).[33] He used a similar technique on paper, where he employed blue paint to mark out contours, which he then filled in with patches of colour, often leaving the painted drawing visible in gaps between the edges of forms. Technical evidence suggests that, for Cézanne, painting and drawing were not separate stages, but were used interchangeably and as the work evolved. This is true of the pictures examined in this study. In all four of the painted versions of the *Card Players*, the basic composition was established at an early stage using diluted painted lines of blue, red lake, purple, black or green. Both the initial drawing in paint, and the re-drawing of forms over patches of paint, is visible to the naked eye, as well as under examination with the microscope. This is confirmed by study of paint cross-sections. Examples of Cézanne's use of

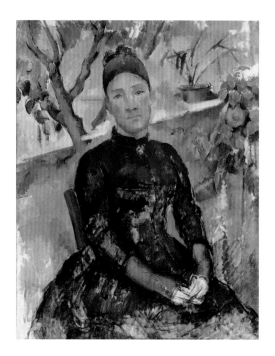

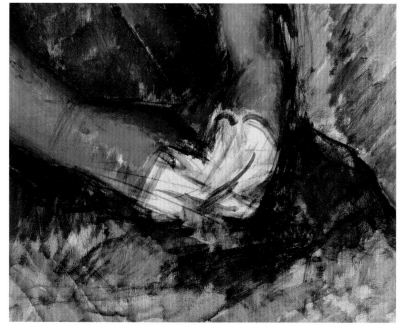

dark-blue paint to redefine outlines, to reiterate the edges of forms and to emphasise contours over patches of thicker paint are found in all the works studied here, in addition to its use for the initial, underdrawn lines in his final compositions. Interpretation of this evidence and method of working calls into question the accepted chronology of the *Card Players*.

The multi-figure compositions

There is a relatively large group of extant studies on paper that relate closely to the four-figure painting in the Metropolitan Museum and the larger five-figure painting in the Barnes Foundation, including the quick sketches for the seated left and middle figures (cat. 10 and 11) and two closely related studies for the seated figure on the right in pencil (cat. 8) and in pencil and watercolour (cat. 9). In both the studies, the presence of the table and the indication of the curtain suggest that the model posed in a studio space. It was important that such sketches related the figures to their settings: the curtain is indicated with a few summary lines and the placement of the figure at the table is explored in some detail. The heads in the two sketches are so different that they almost seem like different sitters, one bulky and the other attenuated. The drawing in the Academy of Fine Arts, Honolulu (cat. 8), which depicts the man down to his thigh, is more direct and naturalistic. The Rhode Island School of Design study (cat. 9), which shows the figure down to below his knees (as he appears in both paintings), is more freely worked, with a greater degree of abstraction, emphasising the contrast between the voluminous smock and the much narrower head. A more fully worked pencil and watercolour sketch exists for the card player at the left (cat. 7), in which the model is seated on a chair at the same table.

An oil study in the Musée d'Orsay (cat. 5) shows the man seen on the left of the Metropolitan and Barnes paintings, only seated at the opposite side of the table; his reversed placement and more forward-leaning posture distance this study from those likely to have served as direct models for the multi-figure *Card Player* paintings, namely oil sketches of the standing man (cat. 3) and the seated middle figure (cat. 4). As in the other studies, the key focus of the latter canvas is the fall of light, but the figure is further elaborated and contextualised in paint. The study includes the blue studio wall, part of the standing man, the cards held in the player's hands, and those laid on the table. The man's face is turned slightly to the left, so that his left ear is seen, as in the speedy notebook sketch (cat. 10), though here, in contrast, he wears a hat. This oil sketch is the only study to indicate a second figure, however cursorily, which suggests that Cézanne had some idea of the broader composition when he made it. There is technical evidence that the Worcester Art Museum oil study (cat. 4) preceded the Metropolitan

Fig. 16
X-radiograph of cat. 1

painting: close examination of the X-radiograph (fig. 16) shows that the initial iteration of this figure, including the angle of his head, shape of his hat and his spatial relationship with the standing man, corresponded very closely to the sketch. All these features were adjusted in the course of painting. The Worcester sketch is also the only study where the scale matches that of the corresponding figure in a completed painting. This raises the possibility that it was traced, although Cézanne's oeuvre indicates that he was able to – and generally did – transpose images of different sizes freehand.[34]

As indicated previously, for both the Metropolitan and Barnes pictures Cézanne sketched parts of the composition in graphite, and used blue and red lake paint to draw and re-draw over painted passages. Infra-red examination of the Metropolitan painting revealed soft graphite or charcoal-like marks under the paint for the left figure. Particularly striking are the swiftly drawn lines across the sitter's cheek and down the middle of his

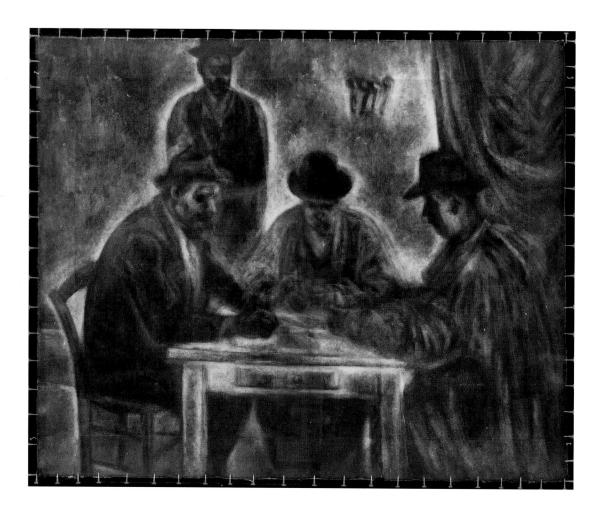

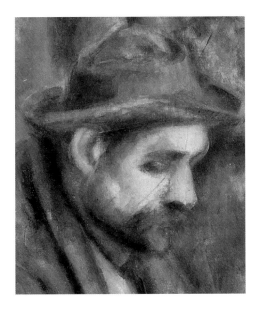

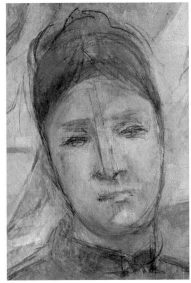

Fig. 17
Digital infrared reflectogram detail
of cat. 1, showing swiftly drawn lines
on sitter's cheek and forehead

Fig. 18
Digital infrared reflectogram detail
of fig. 14, showing registration lines in
the face

forehead (fig. 17). Similar registration lines are faintly evident in the water-colour study for this figure (cat. 7), as well as in the infra-red image of the Metropolitan Museum's *Madame Cézanne in the Conservatory* (fig. 18). The artist's underdrawing of the bottom of the jacket, longer and more open than it was eventually painted, matches its curve in the watercolour. The rough graphite lines running down the centre of the arm (fig. 19) recall Chappuis's proposition that often in Cézanne's drawings "outlines are not defined by a single stroke, but by several strokes close together".[35] Similar marks are seen in the proper left arm and proper right hand of the water-colour study (cat. 7). The shadows on the sitter's legs under the table have been hatched in diagonally in an emphatic manner, again echoing the handling of the sketch. Infrared reflectography does not reveal graphite drawing in the other figures in this painting; however, it is possible that more drawing is present but has been blocked by subsequent paint layers.

Infrared images of the Barnes Foundation painting show fine dry drawing, most clearly visible beneath the paint of the right-hand seated card player and the curtain behind him. Thin 'pencil-like' lines roughly mark out the position of the sitter's proper left sleeve, and these lines have been redrawn a number of times, as if Cézanne struggled to find the correct position for the sleeve and arm (fig. 20). Cézanne's free and sketchy under-drawing for this painting and others in the series suggests that he did not create a perfectly accurate composition at the outset. Rather, using his preliminary studies as points of reference, he had the confidence to paint the composition directly on to the canvas sometimes with little or no underdrawing in a dry medium.

Fig. 19
Digital infrared reflectogram detail
of cat. 1, showing rough graphite
lines on arm

Fig. 20
Digital infrared reflectogram detail
of cat. 2, showing redrawing of
the sleeve

Contrary to the established chronology, technical evidence suggests that the Metropolitan's *Card Players* was painted before the Barnes Foundation version. The genesis of the seated figure on the right strengthens the case. In the Metropolitan painting the head was originally drawn (in paint) looking very much like the attenuated head of the Rhode Island School of Design pencil and watercolour study (fig. 21); subsequently it was broadened slightly in the course of painting. The head in the Barnes picture is bulkier (more like the Honolulu sketch) and more abstracted. The Metropolitan painting follows the perspectival rendering of the underside of the right section of the table (shown in both preliminary drawings). And while the X-radiograph (fig. 16) reveals that the side of the table was originally painted at the same steep angle seen in the drawings, in the Barnes composition this feature was eliminated entirely.

In a similar trajectory, in the Metropolitan version Cézanne initially followed the distinctive contour of the right arm in the Honolulu drawing (cat. 8), but the billowing fold of the smock over the upper arm was painted over to create a simplified diagonal profile. This contour

Fig. 21
Digital infrared reflectogram detail
of cat. 1, showing original drawing
of the right-hand figure's head

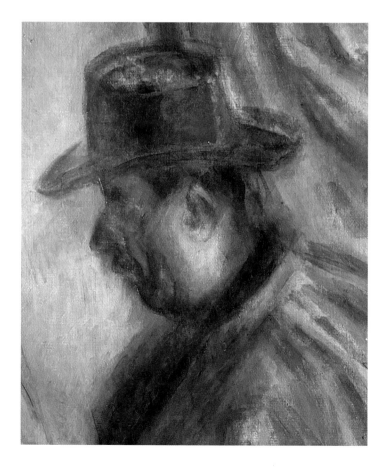

CÉZANNE'S DEVELOPMENT OF THE *CARD PLAYERS*

seems to have been followed and abstracted further in the Barnes painting. Furthermore, the lack of resolution around the figure's proper right hand in the Metropolitan painting reflects the minimal information provided by the Rhode Island School of Design drawing. It surely preceded the initial exploration and final resolution of the hands and cards in the larger work, revealed by the infrared images (fig. 9).

A further critical piece of evidence for the chronology of the *Card Players*, and perhaps one of the most compelling, relates to the development of the central seated card player. Examination of the surface of the Barnes picture in raking light revealed a build-up of underlying layers of paint which follow the contours of a hat that had been painted out. This points to the conclusion that Cézanne made the Barnes painting using the Metropolitan version as a compositional reference, deciding that the figure worked better with the hat omitted. The paint application is generally thicker in the Metropolitan picture, pointing to reworkings and other adjustments made during the painting process. In the Barnes picture the abstraction of the figures is more pronounced (see, for example, the profile of the figure on the right and the folds of his smock), the wider format gives them more space, and the relationships between them are more resolved.

The two-figure compositions

Having first painted the multi-figure compositions, it seems that Cézanne went on to create the two-figure pictures (cat. 12–14). The extant sketches relevant to these include, for the left-hand figure, *Man with a Pipe* (cat. 16) in watercolour, the pencil sketch of the same figure's head on the reverse of this sheet, and the painted sketch of the man's head (cat. 15). For the right-hand player we know only of a pencil study of the man's head (cat. 17) and a fuller-length watercolour, which is untraced (fig. 59). The detailed study in the Morgan Library (cat. 7) and the painted study in the Musée d'Orsay (cat. 5) might have informed the development of this figure but, despite similarities, there are significant differences in pose, proportion and setting. The man in the painted study is shown less in profile than in all three of the two-figure versions; he wears a brown coat, whereas in all the two-figure paintings the man on the right wears a long beige jacket. The Morgan study shows a different tilt of the hat. Moreover, the palette of the oil study and the fact that the table is not covered with a cloth in either work strongly suggest that they relate more closely to the left-hand figure in the Metropolitan and Barnes paintings, despite the fact that the man's position is transposed. The head study in the Boijmans Van Beuningen Museum (cat. 17) includes horizontal marks to indicate the architrave apparent in the background of all three of the two-figure paintings. The fuller-length watercolour of this figure (fig. 59) seems to be most closely

linked to the pose of the figure in the Orsay painting in terms of posture and relationship to the table.

Infrared examination shows that Cézanne sketched key elements of the Orsay picture in graphite directly on to the canvas, while there are only small indications of planning in this medium in the Courtauld version. In the Orsay picture, graphite underdrawing is used to sketch the figures in some detail – to locate the inner and outer contours of the left-hand player's proper right arm (fig. 22) and to mark out his hand (although these short swift lines do not correspond directly to a particular contour). Rough pencil lines, similar to those in the painted study (cat. 5), loosely outline the horizontal edge of the table-top. Changes and redrawing in paint are most evident in peripheral parts of the composition, which had not been worked out in the sketches. These include the pipe-smoking figure's three knees, left visible and clearly of less importance to Cézanne than a more significant change he made to the jacket, which echoes a repositioning of the angle of the arm. Both of these alterations were painted over.

In contrast to the pipe smoker, the figure on the right in all three two-figure versions appears to have been resolved more easily. Cézanne clearly used the preliminary studies as a guide for his graphite drawing of this figure on to the ground, in some detail in the Paris picture and more cursorily in the Courtauld version.

Fig. 22
Digital infrared reflectogram detail of cat. 12, showing graphite underdrawing on inner and outer contours of the left-hand player's arm

The infrared image of the Courtauld *Card Players* shows very little evidence of dry underdrawing. Instead, Cézanne worked out the composition in paint, using French ultramarine blue in oil as a drawing medium, traces of which are still visible at the edges of certain forms, such as the head and hat of the left-hand player (fig. 23). Ultramarine blue drawing is also evident in the left-hand figure's arm, applied over the white ground and left exposed between patches of painted drapery (fig. 24). Evidently Cézanne, having drawn the contours of the head and features of the left figure in French ultramarine, chose to leave this initial blue drawing uncovered in areas where the line defined the perimeter of the form to his satisfaction.[36] In the Courtauld painting, and more extensively in the Orsay version, painted drawing – typically in dilute and fluid paint containing French ultramarine blue (but also in pure red lake, emerald green or black) – reinstated the edges of forms at several stages in the working process. Repeated reworking is most evident in the Orsay *Card Players*, where Cézanne used both ultramarine blue paint and graphite for underdrawing and re-drawing over paint, for example to reiterate the perimeters of the mens' sleeves (fig. 25).[37]

Although Cézanne's unconventional use of drawing is evident in all the paintings examined, the two-figure versions show significant differences in the handling and application of paint. In the Orsay painting the right-hand figure was painted using thick applications of opaque paint given

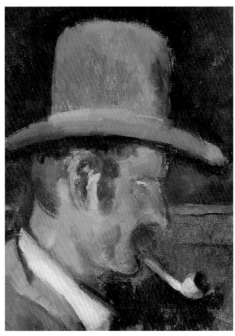

Fig. 23
Detail of cat. 13, showing traces of ultramarine blue in the contours of the left-hand player

Fig. 24
Detail of cat. 13, showing the left-hand player's arm, in which the ultramarine blue drawing over the white ground is left exposed between patches of painted drapery

body by the addition of lead white, while the same figure in the Courtauld picture was defined with washes of thin paint, which have an overall bluish tonality. In an X-radiograph of the Orsay canvas, light halos around the forms indicate the build up of paint as Cézanne sought to define and re-draw edges of important compositional elements (fig. 26), a technique he also used in the Metropolitan picture (see fig. 16).

It has not been possible to undertake a technical examination of the private collection *Card Players* (cat. 14) but a high-resolution image of the work suggests that its figures were painted using relatively fluid paint, and finalised in fewer campaigns of painting and re-drawing. White ground remains visible in passages of the clothing of both figures, and there are few changes in the composition. This indicates that Cézanne laboured less, and more readily brought the work to a conclusion that was satisfactory to him, in striking contrast to the Orsay picture, which underwent a number of changes, including, most notably, the parallel adjustments to the angle of the left sitter's arm and to the bottom of his jacket (fig. 26).

Cézanne appears to have struggled with the features of the left-hand figure in the Orsay *Card Players*, drawing and reworking the eye repeatedly. In an apparent attempt to focus the man's gaze at his hand of cards, he modified the tilt of the head. The Washington study of the pipe smoker's head (cat. 15) is very close to the same figure in the Orsay painting, both in the man's pose and in its reddish-brown colouration (fig. 27). Cézanne's

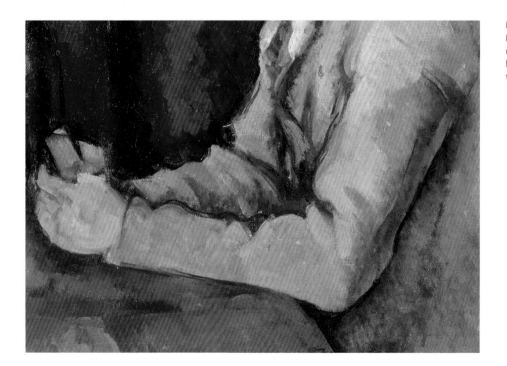

Fig. 25
Detail of cat. 13, showing reiteration with ultramarine blue paint and graphite in the right-hand player's sleeve

CÉZANNE'S DEVELOPMENT OF THE *CARD PLAYERS*

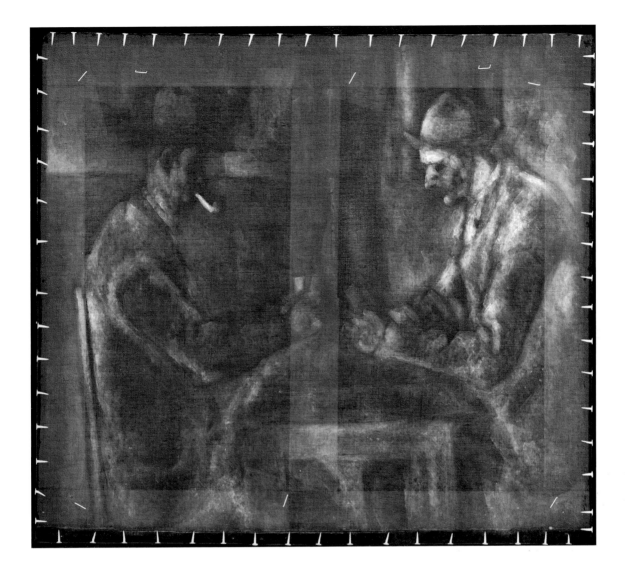

Fig. 26
X-radiograph of cat. 12

working out of this individual's head in the Orsay picture, and the more refined resolution in the sketch, could suggest that the sketch was painted after the Orsay work, in preparation for the subsequent versions, especially the larger private collection painting, in which this element of the composition is clearly resolved.

The relatively abstract depiction of figures and the wider viewpoint of the Courtauld *Card Players* distances it to an extent from the other two versions. In the Orsay picture, Cézanne sought to resolve the relationships between the figures and other elements in a narrowly focused space, and tackled this problem again in the private collection painting, where the proportions of the left-hand figure's head and limbs have an anatomical accuracy lacking in the Orsay picture. In contrast, the same figure in the

Fig. 27
Detail of cat. 12, showing reddish
brown colouration in the left-hand
sitter's head

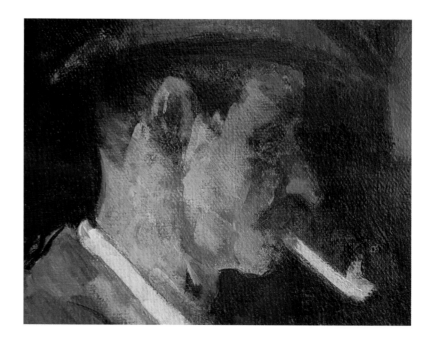

Courtauld painting is stylised and disproportionately attenuated. In this version, the depiction of the figures and their proportional relationships are secondary to a sense of overall balance, achieved rather more simply. Here the players are organised, centrally around the bottle, as only one of many pictorial elements in the composition. The Courtauld painting also exhibits less underdrawing and less reworking of well-rehearsed motifs, suggesting that it might have been the last of the series. This hypothesis cannot be fully evaluated in the absence of technical investigation of the largest two-figure painting (cat. 14). However, the discoveries made during technical examination of the other versions of the *Card Players* indicate that the series began with the smallest painting (cat. 12), which is the most worked and altered. Cézanne may then have moved on to the larger painting (cat. 14), where many of the formal difficulties appear to have been resolved. After this, perhaps, in the Courtauld version of the composition (cat. 13) Cézanne was able to develop new ideas and emphases. Nevertheless, without close study of the extent of the re-drawing and reworking in the largest work (cat. 14), the possibility remains that Cézanne followed the conventional sequence of small to large and, after exploring different aspects of the composition in the Orsay and Courtauld pictures, concluded with the private collection painting, which is the most anatomically correct.

Conclusion

Technical study of four of Cézanne's *Card Players* paintings and consideration of their relationship to the various single-figure studies suggests a new hypothesis for the order in which these paintings were created: the series was initiated with the multi-figure composition in the Metropolitan Museum, which was followed by the Barnes picture, after which Cézanne moved on to the various two-figure compositions, in the order discussed above.

This investigation suggests that Cézanne relied on formal and informal studies of individual figures as a guide for composing his oil paintings. Comparisons of these studies with the graphite underdrawing revealed in infrared images of the finished compositions suggest that Cézanne rehearsed drawing his sitters before embarking upon more complex arrangements. The studies were not generally drawn to scale, and were used as a visual aid for drawing the figures freehand on to the canvas, rather than to transfer forms. The compositions were worked out during the painting process, as the artist repeatedly painted and re-drew over paint to define edges of forms.

For all the works in the series Cézanne employed an unconventional technique, using drawing throughout the process of painting. Drawing marks made at all the stages of composition are visible on the surface in the final works. Close study suggests that this relationship between drawing and painting evolved during the production of the *Card Players* paintings. A lessening dependence on graphite underdrawing and an increased use of paint for drawing emerges in the development of the subject. Cézanne's technique of creating forms with patches of coloured paint, reinstating lines at the edges of shapes, is pronounced in the progression of this series. The accomplishment of the forms to his satisfaction with less evident labour in the later versions of the *Card Players* – and his decreasing use of graphite and paint underdrawing applied at the initial stages of working out a pictorial idea – might also mark the evolution of his painterly goals. Nonetheless, it is important to recognise that the development of the compositions was not linear or systematically layered. This practice of continual enhancement and improvement throughout the process of painting, as it is presented by these works, brings to mind Cézanne's later comment to Émile Bernard: "...time and reflection gradually modify our vision, and at last understanding comes to us".[38]

NOTES

We would like to thank Nancy Ireson, Barnaby Wright and Gary Tinterow for their helpful comments. The technical study on which this essay is based is indebted to all those who have very kindly given us access to the works in their care or ownership. For their most generous assistance we owe a particular debt of gratitude to Rita Albertson, Graeme Barraclough, Barbara Buckley, Rachel Billinge, Silvia Centeno, Elsa Lambert, Martha Lucy, Bruno Mottin, Winnie Murray, Sylvie Patry, Elisabeth Reissner, Laure-Caroline Semmer and Johanna Savant.

1 John Rewald with Walter Feilchenfeldt and Jayne Warman, *The Paintings of Paul Cézanne: A Catalogue Raisonné*, New York: Harry N. Abrams, and London: Thames and Hudson, 1996, nos. 855, 856, 857.
2 Theodore Reff, 'Cézanne's "Cardplayers" and Their Sources', *Arts Magazine*, November 1980, pp. 104–17. Émile Bernard reported that the painter spoke often of the Le Nains: Émile Bernard, *Souvenirs sur Paul Cézanne*, 3rd edition, Paris: La Rénovation Esthétique, 1921, p. 18; and Joachim Gasquet claimed that the artist saw the work as exemplary: Joachim Gasquet, *Cézanne*, Paris: Bernheim-Jeune, 1921, p. 18. See the essay by Nancy Ireson and Barnaby Wright in this volume for further discussion.
3 See Nina Maria Athanassoglou-Kallmyer, *Cézanne and Provence: The Painter in His Culture*, Chicago: Chicago University Press, 2003, pp. 207–15; Philip Conisbee, 'Cézanne's Provence', in *Cézanne in Provence*, exh. cat., Musée Granet, Aix-en-Provence, and National Gallery of Art, Washington, 2006, esp. pp. 21–22.
4 Lionello Venturi, *Cézanne. Son art, son œuvre*, 2 vols., Paris: Paul Rosenberg, 1936, I, pp. 59, 184–85. He characterises the painting now in a private collection (cat. 14) as "*la plus importante*".
5 Cited in Robert Ratcliffe, 'Cézanne's Working Methods and their Theoretical Background', PhD, Courtauld Institute, 1961, pp. 19–20.
6 "*Les journées, il peint au Jas de Bouffan, où un ouvrier lui sert de modèle, et où j'irai un de ces jours voir ce qu'il fait*": Paul Alexis, letter to Émile Zola, February 1891, Paul Cézanne, *Correspondance*, ed. John Rewald, Paris: Grasset, 1978, p. 235.
7 "*Il y a dans l'atelier du Jas de Bouffan quelques toiles où se reposent de leurs travaux de robustes paysans D'autres, dans une salle de ferme, jouent aux cartes, en fumant*": see Joachim Gasquet, 'Le sang provençal', *Les Mois Dorés*, Paris, March–April 1898, pp. 379–80.
8 Georges Rivière, *Le Maître Paul Cézanne*, Paris: Floury, 1923, p. 218; Georges Rivière, *Paul Cézanne. Le peintre solitaire*, Paris: Floury, 1936, pp. 142–51.
9 Joachim Gasquet, *Cézanne*, Paris: Bernheim-Jeune, 1926.
10 Rivière 1923, pp. 218–19.
11 Venturi 1936, nos. 556–60, pp. 184–86; Albert C. Barnes and Violette de Mazia, *The Art of Cézanne*, New York: Harcourt, Brace, 1939, pp. 415–16.
12 See, for example, Kurt Badt, *The Art of Cézanne*, trans. S. Ogilvy, Berkeley and Los Angeles: University of California, 1965, p. 88.
13 This argument was made influentially by Venturi: Venturi 1936, I, p. 185.
14 Joseph J. Rishel, 'Paul Cézanne: The Card Players', in Richard J. Wattenmaker and Anne Distel, eds., *Great French Paintings from the Barnes Collection*, New York: Knopf, 1993, p. 125.
15 Bernard Dorival, *Cézanne*, Paris and New York: Continental Book Center, 1948, pp. 60–63.
16 See, for example, Douglas Cooper, 'Two Cézanne Exhibitions', *The Burlington Magazine*, vol. 96, 1954, pp. 378–83, at p. 380; Lawrence Gowing, 'Notes on the Development of Cézanne', *The Burlington Magazine*, vol. 98, no. 639, June 1956, pp. 185–92, at p. 191; John Rewald with Walter Feilchenfeldt and Jayne Warman, *The Paintings of Paul Cézanne: A Catalogue Raisonné*, New York: Harry N. Abrams, and London: Thames and Hudson, 1996, I, no. 714, pp. 447–48; *Cézanne*, exh. cat., Grand Palais, Paris; Tate, London; and Philadelphia

Museum of Art, 1995–96, p. 338; *The Courtauld Cézannes*, exh. cat., The Courtauld Gallery, London 2008, no. 6, p. 90 (entry by John House).

17 Meyer Schapiro, *Cézanne*, New York: Abrams, 1952, p. 16.

18 Paris, London and Philadelphia 1996, pp. 335, 338.

19 Venturi 1936, nos. 556–60, pp. 184–86.

20 Paris, London and Philadelphia 1996, no. 172, pp. 410–12.

21 See, for example, Cooper 1954 (1), p. 380; Gowing 1956, p. 191; Rewald 1996, nos. 706, 707, 708, 709, 710, 713, 714. See also London 2008, no. 6, pp. 90–93 (entry by John House).

22 Badt 1965, pp. 88–89.

23 *Ibid.*, p. 89.

24 For Cézanne's portraits of Vallier, and discussion of them, see Paris, London and Philadelphia 1996, nos. 225–26, pp. 512–15, figs. 1 and 2 on p. 515.

25 Elizabeth Reissner, 'Transparency of Means: "Drawing" and Colour in Cézanne's Watercolours and Oil Paintings in The Courtauld Gallery', in London 2008, pp. 58–59.

26 We are grateful to Laure-Caroline Semmer for her insights regarding this aspect of the picture.

27 See Nancy Ireson's and Barnaby Wright's essay in this catalogue.

28 See, for example, Rewald 1996, nos. 634, 663, 769.

29 *"L'imagination de Cézanne était pauvre: il n'avait pas qu'un goût très fin d'arrangement Il ne savait pas dessiner sans le modèle"*: Émile Bernard in Michael Doran, *Conversations avec Cézanne*, Paris: Macula, 1978, p. 69.

30 See the essay by Nancy Ireson and Barnaby Wright in this volume, in particular note 9.

31 See also Rewald 1996, no. 711.

32 Infrared photography of the Barnes *Card Players* was carried out using a Nikon Coolpix 995 digital camera adapted with a 780nm

filter; the Courtauld *Card Players* was examined by Rachel Billinge using a OSIRIS camera with an InGaAs detector, 900–1700nm wavelength sensitivity. The Metropolitan Museum Cézannes were examined using an Indigo Systems Merlin InGaAs near-infrared camera sensitive to wavelengths from 900 to 1700nm, with a StingRay near-infrared optimized lens. IR imaging of the Orsay *Card Players* was carried out by Elsa Lambert at the Centre de Recherche et Restauration de Musées de France (C2RMF), discussed in dossier F489 (28 April 2010), using an OSIRIS camera with detector sensitive to 900–1700nm wavelengths.

33 Pigment analysis was carried out using Raman spectroscopy by Silvia Centeno of the Metropolitan Museum's Department of Scientific Research.

34 The infrared reflectogram shows no evidence of the means by which the composition might have been transferred. Thanks to Rita Albertson and Winnie Murray at Worcester Art Museum for providing a tracing of the figure in the sketch from the Museum.

35 Adrien Chappuis, *The Drawings of Paul Cézanne. A Catalogue Raisonné,* 2 vols., Greenwich, Conn., and London: New York Graphic Society, 1973, vol. 1, p. 10.

36 Reissner noted that in this and other paintings by Cézanne these initial painted lines find "a place in the paintings' surface at the point that Cézanne chooses to stop working on it": Reissner 2008, p. 61.

37 Technical Report dossier F489 28/4/2010, Centre de Recherche et Restauration de Musées de France (C2RMF), including characterisation of elements associated with pigments using XRF by Johanna Savant.

38 *"Le temps et la réflection d'ailleurs modifient peu à peu la vision, et enfin la compréhension nous vient"*: Paul Cézanne to Émile Bernard, Friday [1905], Letter B7 in London 2008, pp. 160–61, translated by John House.

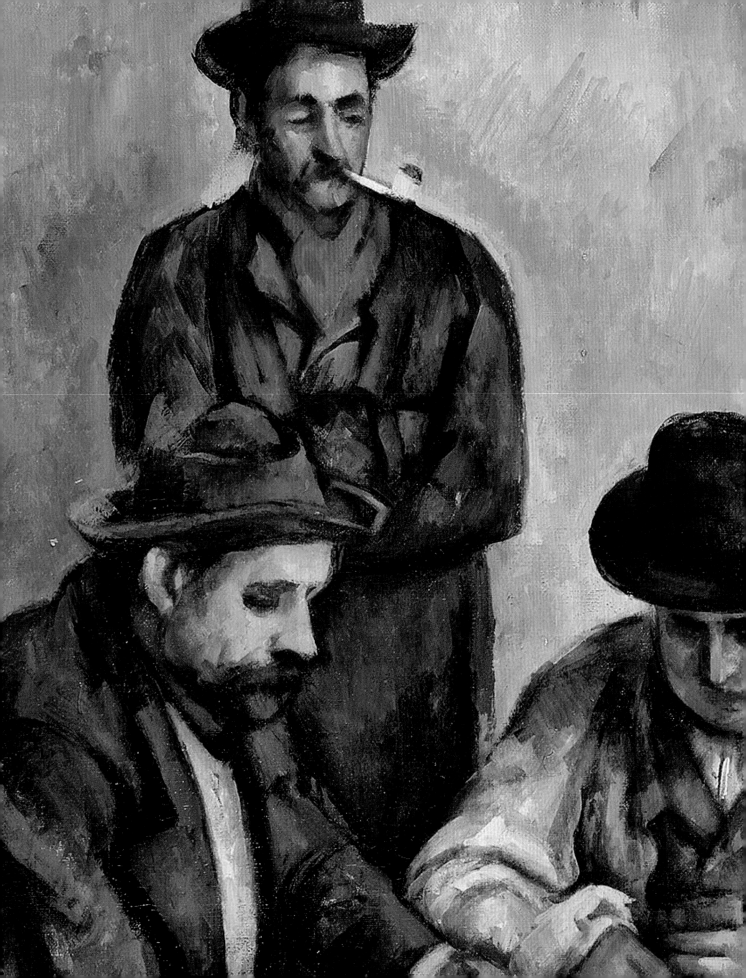

Cézanne's *Card Players*
Art without Anecdote

JOHN HOUSE

Cézanne's canvases of peasants playing cards, together with his single-figure paintings of peasant models, played a central role in his art in the early to mid 1890s (cat. 1, 2, 12–14, and for, example, 18–24). His sustained focus on the imagery of card players, in particular, together with the monumental scale of two of the canvases, shows that the project had great significance for him; indeed, the paintings occupy a role in his work in these years comparable to the large *Bathers* compositions of his next, and final, decade.

In broad terms, the *Card Players* and the single peasant figures are clearly what were classified in the nineteenth century as genre paintings – paintings of everyday life whose figures are presented as generic types, not as portraits of unique named individuals.[1] Moreover, they treat familiar themes – figures in interiors; figures around a table; men playing games; men with alcohol (the two-figure compositions include a wine bottle). Yet the ways in which Cézanne handled these themes were strikingly unconventional by contemporary standards – in their ambiguous settings and in their lack of facial expression, communicative gestures and anecdotal detail. Their exclusive focus on male figures was also most unusual in contemporary peasant painting.

The figure groupings in the *Card Players* pictures invoke echoes of a wide range of images from the art of the past and the work of Cézanne's contemporaries. Yet their treatment suggests that the nature of their relationship (if any) to these other images is oblique at best. The distinctive characteristics of Cézanne's canvases can best be defined by highlighting the ways in which they differ from the compositions that at first sight they most closely resemble.

Paintings of the countryside and its inhabitants may be viewed within two distinct frames – in relation to the material conditions of the countryside, and in the context of contemporary conventions of visual representation. Yet this distinction between 'reality' and 'art' is too simplistic, since the textual discussions that form our primary evidence about material conditions were themselves forms of representation that demand analysis in terms of the values that underpin them; and visual imagery in turn contributed to the formulation of these texts.

Fig. 28
Léon Lhermitte, frontispiece from André Theuriet,
La Vie rustique, Paris: Launette, 1888

Descriptions of rural life in France in the late nineteenth century were structured around two central issues – disputes about the 'essence' of rural society, whether it should be seen as benign or malign, noble or bestial; and the widely perceived 'crisis' of the countryside, precipitated by migration to the cities and overseas agricultural competition.[2] These two issues came together in 1887–88 in two sharply divergent texts, Emile Zola's epic novel *La Terre* and the novelist and poet André Theuriet's *La Vie rustique*, a finely produced and ostensibly documentary volume illustrated by the painter Léon Lhermitte. In *La Terre*, despite the paeans to the beauty of the countryside delivered by Zola's authorial voice, we are presented with a vision of rural society dominated by unbridled lust and cupidity and mired in blinkered self-interest. The narrative of rural decline lies in the background, but the essential characteristics of village life are presented as timeless, and inseparable from the soil that dominates the peasant's world view – soil to be worked, soil to be fought over, and soil, ideally, to be owned. Theuriet's text is presented as a response to the rural 'crisis' and as an attempt to document a whole way of life before it disappeared; here, work is hard but rewarding and ennobling, and rural society is healthy and mutually supportive. Theuriet's text is complemented by the imagery of Lhermitte's illustrations, epitomised by the book's frontispiece, which sums up his vision of rural life (fig. 28); these illustrations are presented, like the text, as evidence of a reality, rather than as the idyllic, and ideological, visions that seem so evident to us today.

Theuriet also included an implicit criticism of Zola's novel; in the introduction, dated 15 October 1887, just a month after the completion of the serial publication of *La Terre* in *Gil blas* and before it appeared in book form, he declared his determination to avoid the "brutal and false bias of what is called the *naturalist school*".[3] At the same time, he held up his image of rural life as an example to the bourgeoisie:

"Today, in France, it is in the lowly classes of the peasantry that the best-tempered characters, the most determined energy, the liveliest and most robust intelligences can be found. The day when the cult of the land is neglected by us will be the final day, and we could say, on that day, that France is truly finished. The peasant family, even with its roughness, its coarseness and its defects, is still the most active and healthy element in contemporary society, and it is in the cultivation of the land, in rural life in the open air, that the French bourgeoisie must from now on seek renewal and salvation."[4]

On this account, it was only the values of rural life that could offer France health and stability.

Cézanne's representations of peasants are strikingly unlike either Zola's or Theuriet's visions of rural life. In the painting of the period, it was a

Theuriet-like vision that predominated. By the late 1880s, the relatively harsh imagery presented in the exhibition pictures of Jules Bastien-Lepage, who died in 1884, had given way to a more expansive, idyllic vision – in the recent work of Salon painters such as Jules Breton, Julien Dupré, Edouard Debat-Ponson, and, most strikingly, Lhermitte, several of whose illustrations for Theuriet's book also appeared, on a large scale, in paintings at the Salon. In these pictures, female field workers predominate. Where men are represented, they generally appear ennobled but wearied by labour, but occasionally also as young innocent lovers. Lhermitte's *The Harvest* (fig. 30), shown at the Salon in 1883 and again at the 1889 Exposition Universelle, typifies the former option, with its aggrandised figure of a male reaper; Debat-Ponson's *Peasantry* (fig. 29), exhibited in 1888, represents the latter, the picture's original title, *Paysannerie*, suggesting that this scene of decorous courtship represents the essence of rural life – no hint here of the lust and sexual violence of Zola's novel.

Fig. 29
Edouard Debat-Ponson, *Peasantry* (*Paysannerie*), 1888
Size and whereabouts unknown, reproduced from Henri Houssaye, *Le Salon de 1888*, Paris: Boussod, Valadon & Cie, 1888

Fig. 30
Léon Lhermitte, *The Harvest*
(*La Moisson*), 1883
Oil on canvas, 233.7 × 265 cm
Mildred Lane Kemper Art Museum,
Washington University, St Louis
University purchase,
Parsons Fund, 1912

Fig. 31
Jules Breton, *Monday*
(*Lundi*), 1858
Oil on canvas, 75.6 × 110.2 cm
Mildred Lane Kemper Art Museum,
Washington University, St Louis

The imagery of male peasants in interiors carried other associations – with alcohol and drunkenness. Rural *cabarets* were widely viewed as a threat both to family life and to hard, committed work in the fields: Jules Breton's *Monday*, shown at the 1859 Salon (fig. 31), reiterates this stereotype, as the men's wives, and a dog, seek to coax their dissolute menfolk out of an inn on a Monday, when they should be at work. A more benign view of social drinking appears in Lhermitte's *Wine*, shown at the 1885 Salon and again at the 1889 Exposition (fig. 32); here, in a humble rural winery, a group of men are drinking, and one of them – perhaps the proprietor – turns to grasp the shoulder of a handsome peasant woman accompanied by two young children. Although the mood seems to be good-humoured, the scene carries an undercurrent of intense psychological, and indeed sexual, interchange. In stark contrast, Cézanne's two-figure *Card Players* canvases all include a wine bottle, but no wine glasses; the static, inexpressive figures comprehensively reject the rhetoric conventionally linked with images of peasants and alcohol.

More specifically, card playing among peasants, and its corollary, gambling, were regularly associated with drunkenness. Zola, that master of the cultural cliché, supplies ample evidence for this in *La Terre*: in two passages early in the novel drunken card-playing is used as the scenario for the most excessive and uncontrolled behaviour of the wastrel Fouan brother 'Jesus Christ'.[5] Again, Cézanne's tranquil figures wholly repudiate this chain of associations.

Fig. 32
Léon Lhermitte, *Wine*
(*Le Vin*), 1885
Oil on canvas,
245 × 307.8 cm
Musée des Beaux-Arts,
Reims

Cézanne's choice of the subject of card players has recently been viewed
in the context of the move, proposed in 1894 and voted into law late in 1895,
to increase taxes on, and controls over, the production of playing cards,
as part of a move to control gambling and, presumably, drunkenness,
a proposal vigorously opposed by the local politician Victor Leydet, a boyhood
friend of Cézanne with whom the artist had remained in contact.[6] Clearly,
Cézanne's canvases can be read as endorsement for the views that card
playing need not involve gambling (no coins can be seen in the canvases)
or excessive drinking. However, a direct connection seems unlikely, since
it seems that Cézanne began to treat the subject before 1894.[7]

Beyond this, though, we must ask how far, and in what terms, Cézanne's
choice and treatment of his subject-matter can be related to specific
contemporary historical circumstances such as these. His surviving letters
and recorded conversations give no indication of such concerns. Rather,
the few comments that we have about his social and physical surroundings
belong broadly to the 'good old days' tradition – nostalgic evocations of a
notional unchanging past, set against the visible transformations that he
saw taking place around him in the present.[8] In a letter in 1902, he lamented

the changing appearance of L'Estaque, where he had painted so often during the 1870s and 1880s: "I so well remember the Establon and the sea coast at L'Estaque, which was once so picturesque. Unfortunately, what is called progress is merely the invasion of bipeds, who do not stop until they have transformed everything into odious quays with gas lamps or, which is even worse, with electric lighting. What times we live in!"[9] Cézanne's thoughts at the end of his life were recorded by Jules Borély: "Today everything changes in reality, but not for me, I live in the town of my childhood, and it is with the eyes of the people of my own age that I see again the past. I love above all else the appearance of people who have grown old without breaking with old customs."[10] If we are to read some form of social commentary into the *Card Players* paintings, it is this comment, rather than the specifics of the playing-card debate, that seems best to characterise the immobile, expressionless figures in the paintings: these are peasants of Cézanne's own generation, presented as if they belonged to a timeless unchanging world.

The paintings are further distanced from actuality by Cézanne's treatment of the figures and their settings; consistently we are reminded that these are not straightforward naturalistic depictions of actual spaces and actual situations. None of the canvases gives any sign of activity; there is no interchange between the figures, no communicative facial expression, no hint of any gesture that might lay a card on the table – the figures are posing, not playing.

The settings are equally unreal. In the two-figure compositions, in addition to the absence of wine glasses, the nature of the background space is not clearly defined. The line of the dado running between the two men's heads, with panelling beneath it, is clearly articulated, but the area above it can be interpreted in various ways, both as a wall and as an open space, perhaps a mirror,[11] perhaps another room, or even a dusky outdoor view (in cat. 12 and 13 some of the brushstrokes in this zone can be viewed as suggesting foliage); moreover, it is unclear what the verticals behind the right figure represent. The setting can be interpreted as a café interior, but no firm identification can be made.

There is no such spatial ambiguity in the multi-figure compositions. In both, the pipe-rack on the background wall suggests that this is a modest peasant interior, but the gilt-framed picture in the Barnes Foundation painting (cat. 2) seems to belong to a different world from these humble pipes. Moreover, in both the Metropolitan Museum and Barnes compositions the curtain behind the right figure adds a blatant element of artifice – a framing device that invokes memories of the Venetian High Renaissance rather than everyday life in the countryside. Curtains, in past art, could act as a marker of status in a portrait; in a figure subject, they could lend it a sense of drama, drawing on their associations with the stage, or hint at an

act of unveiling or voyeurism. By contrast, the curtains in the Card Players canvases are drained of any such significance, and retain a rhetoric that is purely pictorial, alongside the modest, self-absorbed figures.[12]

Likewise, most of the single-figure peasant canvases are set in contexts that detach the sitters entirely from their everyday habitat – notably by placing them in front of Cézanne's own paintings, and thus implicitly in his studio (see, for example, cat. 21 and 22), or, most startlingly, in front of the pseudo-Rococo decorative screen (perhaps painted by Cézanne himself)[13] that adorned the Jas de Bouffan (cat. 23). The juxtaposition of peasant figures with fragments of Cézanne's own work has been viewed as an indication of the artist's self-identification with the local peasantry.[14] However, the very artifice of the arrangements, located in that ultimate laboratory of artifice, the artist's studio, suggests the opposite conclusion, that the compositions are primarily concerned, not with social identity, but with their own artistic integrity.

Consistently, the Card Players paintings and the single peasant figures reject the conventions of contemporary peasant painting, which sought to present the figures as an integral part of and inseparable from their surroundings, inviting the viewer to see the peasant world as a seamless whole in which figures knew their place and belonged unquestioningly in that place, as a part of a 'natural' order. By highlighting the artifice of his compositions in these varied ways, Cézanne created a categorical disjunction between the everyday world in which his models lived, on the one side, and the world of fine art on the other, and specifically the pictorial world that was wholly of Cézanne's making.

In these same years, Jules Breton, following in the footsteps of Jean-François Millet, was cultivating the public persona of a 'peasant painter', culminating in his autobiography published in 1896 with the title Un Peintre paysan, as he sought to establish the authenticity of his vision of rural life. Cézanne seems to have been working explicitly against any such identification between himself and his models, both in his treatment of his figures and in the studied artifice of their settings. Posed as they are and acting as models (who seem to have been paid), they belong unequivocally within the 'fine art' realm of the artist's studio, cut off from their everyday habitat.

The sense that the paintings belong categorically within the world of fine art is heightened by the reminiscences or echoes that the Card Players paintings – especially the multi-figure compositions – carry of the art of the past. The putative 'sources' of the paintings have been extensively studied, in greatest detail in an essay by Theodore Reff,[15] but the nature of the relationship between them and these precedents remains problematic.

Most directly, the paintings belong to a lineage of everyday scenes of figures seated around tables, eating, drinking or playing games. The most

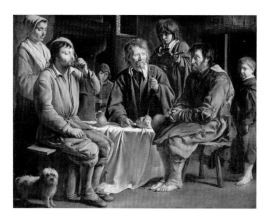

Fig. 33
Louis Le Nain
The Peasants' Meal
(*Le Repas de paysans*), 1642
Oil on canvas, 97 × 122 cm
Musée du Louvre, Paris

Fig. 34
David Teniers the Younger
The Game of Cards at an Inn
(*La Partie de cartes dans
une hôtellerie*), c. 1640–45
Oil on canvas, 62 × 88 cm
Musée de Grenoble (on deposit
from Musée du Louvre, Paris)

obvious precedent, by an artist we know Cézanne greatly admired, is Louis
Le Nain's *Peasants' Meal* of 1642 (fig. 33), which entered the Louvre in 1870
as part of the La Caze bequest; the monumental and symmetrical composi-
tion can readily be compared with Cézanne's paintings. Joachim Gasquet
recorded Cézanne's admiration for a seventeenth-century card-playing
scene attributed to the Le Nain brothers in the museum in Aix-en-Provence
(fig. 8), and compared this picture with Cézanne's *Card Players*.[16] However,
its composition resembles Cézanne's canvases less closely than does the
Louvre *Peasants' Meal*. As Nina Maria Athanassoglou-Kallmyer has
suggested, Cézanne is likely to have felt a particular sympathy for the
view of the Le Nains as essentially provincial painters whose art was
rooted in their native region, propounded by his friend Antony Valabrègue
in a monograph on the Le Nains, published in 1904 but in preparation
during the 1890s.[17] However, despite the formal similarities between
The Peasants' Meal and Cézanne's canvases, there remains a fundamental
difference between their treatments of the subject: Valabrègue interpreted
Le Nain's image at length in anecdotal terms, as depicting a poor peasant

CÉZANNE'S *CARD PLAYERS*: ART WITHOUT ANECDOTE

Fig. 35
Jean-Louis-Ernest Meissonier
The Lost Game, 1858
Oil on panel, 21.4 × 26.9 cm
The Wallace Collection,
London

giving charitable hospitality to two itinerants poorer than himself – a
far cry from Cézanne's total avoidance of any hint that might trigger an
anecdotal interpretation.[18]

Closer to Cézanne's multi-figure canvases in its arrangement is the
group of men around a table on the left side of David Teniers the Younger's
Game of Cards at an Inn (fig. 34), in those years on display in the Louvre.
Theodore Reff has noted that Teniers's card players were cited by Joris-Karl
Huysmans in his review of the 1882 Impressionist group exhibition, but
without indicating that Huysmans highlights one facet of Teniers's figures
that marks them out as categorically unlike Cézanne's – that they "almost
always look at us out of the corner of their eye" and "pose more or less for
the gallery".[19] Cézanne, however, perhaps surprisingly, revealed an interest
in this type of genre painting in these years, by making a copy, in oils,
of a print after Adriaen van Ostade's *Peasant Family at Home* (fig. 58) – a
complex interior scene not unlike Teniers's canvas.[20]

Equally unlike Cézanne's canvases are the card-playing and gambling
scenes in historical dress by nineteenth-century painters, such as Ernest
Meissonier's *The Lost Game* (fig. 35), in which the emotions of the players
are expressed by an elaborate parade of gestures and facial expressions.

Far closer in tone to Cézanne's compositions is the static figure of the boy in Jean-Baptiste-Siméon Chardin's *House of Cards* (fig. 36), another canvas that entered the Louvre in the La Caze bequest, poised as he seeks to build his fragile edifice of cards;[21] however, there is no trace of the evident philosophical dimension of Chardin's picture – a *vanitas* image – in Cézanne's canvases.[22]

Huysmans's comments about Teniers appear in a discussion of Gustave Caillebotte's *The Besique Game* (fig. 37), exhibited in 1882, a canvas whose static, introspective figures more closely anticipate Cézanne's, as first noted by Kirk Varnedoe, despite the evident distance between Cézanne's peasant figures and ambiguous settings and Caillebotte's prosperous bourgeois men in a neo-Rococo interior.[23] A final modern-life precedent, again proposed by Reff,[24] is an illustration by Jean-François Raffaëlli from the lavishly illustrated volume *Les Types de Paris*, published in 1889 (fig. 38). Here, though, it is the informal tone of the image and Raffaëlli's evident interest in distinctive physiognomies that mark its difference from Cézanne's figures.

A different chain of associations links Cézanne's multi-figure *Card Players* paintings to biblical scenes of suppers and banquets, and especially to depictions of the Supper at Emmaus, when Jesus appeared to two of his disciples after the Resurrection: Paolo Veronese's version in the Louvre (fig. 7) has been most often cited,[25] but the simplicity of Titian's version

Fig. 37
Gustave Caillebotte
The Besique Game (Partie de bésique),
1880
Oil on canvas, 121 × 161 cm
Private collection

Fig. 38
Jean-François Raffaëlli
Illustration from J.K. Huysmans, 'Les
Habitués de café', in *Les Types de Paris*,
Paris: Le Figaro, 1889

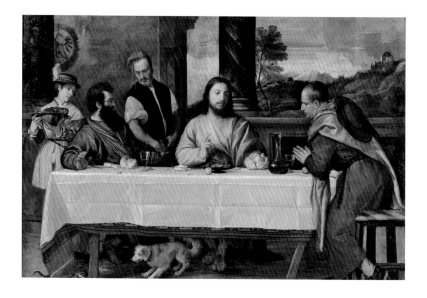

Fig. 39
Titian
The Supper at Emmaus, 1533–34
Oil on canvas, 169 × 244 cm
Musée du Louvre, Paris

(fig. 39), also in the Louvre, is perhaps closer to Cézanne's compositions. This subject was given a fresh and explicitly contemporary relevance by two paintings shown at the Paris Salon de la Société Nationale in the spring of 1892. In Lhermitte's *Friend of the Humble* (fig. 40), Jesus appears to a peasant family in a humble rural home, while in Jacques-Emile Blanche's *The Guest* (fig. 41) Jesus is seated presiding over a fashionable bourgeois dinner table, the central focus of a composition strikingly similar to Cézanne's five-figure *Card Players* canvas (cat. 2). Yet, beyond the thematic contrast, there is a fundamental difference between the compositions.

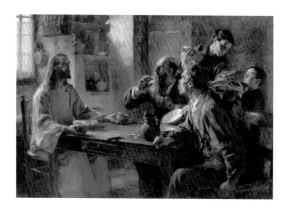

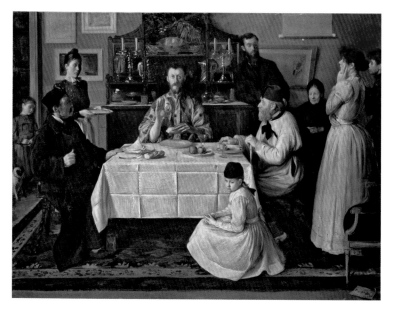

Fig. 40
Léon Lhermitte
The Friend of the Humble
(*L'Ami des humbles*), 1892
Oil on canvas, 155.5 × 222.9 cm
Museum of Fine Arts, Boston,
Gift of J. Randolph Coolidge

Fig. 41
Jacques-Émile Blanche
The Guest (*L'Hôte*), 1891–92
Oil on canvas, 220 × 290 cm
Musée des Beaux-Arts,
Rouen

Cézanne's has a monumental order, but wholly without the hieratic tone of Blanche's painting, and no hierarchical distinction is made between the figures in any of Cézanne's canvases.

The argument here is that Cézanne could deploy compositional arrangements that carried echoes of past precedents whilst stripping the forms of the chain of associative meanings that they carried in their previous incarnations. The same issue arises, in a particularly vivid form, in relation to Kurt Badt's argument that the *Card Players* paintings should be interpreted in the light of Cézanne's so-called 'Ugolino' drawing, a sketch in a letter that he wrote to Emile Zola in 1859, showing a scene loosely derived from Dante of a group of men around a table about to devour a human head.[26] As Theodore Reff has insisted, it is quite implausible that memories of a sketch made thirty years earlier in a letter to which he had no access would have provided the starting point for the *Card Players* paintings;[27] moreover, his self-absorbed and emotionally inexpressive figures work against any such interpretation. However, Mary Louise Krumrine has extended a similar interpretative path, linking the paintings to the 'Ugolino' drawing and, beyond that, to the tradition of *vanitas* imagery and specifically to the image of card players, representing 'the Gambler', in Hans Holbein the Younger's woodcuts of the *Dance of Death* (fig. 42).[28] Once again, we find an evident similarity to the multi-figure *Card Players* paintings in the placing of the figures, but Cézanne's wholly lack the dramatic gestures that so vividly convey Holbein's moral message.

Cézanne alluded to the theme of mortality and death in certain paintings during his last decade – still lifes of skulls and, most strikingly, a large canvas of a young man in a pose that evokes the imagery of melancholia, seated at a table with a skull on it (*Young Man with Skull*, c. 1896–98; Barnes Foundation). However the presence of such overt signs in some paintings does not justify the wholesale attribution of symbolic meanings to paintings where no such signs appear. The longer history of Cézanne's career reveals a striking shift from the heightened gestures and emotive subjects of his early work to the stillness and emotional restraint of which the *Card Players* paintings are a prime example. In the light of this total transformation of the rhetorical language of his paintings, it is most implausible that he sought to infuse his later paintings with the same emotive and symbolic meanings as his early work; rather, the change of pictorial language must be seen as the expression of a fundamental shift in his overall artistic project.

What, then, should we make of this long and bafflingly diverse list of potential 'sources' for the *Card Players* paintings? Their overall compositional arrangements have so many precedents, in images of very divergent meanings and purposes, that it seems inappropriate and unproductive to propose any one, or any selection of them, as a 'source' for Cézanne. He was, surely self-consciously, working within this loosely structured visual

Fig. 42
Hans Holbein the Younger
Death and the Devil come for the Gambler, woodcut, first published 1547
Private collection

tradition, and thus establishing himself as a painter with umbilical links to many threads in the past history of European figure painting – what he called the "art of the museums". However, what marks out his paintings is not their similarity, in whole or part, to any of these images, but rather their radical difference of tone from all of them. He rejected both the anecdotal language of conventional genre paintings and the hieratic, sacerdotal rhetoric of religious imagery, recreating the general configuration of his precedents in terms that demand to be viewed first and foremost as art.

Only in Caillebotte's *Besique Game*, of 1880, do we find a comparable physical and emotional detachment, but Caillebotte's canvas evidently presents a milieu that was very much the artist's own, and we can imagine him in that room as part of this bourgeois homosocial group, looking on as his friends played their game. By contrast, as we have seen, Cézanne's canvases ensure that we cannot see them as straightforward images of actual spaces and everyday situations, and they give no sense that Cézanne himself might be a part of the card-playing party.

The pictures parade the artifice of their conception and making just as vividly as Cézanne's still-life paintings of the period, whose compositions are so evidently the product of complex processes of arrangement of their diverse ingredients, brought together as artistic motifs, rather than serving as images of everyday combinations of vessels and foodstuffs. In his figure paintings as in his still lifes Cézanne deliberately highlighted this artifice, so as to ensure that his paintings could not be read transparently, as images of a 'real world' beyond them, but rather demanded to be viewed, as he famously put it, as a "harmony parallel with nature".[29]

In this context, Zola's *La Terre* and its critical reception are both relevant and revealing. The book was widely and harshly criticised, but this criticism took two very different paths. Some reviews accused its author of calumniating the peasantry, pitting his unremittingly black vision of the peasant against the 'reality' presented in representations such as Theuriet's text and Lhermitte's images. But the second line of argument insisted that the sordid detail and bestial action of the novel had no place in fine art – that Zola had transgressed the boundaries of 'art' in his pursuit of sensation and controversy. Both arguments were rehearsed in the so-called 'Manifeste des cinq', a review of *La Terre* published in August 1887 in the widely circulated newspaper *Le Figaro* by five young writers: the 'Manifeste' attracted widespread attention both for its hostility to the book and for its very personalised attack on Zola himself.[30] After lambasting the indecency of the language and the exaggerated, caricatural characters, it ended with a call to order, in the name of 'art': "It is essential that we should behave with uprightness and dignity when faced with a literature that lacks nobility, and that we should protest in the name of healthy and manly ambitions, and in the name of our cult, our deep love and our supreme respect for Art".

Much has been written about Cézanne's relationship with Zola and its ending. Intimate boyhood friends, the two men seem to have had no further contact after Cézanne wrote to acknowledge receipt of Zola's L'Œuvre in 1886, a novel whose principal character was evidently based in part on Cézanne himself. Many historians have followed John Rewald's argument that L'Œuvre caused their definitive rupture;[31] however, Joachim Gasquet, who knew Cézanne well in the later 1890s, insisted that "the book played no part in his quarrel with his old companion".[32]

There can be no doubt, though, that by the early 1890s Zola's and Cézanne's paths had diverged decisively, in both social and artistic terms. As Zola immersed himself ever more deeply in his exploration of the beast in man,[33] Cézanne was articulating ever more clearly, in his working practice as he would later in words, his idea of art as a "harmony parallel to nature", but one that was also categorically distinct from its natural starting point. Viewed from this perspective, the Card Players paintings can be seen as a riposte to and a critique of Zola's vision of the peasantry in La Terre. The thematic contrast is evident: Cézanne's card players are not drunken gamblers but, rather, quietly and soberly pursue their pastime. Crucially, Cézanne's paintings transform their humble subject into artistic compositions of great monumentality and grandeur – compositions whose artifice ensures that they cannot be seen as transparent records of the 'real world'. Whether or not La Terre was a trigger for Cézanne's decision to make the local peasantry the subject of his most ambitious paintings of the early to mid 1890s, these canvases are a decisive repudiation of Zola's aesthetic and world view.[34]

Similarly, as we have seen, they turn their back decisively on the current imagery of the peasant as seen on the walls of the Paris Salons. Their subject-matter and treatment distance them from current debates about the nature and state of the countryside. They wholly lack the anecdotalism and sentimentality of contemporary genre painting, and systematically eschew the stock means by which these paintings communicated with their viewers – by gesture and body language, physiognomy and facial expression. Their monumental compositions carry evident echoes of past art, but the figures are presented in a way that baulks any attempt to interpret their meanings in the light of these past precedents. They may be seen to convey an underlying belief in the values of "people who have grown old without breaking with old customs", and in these terms they can be viewed as endorsing the idealising view of the Provençal peasant promoted in the writings of Joachim Gasquet and his fellow Provençal writers in the 1890s.[35] Yet, in the final analysis, the form and treatment of the paintings distances them from the poetic and evocative language of the Provençal revivalists. Peasant leisure is here transfigured into – to quote Cézanne – "something solid and durable like the art of the museums".[36]

NOTES

My thanks to Nancy Rose Marshall and Barnaby Wright for their comments on the first draft of this essay.

1 See also Jon Kear, *Cézanne and Genre: Readings in the Oeuvre of Paul Cézanne*, PhD thesis, Courtauld Institute of Art, London, 2001, pp. 125ff.; Jean Arrouye, 'A balance of dissimilar elements – Cézanne's Card Players', in *Jas de Bouffan: Cézanne*, Aix-en-Provence: Société Paul Cézanne, 2004, pp. 141–42.

2 On the 'crisis' in general, see Gabriel Désert, 'La grande dépression de l'agriculture', in Georges Duby and Armand Wallon, eds., *Histoire de la France rurale*, III, Paris: Seuil, 1982, pp. 387–407; in relation to the Midi, see Nina Maria Athanassoglou-Kallmyer, *Cézanne and Provence: The Painter in His Culture*, Chicago: Chicago University Press, 2003, pp. 207–08.

3 André Theuriet, *La Vie rustique*, Paris: Launette, 1888, p. vii: "*parti pris brutal et faux de l'école dite* naturaliste".

4 "*Aujourd'hui, en France, c'est dans les couches profondes de la paysannerie que se recrutent les caractères les mieux trempés, les énergies les plus opiniâtres, les intelligences les plus vives et les plus robustes. Le jour où le culte de la terre serait dédaigné chez nous serait l'ultima dies, et nous pourrons dire, ce jour-là, que la France est bien finie. La famille paysanne, même avec ses rudesses, ses grossièretés et ses tares, est encore l'élément le plus vivace et le plus sain de la société actuelle, et c'est dans la culture de la terre, dans la vie campagnarde en plein air que la bourgeoisie française devrait désormais chercher le rajeunissement et le salut*": ibid., p. 224.

5 Émile Zola, *La Terre*, first published Paris: Charpentier, 1887, Part One, chapters 4–5; Part Two, chapter 6.

6 Athanassoglou-Kallmyer 2003, pp. 212–15, 290–92.

7 The beginning of Cézanne's work on the *Card Players* paintings has generally been linked to a letter from Paul Alexis to Zola of February 1891, which states that Cézanne was "painting at the Jas de Bouffan, where a worker acts as his model" ("*il peint au Jas de Bouffan, où un ouvrier lui sert de modèle*"): Paul Alexis, letter to Émile Zola, February 1891, Paul Cézanne, *Correspondance*, ed. John Rewald, Paris: Grasset, 1978, p. 235. It is possible, though, that initially he was working on single-figure compositions from his single peasant model, and that work on the multi-figure compositions began later.

8 For a classic analysis of this pattern of thinking, in the context of English literature, see Raymond Williams, *The Country and the City*, London: Chatto and Windus, 1973.

9 "*Je me souviens parfaitement de l'Establon et des bords autrefois si pittoresques du rivage de l'Estaque. Malheureusement ce qu'on appelle le progrès n'est que l'invasion des bipèdes, qui n'ont de cesse qu'ils n'aient tout transformé en odieux quais avec des becs de gaz et – ce qui est pis encore – avec éclairage électrique*": letter from Cézanne to Paule Conil, 1 September 1902, in *Correspondance* 1978, p. 290.

10 "*Aujourd'hui tout change en réalité, mais non pour moi, je vis dans la ville de mon enfance, et c'est dans le regard des gens de mon âge que je revois le passé. J'aime sur toutes choses l'aspect des gens qui ont vieilli sans faire violence aux usages*": Michael Doran, ed., *Conversations avec Cézanne*, Paris: Macula, 1978, p. 21.

11 Suggested as a possibility by Arrouye in *Jas de Bouffan* 2004, p. 144. See also the essay by Aviva Burnstock, Charlotte Hale, Caroline Campbell and Gabriella Macaro in this catalogue.

12 I thank Nancy Rose Marshall for her thoughts about curtains.

13 For an extended discussion of the origins and authorship of this screen, see Theodore Reff, 'Cézanne's early Paravent at the Jas de Bouffan', in *Jas de Bouffan* 2004, pp. 56–66.

14 See for example Kear 2001, pp. 139–40.

15 Theodore Reff, 'Cézanne's "Cardplayers" and Their Sources', *Arts Magazine*, November 1980, pp. 104–17.

16 Joachim Gasquet, *Cézanne*, Paris: Bernheim-Jeune, 1921, p. 18; Reff (1980, p. 108) dismisses Gasquet's story, claiming that the picture was then attributed to another artist. However, the monograph on the Le Nain brothers by Cézanne's friend Antony Valabrègue notes that this picture had recently been attributed to the Le Nains (Antony Valabrègue, *Les Frères Le Nain*, Paris: Librairie de l'art ancien et moderne, 1904, p. 165).

17 Athanassoglou-Kallmyer 2003, pp. 208–09.

18 Valabrègue 1904, pp. 83–84.

19 "...*où les joueurs nous surveillent presque toujours du coin d'oeil, où ils posent plus ou moins pour la galerie*": Reff 1980, pp. 108–09; J.-K. Huysmans, *Écrits sur l'art 1867–1905*, ed. Patrice Locmant, Paris: Bartillat, 2006, p. 267, first published in Huysmans, *L'Art moderne*, Paris: Charpentier, 1883.

20 See John Rewald with Walter Feilchenfeldt and Jayne Warman, *The Paintings of Paul Cézanne: A Catalogue Raisonné*, New York: Harry N. Abrams, and London: Thames and Hudson, 1996, no. 589, dated *c.* 1885–90; reproduced in colour in sale catalogue, *Impressionist and Nineteenth Century Art*, Christie's, London, 24 June 1998, lot 23.

21 See, for example, Reff 1980, pp. 110–11.

22 For a nineteenth-century analysis of its philosophical dimension, see Théophile Gautier, 'Les Coloristes français: Chardin', *L'Artiste*, 15 February 1864, p. 74.

23 See *Gustave Caillebotte: A Retrospective Exhibition*, exh. cat. by Kirk Varnedoe, Museum of Fine Arts, Houston, 1976, p. 143.

24 Reff 1980, pp. 113–15.

25 For example, Reff 1980, pp. 109–10.

26 Kurt Badt, *The Art of Cézanne* [first published in German in 1956], London: Faber and Faber, 1965, pp. 92–123 and fig. 7; the drawing is reproduced in *Correspondance* 1978, fig. 12, and Reff 1980, p. 117.

27 Reff 1980, pp. 114–16.

28 Mary Louise Krumrine, 'Les *Joueurs de cartes* de Cézanne: un jeu de la vie', in Françoise Cachin, Henri Loyrette and Stéphane Guégan, *Cézanne aujourd'hui*, Paris: Réunion des Musées Nationaux, 1997, pp. 65–74.

29 "...*une harmonie parallèle à la nature*": letter from Cézanne to Joachim Gasquet, 26 September 1897, in *Correspondance* 1978, p. 262. For an overview of Cézanne's career viewed in these terms, see John House, 'Cézanne's Project: The "Harmony parallel to Nature"', in *The Courtauld Cézannes*, exh. cat., London, 2008, pp. 27–47.

30 "*Il est nécessaire que ... nous adoptions une tenue et une dignité en face d'une littérature sans noblesse, que nous protestions au nom des ambitions saines et viriles, au nom de notre culte, de notre amour profonde, de notre suprême respect pour l'Art*": Paul Bonnetain, J.-H. Rosny, Lucien Descaves, Paul Margueritte, Gustave Guiches, 'La Terre: A Emile Zola', *Le Figaro*, 18 August 1887, reprinted, with extracts from other reviews of *La Terre*, in Émile Zola, *Les Rougon-Macquart*, ed. Henri Mitterand, Paris: Gallimard, 1966, vol. III, pp. 1526–36.

31 See John Rewald, *Cézanne et Zola*, Paris: Sedrowski, 1936, pp. 137–42, and subsequent editions.

32 "*Pourtant il m'affirma toujours, et il ne mentait jamais, que ce livre n'était pour rien dans cette brouille avec son vieux compagnon*": Gasquet 1921, p. 49.

33 The title of Zola's 1890 novel *La Bête humaine* can stand as shorthand for his vision of humanity.

34 Nina Athanassoglou-Kallmyer has suggested that the *Card Players* paintings might be viewed as Cézanne's act of "shaking hands in spirit" with Zola, by painting peasants who were the "fraternal counterparts of the tragic miners in *Germinal*" (Nina Athanassoglou-Kallmyer, 'Cézanne and his friends at Jas de Bouffan', in *Jas de Bouffan* 2004, p. 55). My argument here is that Cézanne's treatment of his figures runs categorically counter to any such rapprochement.

35 Doran 1978, p. 21. On Cézanne's relationship to Gasquet and the ideas of his circle, see Richard Shiff, 'Introduction', in *Joachim Gasquet's Cézanne: A Memoir with Conversations*, London: Thames and Hudson, 1991; Athanassoglou-Kallmyer 2004; Philip Conisbee, 'Cézanne's Provence', and Paul Smith, 'Cézanne's Late Landscapes, or the Prospect of Death', in *Cézanne in Provence*, exh. cat., National Gallery of Art, Washington, DC, 2006.

36 "...*quelque chose de solide et de durable comme l'art des Musées*": Cézanne, as quoted by Maurice Denis, 'Cézanne', *L'Occident*, September 1907, reprinted in Doran 1978, p. 170.

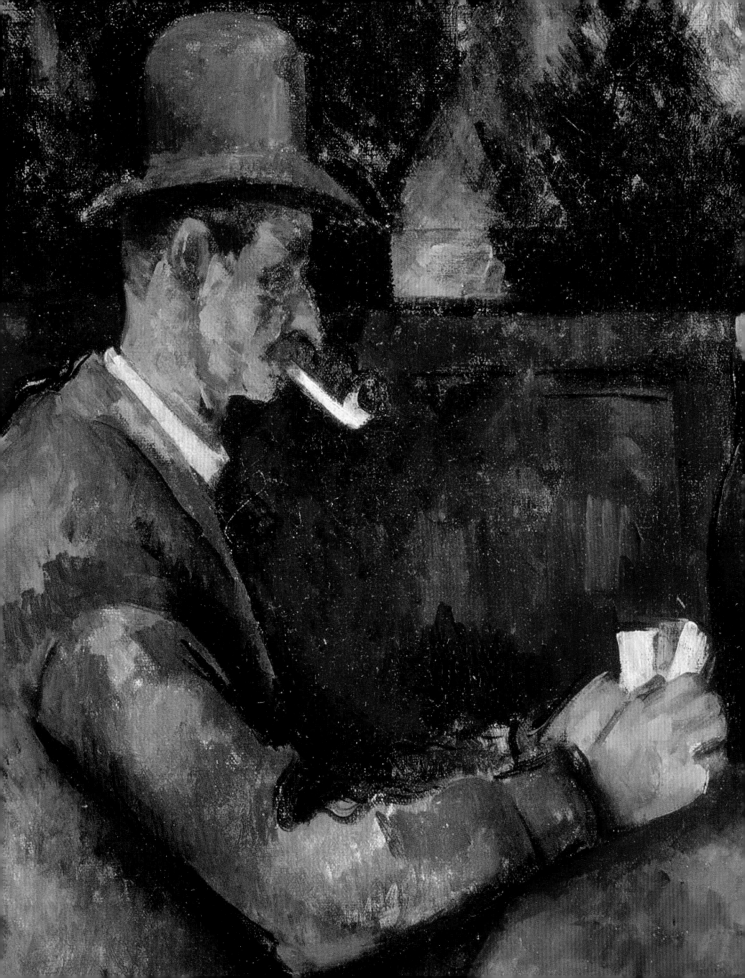

He Painted

RICHARD SHIFF

"Having become rich, he changed nothing of his way of life. He continued as before, painting assiduously, never taking interest in anything except his art. The years seemed to go by while leaving him isolated": this is the situation of Paul Cézanne, explained by Théodore Duret.[1] Because Cézanne's career was still progressing, Duret set some of his descriptive passages in the present tense. The account constitutes a chapter of his *Histoire des peintres impressionnistes*, published in 1906, apparently during the autumn, close to when Cézanne died.[2] Even with the artist deceased, Duret's conclusion remained correct: "The times had worked in favour of Cézanne". Since the late 1890s his paintings had been selling at a respectable rate, despite the disconnect between the social conservatism of this *bourgeois riche* and the public fantasy of his wildness – *Communard, anarchiste*, as members of his own class called him, unable to abide the look of his art.[3] Isolated or not, revolutionary or traditional, by the beginning of the twentieth century Cézanne appeared assured of recognition, at least among a vanguard of young painters and critics.[4]

Duret's presentation of Cézanne implies that social and emotional detachment does not impede and may even contribute to extraordinary artistic accomplishment. The writer seems to imagine a shadow history of expressive form that runs parallel to the main line of social history, not necessarily moving in tandem with the everyday needs and desires of social life, yet a feature of the same world. Cézanne's technique counted as a main event in this shadow history – his method of "strokes next to each other, then on top of each other". Duret reaches for a metaphor: "We might go so far as to say that, in certain cases, he lays his painting with bricks ... an accumulation that seems gross, barbarous, monstrous".[5] Apparently, Cézanne created no monsters in the eyes of Duret himself, a longtime champion of controversial figures, particularly Edouard Manet and James McNeill Whistler, both of whom painted his portrait. His personal collection included a number of Cézanne's works – not chance gifts but thoughtful purchases.[6] Several clearly fit the "masonry" characterisation, such as a view of Mont Sainte-Victoire used as an illustration for Duret's *Histoire* (fig. 43). So Cézanne had a distinctive form, a procedure, his own individual means –

"rough in spots … leaving certain areas bare … repetitive strokes juxtaposed or superimposed … a technique [without] any trace of what we could call virtuosity". Yet, even with virtuosity lacking, and perhaps because of this, "strong, direct expression" resulted.[7] Whatever the lineage of this technique – Duret mentions the importance of Gustave Courbet – its historical trajectory need not engage the forces driving social history at any given time.[8] The possibility of aligning aesthetic and social stars hardly motivated Cézanne. Duret believed that critical opinion never guided him, just as the fame that would follow from approval never tempted him. Cézanne painted according to his desire as he alone felt it: "He continued painting as his exclusive occupation, because he needed to satisfy himself. He paints because he is made for painting. … He paints solely for himself." Apparently, painting for oneself yields painting in itself – a freedom, an autonomy. Cézanne's "superior achievement", Duret claimed, corresponded to "the quality of painting in itself [la peinture en soi], inaccessible to [typical bourgeois] viewers".[9]

It would be reasonable to argue that Duret's notion of such a rarefied, untethered practice of painting, accomplished by an artist in social isola-tion, was no more than a myth, that it must have been serving a political or ideological charge of the writer's own moment (which, in this instance, coincided with the painter's moment – they were of the same culture, same class, same generation). It was becoming common at this time for critics to

refer to "pure painting" and to identify it with a technique of "abstraction", in the sense that various extraneous concerns were abstracted from the work.[10] Either of two complementary actions might be conducted. A painter could remove (abstract) the narrative or symbolic significance of the subject from the picture, or extract (abstract) the expressive form of the picture from its nominal subject. This is the phenomenon of the loss of subject or the absent subject: "The subject disappears; there is only a [formal, abstract] motif".[11] The words are Paul Sérusier's; they correspond to the thinking of many other artists and critics who reached professional maturity during the 1890s, the era of Cézanne's series of Card Players, which, recognizable as genre painting, ought to have had a subject.

Every society, every culture and subculture, has its mythologies, a defining aspect of its historical course, perhaps the best guide to its members' moral choices and conduct. Mythologies enter the bloodstream of the mind; you think them without thinking. Why develop a myth of "painting in itself", this "pure painting" produced by an artist who "paints solely for himself", as Duret put it? If you regard the failings of your society and its culture as a serious threat, you might look to someone apart from society for inspiration – a way out. This would return social value to social isolation and respond even to the challenge of images appearing "gross, barbarous, monstrous" – images isolated from social standards of quality and taste. It would explain how, in the case of Cézanne, social history made contact with a channel of expression regarded as independent of social history. To break a chain of social failings (which becomes a subculture's social need), turn outside the customary social framework. Look to the extremes or the isolated case.

"Never taking interest in anything except his art." Georges Braque, an early admirer but not among those who met Cézanne personally, repeated Duret's notion more than a half century later at the end of his own career, expressing it all the more succinctly with a typically French use of chiasmus: "With him, you find yourself at the antipodes of decorum. He bound his life into his art, his art into his life."[12] If, for the generations who followed, Cézanne had indicated a way out of a modern cultural impasse, he did so by folding in on himself, within the closed circle of his life-into-art, art-into-life existence. Did Braque repeat this view of a hermetic Cézanne merely because thinking otherwise had become unthinkable? Braque's opinion contributed to the cumulative authority of a cultural icon, by then well established – the mythical Cézanne. But perhaps he was merely proud to recognize his self-image in a revered predecessor – two monomaniacal painters equally extreme in devotion to their practice.

Fig. 44
Paul Cézanne
Portrait of Gustave Geffroy, 1895
Oil on canvas, 110 × 89 cm
Musee d'Orsay, Paris

Solitaire

It was not only emulative artists who persisted in perceiving Cézanne as a dedicated solitary. Even those who viewed pictorial imagery as direct reflections of social forces left Cézanne's representations to Cézanne, this force of one, wrestling with his personal technique and its associated pleasures and anxieties. In 1952, the historian Meyer Schapiro discussed the *Card Players*. His terms were not those of social engagement but psychological withdrawal: "Cézanne preserves a characteristic meditativeness and detachment from desire [He represents] the experience of the qualities of things without regard to their use or cause or consequence." When accounting for the unrevealing appearance of Cézanne's portraits from life, in particular that of the painter's supportive critic Gustave Geffroy (fig. 44), it served Schapiro to refer back to the *Card Players* as a more accommodating subject: "Cézanne often reduces the singularity of human beings; he is most happy with people like his card players, who do not impose themselves, who are perfectly passive or reserved, or immersed in their tasks. The portrait [of Geffroy] becomes a gigantic still life."[13]

Duret had reached the same conclusion by the inverse route: "Cézanne's paintings manifest a range of colour of great intensity, of extreme brilliance. A force independent of the subject derives from this, so that a still life – a few apples and a cloth on a table – assumes a presence equal to that of a human head or a landscape by the sea."[14] Duret's opinions came first-hand. During different periods, he owned one of Cézanne's most impressive still

Fig. 45
Paul Cézanne
Madame Cézanne in a Yellow Chair, 1888–90
Oil on canvas, 80.9 × 64.9 cm
The Art Institute of Chicago,
Wilson L. Mead Fund

Fig. 46
Detail of fig. 45

lifes and a portrait of Madame Cézanne (fig. 45), which, perhaps more than any other, reduced Hortense Fiquet's facial features to coarse graphic signs. To quote an evocative, recent analysis, it is as if expression were "sealed inside [and] tumescent skin has been stretched to bursting".[15] The dark punctuations on the volumetric surface of the figure's head are analogous to (and complements of) the spots of yellow or white with which Cézanne would add an abrupt highlight to an apple or a ceramic jug (figs. 46 and 49). The play of features gives a face personality; the play of light gives an object personality. Both become articulated surfaces, marked by elements of internal difference.

Cézanne developed each of his *Card Players* series, including the large five-figure version (cat. 2), by using a facture that remains coarse at the scale of individual objects. This limits any precise characterisation of facial expression. In the four-figure version (cat. 1), a single stroke or two indicates each shadowed or downcast eye (fig. 47). The only exposed lips, those of the central figure, may have been completed by a single touch of violet-red over a broader stroke of pure red – upper lip over lower. Should we say that this player purses his lips? Or clenches his jaw? Have you ever seen a Cézanne smile? One of Schapiro's contemporaries described Cézanne's human subjects unforgivingly: "The countenances show an emptiness of expression bordering almost on the mask".[16] This is the portrait of Geffroy; this is Madame Cézanne; this is the *Card Players*.

Cézanne's technique somehow equalizes and neutralizes all subject-matter. If meaning lies in differences – as the semiotics of his own era

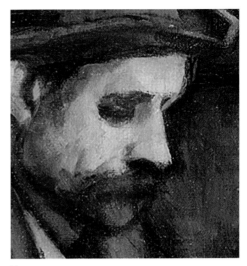

Fig. 47
Detail of cat. 1, showing downcast eye

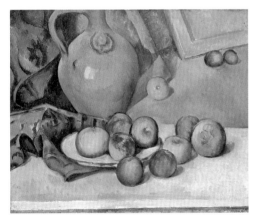

Fig. 48
Paul Cézanne
The Stoneware Jug, 1893–94
Oil on canvas, 38.2 × 46 cm.
Fondation Beyeler, Riehen/Basel

Fig. 49
Detail of fig. 48

established – then, by the implicit standards of his critics, Cézanne was rendering his subjects meaningless through excessive resemblance: one face appeared as impassive as another and, to make matters worse, all were constructed like an apple or a jug. To put it positively, Cézanne's direct way of recording visual experience broke with his own cultural prejudices, obviating numerous cultural hierarchies and the usual order of knowledge.[17] This is what had constituted "pure painting" for those sympathetic to the notion at the beginning of the twentieth century.[18] No doubt, such abstraction of visual form from a known subject could be perceived in the art of earlier periods, but at a certain moment it acquired a special significance. To both the politically left (Duret and Geffroy) and the right (Maurice Denis and Cézanne's friend Joachim Gasquet), "abstraction" – extracting painting from its contemporary turn-of-the-century culture, or removing cultural habit from the painting – offered a way out of conformism, stultification and general oppressiveness.[19]

Though the subject might be neutralized into "meditativeness and detachment from desire", linear configurations and colour harmonies retained a more active expressiveness. Schapiro noted "the arrangement of the books behind [Geffroy], projecting and receding, tilted differently from shelf to shelf". This casual formal order, he realized, seemed "more human than the man".[20] Cézanne had animated the books but not the figure. Here was a semiotic difference. Or perhaps not. In fact, Cézanne had animated both by applying his painter's touch to both. Yet human observers – Duret a century ago, Schapiro a half century ago, we ourselves now – expect to discover more life in people than in things. When technique has been applied uniformly without regard to distinguishing people from things, we tend to judge the organic, human elements as under-animated, while regarding the inorganic elements as over-animated. This is a common human prejudice, and it can sway interpretation. The "pure painting" of modern art, a mid-twentieth-century critic quipped (thinking of Cézanne), has "that strange vegetative stillness, [not] the stillness of still life, but a stillness without life."[21]

Confront Cézanne, and these witticisms fade. Focus on the play of his colour. The emotionality, the indescribable affect of the Card Players shines forth, as Schapiro himself observed: "A subtly contrasted expression [of colour] The inherent rigidity of the theme is overcome also by the remarkable life of the surface. There is a beautiful flicker and play of small contrasts."[22] 'Flicker' is the right word, both in a literal sense (brightening, dimming, brightening) and as a metaphorical evocation of filmic effects. Cézanne animated entire surfaces with sequences of alternating light and dark values and warm and cool hues, often with a surprising continuity, given the abrupt juxtaposition of his strokes. We see this effect in the five-figure Card Players, in the brilliantly patterned top plane of the table,

perhaps covered by a backgammon board.[23] We see it as well in the predominantly light-blue sleeve of the rightmost figure, where passages of dark blue and red-violet, both under-painted and over-painted, cause the surface to warp away from its material flatness. Yet Cézanne's characteristic warp does not necessarily adhere to the representational anatomy or the logical arrangement of a figure in the space of a room. His paintings gain much of their coherence from the insistent sequencing of parallel marks and alternating colours, a feature destined to violate the integrity of the depicted subject.

Note a detail as simple as the knob of the playing table drawer. Cézanne treats it as if it were one of his apples, unable to resist letting the colours of the plane beside the knob enter into it from the right. Simultaneously, in an exchange of properties, he allows the curving strokes of this rounded knob to pass into the flat of the drawer (fig. 51). Turning from the five-figure to the four-figure *Card Players*, we see that Cézanne obscured the upper edge of the same knob (fig. 52), overlaying it with a stroke of pale green, part of a complex play of greens, pinks and blues sustained throughout all surface planes of the table (and similar to his rendering of the plane of the background wall; fig. 50). What motivated the painter to counteract the descriptive integrity of his picture? It must be the technique itself. Look

Fig. 50
Detail of cat. 1, showing rendering of the plane of the background wall

Fig. 51
Detail of cat. 2, showing curving strokes of the knob and flat strokes of the drawer

Fig. 52
Detail of cat. 1, showing the complex play of greens, pinks and blues of the table

just below what appears to be a tobacco pouch on the playing table: a sequence of parallel bars of colour moves from the table-top to the table front and its drawer in this order – light red-orange, pale green, pale yellow-green, light blue, deep blue (the shadowed edge of the table), pale orange and finally the swatch of pale green that obscures the knob – essentially, an alternation of warm and cool. By this technique, all becomes equally animated and similarly volumetric, whether rounded or flat in reality – or, in certain instances, neither rounded nor flat in reality, because correspondence to reality appears utterly lacking. The stem of a pipe resting on the table coexists at its end with the dark pip of a playing card (one spot signifies both). Its bowl disappears beneath a nondescript patch of paint, a non-representational mix of white, blue and red. As a comparison, think of Cézanne's arrays of fruit and how often a contrasting colour emerges at the edge of a rounded contour, for example the pale blue that curves along a green apple in a still life painted around the time of the *Card Players* (fig. 48; detail fig. 53). This blue violates the representational order by eliminating the continuity of the table edge it covers. It has no representational referent, no subject. It is neither a solid nor is it illumination. It is painting – the so-called pure painting of the 1890s – infecting the surface with self-propagation.

Just as Cézanne introduced draped cloth into still lifes, manipulating the chance breaks and continuities of patterns and borders, his method accommodated the gathering of folds of clothing in figure paintings.

Fig. 53
Detail of fig. 48, showing pale blue curving contour of green apple

HE PAINTED

Fig. 54
Detail of cat. 4, showing folds
of clothing

In a single-figure study for the *Card Players* (cat. 4; fig. 54), blues and ochres
alternate around the collar of a peasant's smock, corresponding to a similar
effect along the cuff of the sleeve, as well as to the differentiation of playing
cards held in the hand. The reverse sides of cards would normally be of
uniform design, but here as elsewhere Cézanne presents a play of opposi-
tions – light blues against darker blues, various cool blues against warm
violets. In the same spirit, to the left of the framed picture in the five-figure
Card Players (cat. 2) bands of violet and bright blue parallel the strip of dark
gray-blue shadow. Still more abstracted – that is, generated by a formal motif
as opposed to the requirements of conventional representation – a band of
bright blue parallels the yellow stem of the rightmost pipe suspended from
a pipe rack (fig. 55). This blue accords with a technical principle of alternating
colours but obscures, virtually erases, the presence of the rack itself. The
four-figure *Card Players* (cat. 1) has an analogous detail, causing the wall to
appear to stand beside the pipe rather than lie behind it; pipe and wall
assume equivalent presence (fig. 56). The various sets of non-referential
marks – integral to the technique but abstracted from the subject and
subverting its logic – have the same pictorial status as the pale blue that
Cézanne cast against the curving edge of his green apple. Call these marks
what you will: see them as descriptively procedural and incomplete, or
as witnesses to the artist's existential state and suitably vague in relating
to representational and conceptual orders. Procedural or existential, the
demands of the evolving motif seem to overrule those of any thematic subject.

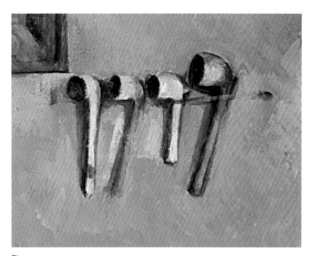

Fig. 55
Detail of cat. 2, showing pipes

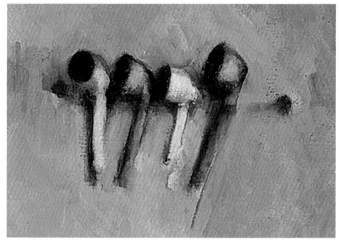

Fig. 56
Detail of cat. 1, showing pipes

A different form of Schapiro's "flicker" – all the more filmic in its sense of animation – occurs in the organisation of legs under the table shown in the five primary *Card Players* compositions. In the four- and five-figure examples we easily imagine a rhythmic pulse allowing the visible fragments of legs to swing, rock or pivot around their points of angular conjunction. In the two-figure versions, knees under the table resemble the volumes of Cézanne's pears and aubergines in still lifes; at the least, the likes of Geffroy and Duret saw it this way, even though art historians today are inclined to resist. Having once been conditioned to see the form at the expense of the representational reference, we have been reconditioned to see the subject at the expense of the form. There are gains in perception, and there are losses. Imagine that each version of Cézanne's table was, in the eyes of his supporters, framing a playful abstraction. Or, to put it more accurately – because his was hardly "abstract art" in the sense of being non-mimetic – his rendering of anatomy abstracted it from its social, thematic context, allowing knees to be interpreted as volumes equivalent to any other volumes.

During the last year of Cézanne's life, one of his admirers wrote to another (André Derain to Henri Matisse) that both were fortunate to belong to the first generation free to capitalise on an acknowledged fact: whatever material an artist chose to use would assume "a life of its own, independent of what one makes it represent".[24] Cézanne, who had pointed the way, belonged to an older generation unable to accept fully the implications of their own practice.[25] Perhaps he believed that, with his technique and its colouristic harmonies and linear rhythms, he had succeeded in revivifying a stilled subject (analogous to "remaking Poussin from nature").[26] If Cézanne's technique had a motivating principle, it may have been this:

let one movement generate the next. The movement of sensation becomes its own motivation. This creates a motif.[27] Cézanne's pencil sketch of a seated man (fig. 57), presumably drawn from life, becomes a cascade of curves, a set of counterbalancing, rapidly executed strokes that resemble each other more than any feature of the generic figure they represent. This is representation by motific infection.

But now turn from focusing on the play of colour and line to concentrate on the human theme as such: all becomes contemplative, emotionally grave, even deadened. In the *Card Players* Schapiro noted the lack of an animating "drama of rival expectations", essential to gaming as usually experienced. Nor did Cézanne capture the regional flavour of card playing in Provence, "convivial and loud".[28] By Schapiro's description, Cézanne's card playing became "a kind of collective solitaire … a model of his own activity as an artist". With this remarkable characterisation, the writer succeeds in presenting the painter's theme as appropriate to his position in isolation from society. Yes, card playing is a social activity, but one that allows its participants to remain solitary: "collective solitaire". Schapiro's

Fig. 57
Paul Cézanne
Seated Man, c. 1892–96?
Sketchbook II, p. xxiii verso
Graphite on wove paper
Sheet 18.4 × 12.7 cm
Philadelphia Museum of Art,
Gift of Mr. and Mrs. Walter H.
Annenberg, 1987

analysis of a two-figure version (cat. 12) produces a Duret-like result, a picture of self-motivation: "It is the image of a pure contemplativeness without pathos For Cézanne, painting was a process outside the historical stream of social life, a closed personal action."[29]

Like Schapiro but a generation later, Theodore Reff identified a single form of expression in the totality of Cézanne's art: "The gravity and reserve of the cardplayers are equally characteristic of Cézanne's other figural subjects [A] pervasive psychological tone . . . reflects the artist's deeply serious personality in everything he paints." If only by default, Cézanne directed all subject-matter toward the same meaning. Reff nevertheless enlisted a set of interpretive metaphors as if they were specific to the Card Players – "massive, brooding concentration", a "profoundly meditative mood", "monumentally calm and impersonal peasants". Rejecting the parallel impulse, he argued against an analogous consistency of expression factored through the materiality of painting: "Earlier writers had impoverished the pictures by reducing their human subjects to mere forms".[30] The two interpretations, however, would be much the same with regard to their descriptive language – concentrated, monumental, impersonal, and so forth. One interpreter's loss is another's gain. Whether perceiving the cultural meaning of the subject or the play of the material, each of these conflicting impulses seems to depend on the other for its metaphors. Slanted whichever way, shifts in interpretive judgment announce no advance in understanding but represent instead historically specific applications of prejudice. If not evidence of a general cultural syndrome, the interpreter's attitude reflects an individual psychological need. Some will not rest until able to identify a phenomenon as a sign that bears communal meaning. Others will value the same phenomenon as concrete sensation – a bit of experience, the feeling of an isolated moment or situation, which may or may not acquire contextual significance.

Loss and gain

Roger Marx, a prominent figure in the Parisian art establishment, wrote in 1904: "From Cézanne has come the tendency, so prevalent today, to express in all fullness the beauty and life of [painting's] materiality [la vie de la matière]".[31] What was instigating this turn to material experience? Around 1900 Cézanne could be viewed as both its initiator and its culmination; he seemed to have made a career of material experimentation.[32] His emerging status as "pure painter" was enhanced in November 1895, when Ambroise Vollard began to show his work in Paris. This caused the artist's old Impressionist colleagues to take a serious second look, but it did not result in the painter himself, his physical presence, becoming any more evident in the capital.[33] Geffroy noted Cézanne's invisibility in statements both before

and after the exposure of his art through Vollard – "living in determined isolation", "working in secret".[34] Cézanne's admirers observed that isolation agreed with him during his "retirement" as a "Provençal landowner".[35] "I always found him completely alone," Charles Camoin remarked to Matisse long after the fact, not certain what to make of this memory of absent family, absent friends.[36] Paradoxically, Camoin had experienced at first hand Cézanne's capacity for good humour and camaraderie.[37] Another witness to the artist's behaviour speculated that he had been dissembling: "He often exaggerated the strangeness of his conduct in order to protect his freedom".[38] Just let me be, Cézanne may have thought: a painter needs to paint. But he also seems to have been pleased to share a meal with old and new acquaintances alike.

The various indicators of the conditions of Cézanne's life, and of his psychological reaction to those conditions, conflict. No doubt influenced by the contemporary mythologies that guide our own lives, we continue to question the degree to which Cézanne may have either enjoyed or suffered his existence in Aix-en-Provence during the years preceding and following the notoriety of his Parisian exhibitions. Parallel to questioning his quality of life, we wonder to what degree the quality of his art may have benefited from his social isolation, however severe (or not) it actually had been. In 1927, Roger Fry was wondering. As Schapiro would do, though in his own way, Fry hedged his bets, reconciling the use of living models with the painter's need to keep to himself: "He evidently studied [this subject] in some humble café in Aix He could rely no doubt on the fact that these peasants took no notice of him."[39] It seems just as likely – or perhaps quite certain, given the various witness accounts including that of Léontine Paulet, the young girl depicted in the five-figure version of the theme – that card playing served to ease the boredom of the workers of Cézanne's estate while they posed for their employer.[40] They could remain inside their social world, even as he remained inside his (anti)social world.

Following Cézanne's death in October 1906, there were several probing assessments of his significance. Among Anglophone art historians today, Maurice Denis's is the best known, perhaps because Fry translated it into English long ago; but Charles Morice took as broad a perspective as Denis did, and his account may be the more balanced.[41] Unlike Denis, Morice had little direct stake in Cézanne's career; his professional investment was in Paul Gauguin.[42] In a series of reviews preceding his essay devoted to Cézanne, Morice developed the argument that two distinct lines of response to the conditions of modern life had become dominant within advanced artistic practice. Different in intent, they manifested a common aspect: they were jointly responsible for giving contemporary painting its increasingly abstract or technical look. Morice believed that the repetitive, abstract marks of the Neo-Impressionist followers of Georges Seurat

derived from a mistaken faith in science, whereas Cézanne's abstract marks were a product of withdrawal and isolation.[43] The cultural impact was the same, a loss of humanistic content coupled with exaggerated materiality – the condition of the absent subject. After Cézanne's death, Morice, who admired his work, summarised the situation: "We hardly dare say that Cézanne lived; no, he painted [His is] painting estranged from the course of life, painting with the [sole] aim of painting . . . a tacit protest, a reaction [to society]."[44] From Duret to Fry to Schapiro to Reff, interpretation never ventures far from Morice's conclusion: "He painted . . . painting with the aim of painting".

Morice took Cézanne's apparent withdrawal from society and culture, his involvement with "art reduced to technique", as a signal that conventional notions of aesthetics were failing present human needs: art would no longer be effective in revealing either universal or personal truths; it would no longer express the spirit of a nation or era; nor would it embody a collective beauty, suitable for public decoration.[45] In 1907 Morice called Cézanne's aesthetic one of "separation", so thoroughly did it break from these traditional ideals, cutting itself off (abstracting itself) from life, whether everyday life or a more idealized existence. Yet, a different sense of living, of existential continuity, would emerge – not life experienced as a narrative sequence of human events, but as an enduring aesthetic sensation, intensely personal. Although the artist never actually ceased to be concerned with the outside world, his peculiarity was to take "no more interest in a human face than in an apple People and things impassioned him only with regard to their quality as objects to be painted Nothing else: painting in itself [la peinture en soi]." Or, to turn from the work to the artist, not painting in itself, but sensing in itself – sensation. The commentary is Morice's, from statements of 1905 and 1907, before and after Cézanne's death, though it sounds like Duret (whom Morice in fact quoted to similar effect) and even like Schapiro.[47]

The subject of genre

Painting in itself impresses us with "the value of art itself [la valeur de l'art lui-même]." This was the position of Théophile Thoré, a Romantic era critic.[48] To privilege sensation over subject was not an innovation of Cézanne's time; it had a history. Thoré wrote that "the subject [in art] means nothing".[49] Out of context, his statement becomes an empty polemic, for a subject that means nothing is hardly a subject. A subject, a representational theme, a topic – such conceptual entities belong to established fields of meaningful discourse. In fact, Thoré was alert to the endless flow of meaning and interpretation. He would admit that even artists who set about to eliminate connotative subject-matter were not immune to commentators

intent on allegorizing the aesthetic product.⁵⁰ A critic can perceive difference and discover meaning in anything.

Ironically, the context of Thoré's remark – "the subject means nothing" – is its justification. He was describing a particularly unyielding genre study by Adriaen van Ostade (fig. 58), a work distinguished more by its technique than by its theme. With a few touches of brilliant colour, the painter had uncharacteristically "cut through the bituminous harmony" of seventeenth-century Dutch painting. "The subject means nothing," Thoré concluded, "and we are deeply embarrassed in describing such naïve compositions, which have no distinct character other than their quality of execution." Apparently, Thoré realised that his *thematic* interpretation was unilluminating. It went nowhere, contributing to the embarrassment: "To the left, two little boys do who knows what; one is lost a bit in the shadow". Thoré then found the gain in the loss: "But these paintings prove all the more the value of art itself, because here serious thinking, with its profound conceptualisation, amounts to absolutely nothing Study these naïve masters, who might pass for naturalists making daguerreotype reproductions, and you will

Fig. 58
Adriaen van Ostade
Peasant Family at Home, 1647
Oil on panel, 43.1 × 36.5 cm
Budapest Museum of Fine Arts

understand that there is nevertheless invention and genius in their impression of nature."[51]

To explain – invention and genius would enter the image naturally, because every human being, every political individual, has a capacity for invention and a share of genius. Thoré was democratic. He believed that all art, sincerely produced, expresses the value and dignity of the human. By comparison, the product of the daguerreotype machine was not devoid of value; but its image was still. Stillness, lack of living sensation, was the problem for Thoré, neither the directness of recording nor the reproducibility (the daguerreotype, as a positive imprint, was in any case unique). A hand-rendered image moved as feelings and sensibilities move, varying from one painter to the next and from one painter on one day to the same on another day.[52] Academically trained artists, attempting to regularize the presentation of a theme, suffered from the desire to eliminate vagaries of emotional mood. They sought an execution that would polish each message to lustrous clarity, as if viewed through a transparent medium. Countering this ideological ideal, Thoré stated bluntly: "[Artists] cannot abstract their personality". Individuals cannot conceptualise personal feeling, cannot create abstractions of the self, removing from the standard thematic product the blur of their idiosyncrasy. The same point has anchored a century of viewing the Card Players: Cézanne's "deeply serious personality [is] in everything he paints" (Reff). To put it another way: no thoroughly objective representation exists. Or, to make a political point, an individual cannot follow someone else's rule, or even his or her own rule, if it takes form as a collective, rational abstraction. "Relative to oneself," Thoré wrote, "everything that exists assumes a form and a colour in accord with one's own organic system."[53] We should not expect to divide our feeling from our thinking.

Perhaps volatile feeling has the final say, not structured reason. Life is manifold, messy, inherently anti-ideological. This is the truth that at least some of Cézanne's early admirers believed his art confirmed. It made them tolerant of the singular opacity – or the utter banality – of images like the Card Players, where marks and their colours attracted more interest than the theme. The subject of Cézanne's genre painting was Cézanne – his sensation, his seeing, his way of moving and emoting with elements of form. He painted. The early critics were not embarrassed to leave interpretation at this level, despite the natural suspicion that the subject might actually have meant something particular and perhaps quite personal to the artist who devoted such energy to it. His following could survive not knowing. If Cézanne had merely posed his card-playing workers "with regard to their quality as objects to be painted" (Morice), this would count as meaning "nothing". In the context of 1895 or 1905, meaning "nothing" meant something. It signified a cultural gain – at the least, an opening to possibility.

I thank Martha Lucy, Jason Goldstein and Roja Najafi for essential aid in research.

1 Théodore Duret, *Histoire des peintres impressionnistes*, Paris: H. Floury, 1906, p. 189 (here and elsewhere, author's translation unless otherwise noted).

2 Charles Morice gave Duret's book a brief laudatory review in 'Revue de la quinzaine: Art moderne', *Mercure de France*, vol. 64, 15 December 1906, p. 625. The bibliographic supplement to the *Gazette des Beaux-Arts* (vol. 36, 1 December 1906, p. 523) listed it as a publication of the second half of 1906. An English translation appeared a few years later as part of a larger study: Theodore Duret, *Manet and the French Impressionists*, trans. John Ernest Crawford Flitch, London: G. Richards, 1910. Duret published a revised French edition in 1919, adding supplementary biographical facts to the beginning and end of the Cézanne chapter: *Histoire des peintres impressionnistes*, Paris: H. Floury, 1919, pp. 115–34.

3 Duret 1906, pp. 192, 195.

4 One example from a Cézanne obituary: "His evident influence on young [artists] is already, in itself, very telling", in anonymous [Charles Morice?], 'Mort de Paul Cézanne', *Mercure de France*, vol. 64, 1 November 1906, p. 154. See also Richard Shiff, 'Introduction', in Michael Doran, ed., Julie Cochrane, trans., *Conversations with Cézanne*, Berkeley: University of California Press, 2001, pp. xix–xxxiv.

5 Duret 1906, pp. 178–79.

6 See Duret's comments recorded in Charles Louis Borgmeyer, 'A Few Hours with Duret', *Fine Arts Journal*, vol. 30, March 1914, p. 127.

7 Duret 1906, pp. 179, 183–84.

8 *Ibid.*, p. 171.

9 *Ibid.*, pp. 180, 182. Duret's opinion in 1914 conveys the same image of Cézanne, who "painted with the greatest difficulty, one might say with hard labour, and yet whatever he did remained broad and strong First and last he pleased himself": Borgmeyer 1914, pp. 118, 124.

10 The following statements to this effect are particularly relevant to the history of Cézanne's reception: "Painting for itself": Émile Bernard, 'Paul Cézanne', *Les hommes d'aujourd'hui*, vol. 8, no. 387, February–March 1891, n. p.; Cézanne "abstracts the picture": Émile Bernard, 'Paul Cézanne', *L'Occident*, vol. 6, July 1904, p. 21; "Painting in itself, the pure act of painting": Maurice Denis, 'De Gauguin, de Whistler et de l'excès des théories' [1905], in *Théories, 1890–1910: Du symbolisme et de Gauguin vers un nouvel ordre classique*, Paris: Rouart et Watelin, 1920, p. 208; "With Cézanne, we think only of the painting": Denis, 'Cézanne' [1907], *ibid.*, p. 247; "The subject no longer matters or hardly matters It will be pure painting": Guillaume Apollinaire, 'Du sujet dans la peinture moderne', *Les soirées de Paris*, no. 1, February 1912, p. 2.

11 Paul Sérusier, quoted by Maurice Denis, 'Cézanne', in Denis 1920, p. 252.

12 Georges Braque, in André Verdet, 'Avec Georges Braque', *XXe siècle*, vol. 24, no. 18, February 1962, supplement, n. p. Braque's statement (in French: "*Il engage sa vie dans l'œuvre, l'œuvre dans sa vie*") is a variation not only of Duret but also of Gustave Geffroy: "Surely this man has lived and is living a beautiful inner fantasy, and the demon of art dwells within him": Gustave Geffroy, 'Paul Cézanne' [1894], *La vie artistique*, 8 vols., Paris: Dentu [vols. 1–4]; Floury [vols. 5–8], 1892–1903, III, p. 260. In a manuscript draft for this essay (Archives of the History of Art, Getty Center for the History of Art and the Humanities, Los Angeles), Geffroy likewise referred to Cézanne's having turned his artistic strength in upon itself. Reflexivity – rhetorically, a figure of self-isolation – has remained a common explanatory device in Cézanne commentary. One writer identified all of the artist's mature work with "complete surrender to loneliness": Kurt Badt, *The Art of Cézanne*, trans. Sheila Ann Ogilvie, London: Faber and Faber [1956], 1965, p. 143.

13 Meyer Schapiro, *Paul Cézanne*, New York: Abrams [1952], 1988, pp. 16–17, 100.

14 Duret 1906, p. 180.

15 Susan Sidlauskas, *Cézanne's Other: The Portraits of Hortense*, Berkeley: University of California Press, 2009, p. 132. For Duret's still life, see John Rewald with Walter Feilchenfeldt and Jayne Warman, *The Paintings of Paul Cézanne: A Catalogue Raisonné*, 2 vols., New York: Harry N. Abrams, 1996, no. 417. Duret sold this painting at auction in 1894.

16 Fritz Novotny, *Cézanne*, New York: Phaidon, 1948. p. 6.

17 Duret: Cézanne's aim was "to fix on the canvas what was before his eyes" (1906, p. 183); Schapiro: "Cézanne differs from his [abstractionist] successors in the twentieth century in that he is attached to the directly seen world" (1988, p. 17).

18 Around 1903–04, "a mass of scientific irrelevancies and intellectual complications had come between the [conventional] artist and his vision, and, again, between the vision and its expression": Clive Bell, *Since Cézanne*, New York: Harcourt Brace, 1922, p. 49; "About 1912, [the remedy] was called pure painting": Robert Delaunay, 'To Sam Halpert' [1924], *The New Art of Color: The Writings of Robert and Sonia Delaunay*, ed. Arthur A. Cohen, trans. Arthur A. Cohen and David Shapiro, New York: Viking, 1978, p. 36. See also note 10 above.

19 See, for example, Denis, 'A propos de l'exposition de Charles Guérin' [1905], in Denis 1920, pp. 43–44.

20 Schapiro 1988, p. 100.

21 Hans Sedlmayr, *Art in Crisis: The Lost Center*, trans. Brian Battershaw, Chicago: Henry Regnery, [1948] 1958, p. 133. Sedlmayr associated "pure painting" with a play of colour divorced from the constraints of line (pp. 84–85) as well as a loss of thematic subject: "Now we no longer have 'Diana and the Nymphs' but simply 'Bathing Women'" (p. 86).

22 Schapiro 1988, p. 94.

23 See Joseph J. Rishel, 'Paul Cézanne', in Richard J. Wattenmaker and Anne Distel, eds., *Great French Paintings from the Barnes Collection*, New York: Knopf, 1993, p. 126.

24 André Derain, letter to Henri Matisse, 15–16 March 1906, quoted in Rémi Labrusse, *Matisse: la condition de l'image*, Paris: Gallimard, 1999, p. 53.

25 On pointing the way, see Richard Shiff, 'The Primitive of Everyone Else's Way', in Guillermo Solana, ed., *Gauguin and the Origins of Symbolism*, Madrid: Fundación Colección Thyssen-Bornemisza, 2004, pp. 64–79.

26 On the significance of Poussin, remaking, and revivifying, see Richard Shiff, *Cézanne and the End of Impressionism*, Chicago: University of Chicago Press, 1984, pp. 175–84.

27 See Richard Shiff, 'Sensation, Movement, Cézanne', in Terence Maloon, ed., *Classic Cézanne*, Sydney: Art Gallery of New South Wales, 1998, pp. 13–27.

28 Schapiro 1988, p. 16. Nina Maria Athanassoglou-Kallmyer, although establishing a far more specific social context for the *Card Players* than her predecessors, acknowledges the same contrast of emotionality between the theme and its rendering. She refers to the lively display of *sociabilité* one would expect to see, as opposed to the "permanence and stability", the "weighty volumes, solid forms" that actually characterise Cézanne's image: Nina Maria Athanassoglou-Kallmyer, *Cézanne and Provence: The Painter in His Culture*, Chicago: University of Chicago Press, 2003, pp. 214–15.

29 Schapiro 1988, pp. 16, 94.

30 Theodore Reff, 'Cézanne's "Cardplayers" and Their Sources', *Arts Magazine*, vol. 55, November 1980, pp. 109–10, 112, 114–16.

31 Roger Marx, 'Le Salon d'Automne', *Gazette des Beaux-Arts*, vol. 32, 1 December 1904, p. 464.

32 "They say that Cézanne spent his life clarifying for himself and for others problems of technique, without caring about the results": Paul Jamot, 'Le Salon d'Automne', *Gazette des Beaux-Arts*, vol. 36, 1 December 1906, p. 466.

33 Camille Pissarro, letter to Lucien Pissarro, 22 November 1895, in Janine Bailly-Herzberg, ed., *Correspondance de Camille Pissarro*, 5 vols., Paris: Presses Universitaires de France [vol. 1]; Valhermeil [vols. 2–5], 1980–1991, IV, p. 121.

34 'Paul Cézanne' [1894]; 'Paul Cézanne' [1895], in Geffroy 1892–1903, III, p. 249; VI, p. 218. Geffroy first published the former essay in late March 1894, more than a year and a half before Vollard's initial Cézanne exhibition, when it was still difficult to find works of the painter. He mentions Duret's collection as a source (III, p. 250). In fact, the essay may have been inspired by the sale some days earlier of works from Duret's collection: see JoAnne Paradise, *Gustave Geffroy and the Criticism of Painting*, New York: Garland, 1985, p. 344; Merete Bodelsen, 'Early Impressionist Sales 1874–94 in the Light of Some Unpublished "Procès-Verbaux"', *Burlington Magazine*, vol. 110, June 1968, p. 345.

35 Thadée Natanson, 'Paul Cézanne', *La revue blanche*, vol. 9, 1 December 1895, p. 497.

Geffroy also referred to retirement or withdrawal: 'Paul Cézanne' [1895], in Geffroy 1892–1903, VI, p. 218.

36 Charles Camoin, letter to Henri Matisse, July 1941, in Claudine Grammont, ed., *Correspondance entre Charles Camoin et Henri Matisse*, Lausanne: La Bibliothèque des Arts, 1997, p. 157. On living alone, see Cézanne's letter to Egisto Paolo Fabbri, 31 May 1899, in John Rewald, ed., *Paul Cézanne, correspondance*, Paris: Grasset, 1978, p. 270.

37 See the witness accounts of Cézanne's joking around with Camoin and others in Edmond Jaloux, *Les saisons littéraires 1896–1903*, Fribourg: Editions de la librairie de l'université, 1942, p. 104; Léo Larguier, *Le dimanche avec Paul Cézanne*, Paris: L'édition, 1925, pp. 32, 121; André Warnod, *Ceux de la Butte*, Paris: René Julliard, 1947, p. 248.

38 Jaloux 1942, pp. 75–76.

39 Roger Fry, *Cézanne: A Study of His Development*, London: Leonard and Virginia Woolf at the Hogarth Press, 1927, p. 71.

40 Robert Ratcliffe interviewed Léontine Paulet in July 1955; on this and other documentation regarding the circumstances of Cézanne's use of models for the *Card Players* series, see Reff 1980, p. 105.

41 Maurice Denis, 'Cézanne', *L'Occident*, vol. 12, September 1907, pp. 118–33; 'Cézanne', trans. Roger E. Fry, *Burlington Magazine*, vol. 16, January–February 1910, pp. 207–19, 275–80; Charles Morice, 'Paul Cézanne', *Mercure de France*, vol. 65, 15 February 1907, pp. 577–94. Morice was a critic of literature and the visual arts and had been Paul Gauguin's (not always congenial) collaborator on the publication of *Noa Noa*. He authored the first book on the emergence of a Symbolist literary movement in France: Charles Morice, *La literature de tout à l'heure*, Paris: Perrin, 1889.

42 See, for example, Charles Morice, 'La IVme exposition du Salon d'Automne', *Mercure de France*, vol. 64, 1 November 1906, pp. 34–48.

43 See, for example, Charles Morice, 'Le XXIe Salon des Indépendants', *Mercure de France*, vol. 54, 15 April 1905, pp. 542, 552–53, 555; 'Le Salon d'Automne', *Mercure de France*, vol. 58, 1 December 1905, p. 390.

44 Morice 1907, pp. 577, 593.

45 Morice 1905, pp. 552–53. The prevalence of private studio imagery (still lifes, models, views from windows) in early twentieth-century painting resulted, at least in part, from isolation being regarded as a suitable response to conditions of modernity. The studio, like the bourgeois home, could be a place of refuge. Artists represented the nude – traditionally, much more than a studio object – "as if they were making a still life, interested only in relations of line and colour [and turning the model into] a decorative accessory": Charles Morice, 'Art moderne: nus', *Mercure de France*, vol. 85, 1 June 1910, p. 546.

46 Morice 1905, p. 552; 1907, pp. 592–93.

47 Morice (1907, p. 592) quoted the passage from Duret's *Histoire* referring to Cézanne's having arranged his figures not to express a theme but "above all to be painted".

48 Théophile Thoré, 'Galerie de M. le Comte de Morny', *L'artiste*, vol. 10, 1847, p. 52.

49 *Ibid.*, p. 52. For virtually the same thought, see Thoré-Bürger (Théophile Thoré), 'Salon de 1847', in *Les Salons*, 3 vols., Brussels: Lamertin, 1893, I, p. 447: "The subject is absolutely indifferent in the arts". In other words, the subject-matter does not determine the quality or emotional value of the work.

50 Thoré, 'Salon de 1845', in Thoré 1893, I, p. 105.

51 Thoré 1847, p. 52.

52 Thoré, 'Salon de 1847', in Thoré 1893, I, pp. 477–78.

53 *Ibid.*, I, p. 478. Coincidentally, using an etching, Cézanne made a copy of the same composition by Ostade that had been Thoré's example: see Rewald 1996, no. 589. In Thoré's terms, Cézanne. who used his characteristic blues for the copy, remade Ostade "in accord with his own organic system". When, to the contrary, an artist seemed to have succeeded in abstracting the personality, it could be grounds for critical objection – here, commentary on Edgar Degas: "His paintings say nothing of his inner being; he is removed [*c'est un abstrait*], self-contained; we know nothing about him, neither his delights, nor his feelings": Camille Mauclair, *L'impressionnisme: son histoire, son esthétique, ses maîtres*, Paris: Librairie de l'art ancien et moderne, 1904, p. 98.

Catalogue

NI Nancy Ireson
BW Barnaby Wright

WITH CONTRIBUTIONS FROM
L-CS Laure-Caroline Semmer

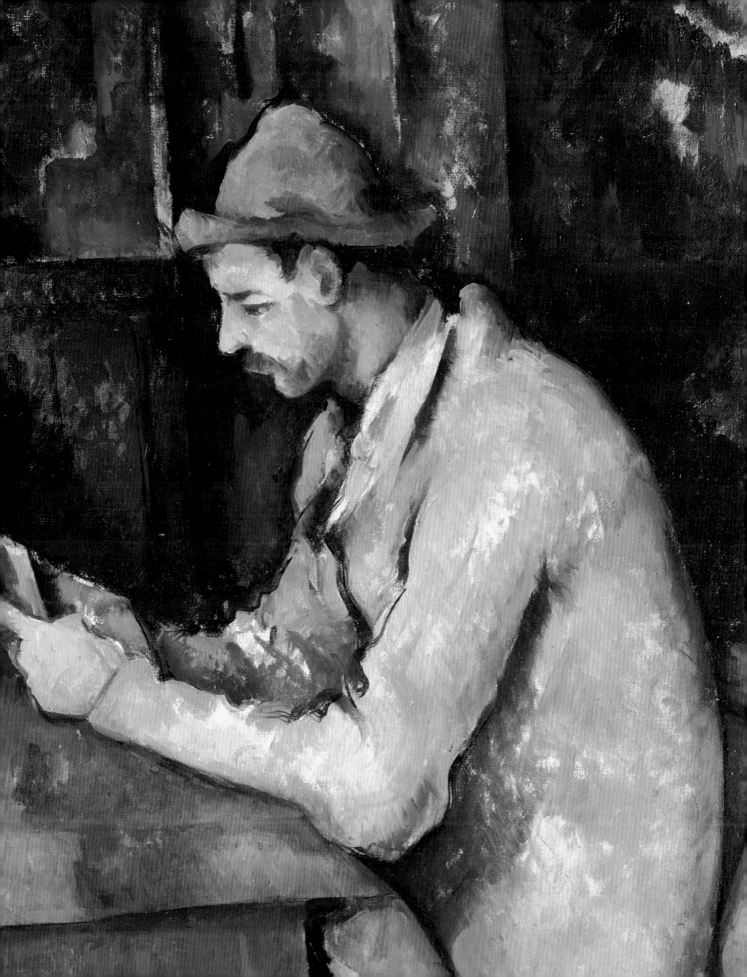

1 The Card Players c. 1890–92

Oil on canvas
65.4 × 81.9 cm
Rewald 707
The Metropolitan Museum of Art, New York
Bequest of Stephen C. Clark, 1960

Cézanne embarked upon his series of *Card Players* paintings at the beginning of the 1890s. Over the following few years he completed a group of five principal canvases, the dating and sequence of which has long been subject to debate. This work, which shows four male figures in working dress, has often been considered as the second in the series – a smaller version of the prior large-scale painting in The Barnes Foundation (cat. 2). The men appear in a sparsely decorated room, three seated at a table, another observing from behind. A curtain frames the scene at the right while, to its left, a pipe-rack balances a compositional arrangement that is simpler than its Barnes counterpart. But new technical research suggests that the Metropolitan Museum canvas may well have been the first painting in the group.[1] Infrared examination reveals considerable evidence of underdrawing, some of it quite speculative in character. Under the paint for the left figure, for instance (and in keeping with a pre-paratory watercolour sketch for the work, cat. 6), numerous soft graphite or charcoal-like marks are apparent. These are particularly pronounced in the description of his head and the line of his jacket. They also appear in the shadows on the legs of the central sitter. The application of oil in this work is quite thick in most areas, with the notable exception of the area beneath the table, where the medium is more dilute.

New technical research has also supported the idea that Cézanne studied his peasant sitters from life individually. Only then would he arrange the figures on the canvas, working from a relatively large group of preparatory studies, many of which (but perhaps not all) are still in existence. At least some of his sitters were workers from the farm on his estate at the Jas de Bouffan, and a few of their number are identifiable. Here, the seated figure on the left is likely to be Paulin Paulet, the man standing behind to be the so-called 'père' Alexandre.[2] But the exact settings of the works remain uncertain. Many have thought that these multi-figure scenes were set in the main house at the Jas, where Cézanne is known to have painted in both his studio and the salon, while Joachim Gasquet maintained that they were produced in a room in the neighbouring farmhouse.[3] However, if it is impossible to identify a particular setting for this work, the concern is of relatively little importance. This space presented here is above all pictorial.

Accordingly, if the area to the left of the chair presents an effect not unlike that of the actual tiled floors in parts of the house, the roughly worked colour also rhymes visually with the hatched areas on the curtain to the right; the heavy blue smock worn by the seated figure beneath shows comparable mark-making. Meanwhile, in the background, the wall

PROVENANCE

Ambroise Vollard, Paris; Josse and Gaston Bernheim-Jeune, Paris; Étienne Bignou, Paris; Knoedler, New York; Stephen C. Clark, New York; Metropolitan Museum of Art, New York (Bequest of Stephen C. Clark, 1960)

SELECTED EXHIBITIONS

Paris, 1910, no. 47; London, 1914, no. 7; Paris, 1917, no. 4; Zurich, 1917, no. 34; Paris, 1920, no. 14; Paris, 1926, no. 39; Berlin, 1927, no. 29; Paris, 1930, no. 28; Chicago, 1933, no. 307; San Francisco, 1934, no. 68; New York, 1934, no. 6; New York, 1934–35, no. 6; Paris, 1936, no. 83; New York, 1938, no. 17; New York, 1939, no. 62; New York, 1940, no. 9; New York World's Fair 1940, no. 340; New York, 1942, no. 14; New York, 1944, n. n.; New York, 1946, n. n.; New York, 1947, no. 45; Chicago and New York, 1952, no. 79; New York, 1954, no. 11; New York, 1955, n. n.; New Haven, 1956, no. 111; New York, 1958, no. 14; 1959, no. 9; 1960, no. 13; Washington, 1971, no. 18; Madrid, 1984, no. 40; Moscow, 1988, no. 35; Williamstown 2006, no. 53; Houston, 2007, no. 80; New York, 2007, no. 53; Philadelphia, 2009, n. n.

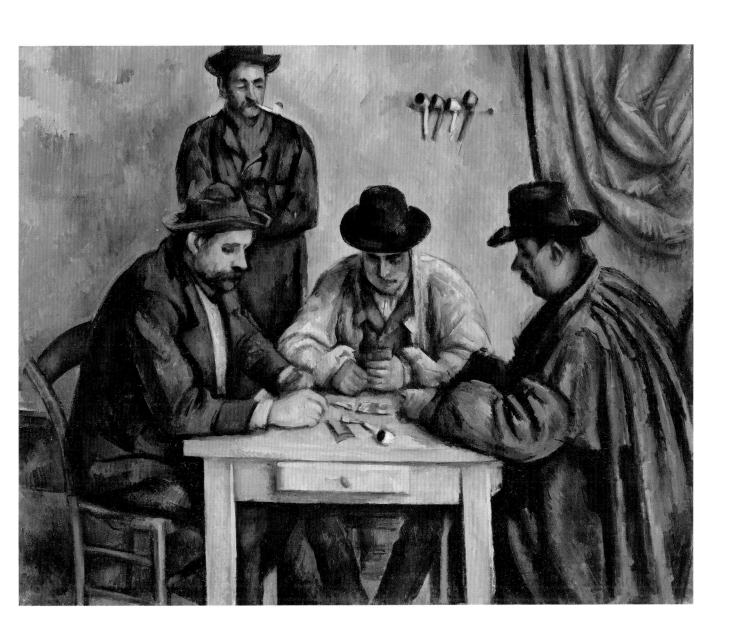

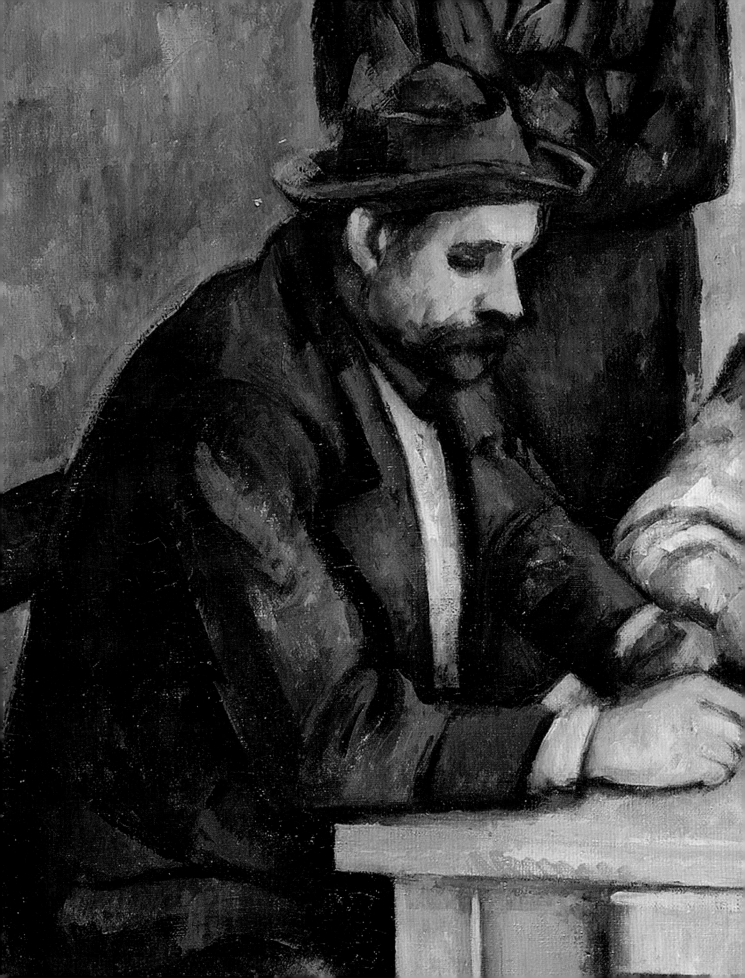

includes a range of colours akin to those found in Cézanne's landscape paintings. If here the artist produced a sense of texture fitting for a simple plaster wall, simultaneously he made it clear that the surface was above all painterly. Applied to a luminous white ground, multiple touches of blue and green harmonise with the shades used in the description of the models, creating a sense of animated natural light.

That part of the floor that is visible in this canvas also changes the pictorial space. The place where the tiles meet the wall is roughly parallel to the chair seats, a feature that allows the viewer to study the group and their play from a position that mirrors that of the standing figure. The effects are perhaps a little predictable. James M. Carpenter likened the arrangement to the kind of "off-centre symmetrical grouping" found typically in Venetian painting and, certainly, the work invites comparisons with the art of the past.[4] Yet it is also likely to have resulted from actual consideration of people seated at a table. Years later, Émile Bernard would describe how, when the artist was at dinner, he would "stop at each moment to study our faces under the effects of the lamp and the shadows; every plate, every meal, every piece of fruit, every glass, every object close to him was the subject of his comments and thought".[5] NI

NOTES

1 See the essay by Aviva Burnstock, Charlotte Hale, Caroline Campbell and Gabriella Macaro in this volume.
2 See the essay by Nancy Ireson and Barnaby Wright in this volume.
3 *Ibid.*
4 Carpenter 1951, p. 185.
5 *"A table il s'arrêtait à chaque instant pour étudier nos figures selon l'effet de la lampe et de l'ombre ; toute assiette, tout plat, tout fruit tout verre, tout objet qui était près de lui faisait le sujet de ses commentaires et de sa réflexion'"*: Bernard 1921, pp. 44–45.

2 The Card Players c. 1890–92

Oil on canvas
134 × 181.5 cm
Rewald 706
The Barnes Foundation, Merion, Pennsylvania

NOT EXHIBITED

This large-scale canvas was bought by the famous American collector Albert Barnes in 1925 from Ambroise Vollard for the extraordinary price of 1,000,000 francs.[1] However, its almost complete inability to travel since that date (the conditions of the Barnes legacy prohibit the lending of works) has hindered its comparison with Cézanne's other paintings on the theme. Here the inclusion of a catalogue entry for the work seeks to facilitate such discussions: it is the largest painting in the series and, as such, is all the more pivotal to understanding the group in its entirety. Though similar to the Metropolitan Museum canvas (cat. 1), it includes additional elements – a picture or mirror on the wall, a shelf with an olive jar, and a gaming board of some variety. A young girl joins the upright onlooker, bringing the figure count to five.

Often seen as a forerunner to the Metropolitan composition, this canvas has aroused disparate conclusions as to its quality of execution, perhaps more than is the case for the other major paintings in the *Card Players* series. In a 1939 text on the work, co-written by Violette de Mazia, Barnes himself expressed the opinion that, although the canvas provided the perfect demonstration of the mature artist's powers of composition – Cézanne's ability to work on a grand scale and to arrange sitters in an interior to maximum effect – it suffered from an "imperfect coordination of light with colour, with the result that colour lacks the effulgence,

depth, solidity, and thoroughgoing organic activity found in his best work".[2] However, Joachim Gasquet had considered it one of the artist's finest works – "the one in which he had grasped the 'formula' that escaped him the most tightly".[3] More recently, the picture has been understood as the most heroic in the sequence and as one of the most ambitious of Cézanne's career, second only to the three large *Bathers* of his final years.[4]

The placement of the picture within the *Card Players* series has also been debated. In 1926 Gasquet described the final *Card Players* painting as one that measured three metres and contained five near-life-size figures[5] (including a young girl, who has since been identified as Léontine Paulet, daughter of Paulin Paulet, who is seated to her far right).[6] This must mean that he considered this painting to be the last of the group, but in 1948 Bernard Dorival declared it instead to have been the first.[7] Rewald also came to the latter conclusion, setting the painting in his catalogue raisonné as an initial multi-figure composition that followed some of the studies of individual models.[8] These authors and others agreed that the group was subsequently rationalised to achieve a more compact arrangement – from five figures, to four figures, to the eventual two-figure canvases (cat. 12–14). This conclusion has since held sway.[9]

Yet the most recent technical research, undertaken for this exhibition,[10] suggests that the production of this work is

PROVENANCE

Ambroise Vollard, Paris; Auguste Pellerin, Paris;
The Barnes Foundation, Merion, Pennsylvania

SELECTED EXHIBITIONS

Washington, 1993–96

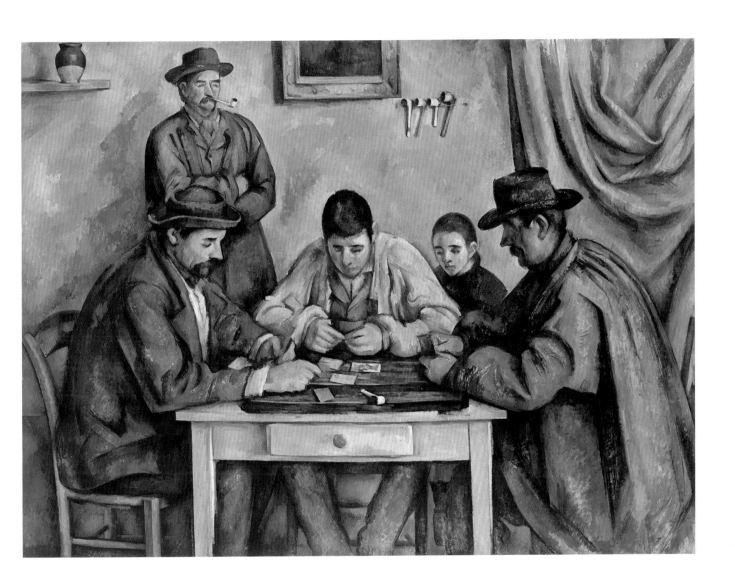

likely to have followed that of the Metropolitan canvas – a proposition first put forward by Georges Rivière in 1923, and supported by Lionello Venturi in his numbering of the works in his 1936 catalogue raisonné.[11] The underdrawing visible in the head area of the seated figure on the right is far more abstracted than it is in the Metropolitan version. The contour of his right arm, too, seems to have been simplified considerably. Most importantly, examination of the work under raking light has revealed that Cézanne had originally painted the central card player wearing a hat. It could well be that the Metropolitan picture served as a reference for these gradual reductions – that it was a testing ground of sorts for this larger work.

The inclusion of various props – the curtain, chairs and olive pot – indicate that the Barnes canvas was a studio piece. This is unremarkable, since all of the major pictures in the series appear to have been posed, regardless of the settings they might intend to show. But here, more than elsewhere, the artist seems to have made little attempt to disguise the staging of the scene. The placement of the figures might recall the moralising card-player scenes of the seventeenth century, or the type of modern religious scenes exhibited in the Salons of nineteenth-century Paris,[12] but the absence of discernible narrative creates quite a different tenor, inviting readings of a different kind, as if the image were devoid of non-formal meaning. "His figures are human beings only in the broadest essentials: psychological characterization … is absent, and little or no emphasis is put on the particular thing the subjects happen to be doing", wrote Barnes and de Mazia. For them, this made the painting distinctly unlike those of Chardin, who, as they understood it, imbued his figures with human warmth and intimacy. The figures here serve above all to structure the composition: "Fundamentally they are static: not inert or dead, but active as a tower, a pier or a buttress is alive".[13] N I

NOTES

1 Vollard had purchased the canvas from the artist's son, in June 1913, for 100,000 francs: Vollard archives, MS 421 (4.7), f. 52; MS 421 (4,8), f. 51; MS 421 (4,14), f. 11; MS 421 (5,9), f. 113, cited in Rebecca A. Rainbow and Jayne Warman, 'Selected Chronology', in Cézanne to Picasso: Ambroise Vollard, Patron of the Avant-Garde, exh. cat., New York, Chicago and Paris, 2006–07, p. 292.

2 Barnes and de Mazia 1939, p. 89.

3 "C'est une de ses plus belles toiles, celle où il a serré de plus près cette 'formule' qui lui fuyait": Gasquet 1926, p. 16.

4 Rishel 1993, pp. 122–27.

5 Gasquet 1926, p. 16.

6 Ratcliffe 1961, pp. 19–20.

7 Dorival 1948, p. 63.

8 Rewald: 706.

9 It has been supported most recently by Haruo Asano, French abstract of Part One of 'Étude sur "les joueurs de cartes" de Paul Cézanne', unpublished thesis in Japanese, from Bulletin du Collège Universitaire des Arts d'Okinawa, Japan, 1993 (Documentation, Musée d'Orsay), n. p.

10 See the essay by Aviva Burnstock, Charlotte Hale, Caroline Campbell and Gabriella Macaro in this volume.

11 Venturi 1936, nos. 559, 560. However, John Rewald questioned this numbering in relation to Venturi's own opinions in 1937: Rewald 1937, pp. 53–54.

12 As discussed in the essay by John House in the present volume.

13 Barnes and de Mazia 1939, p. 3.

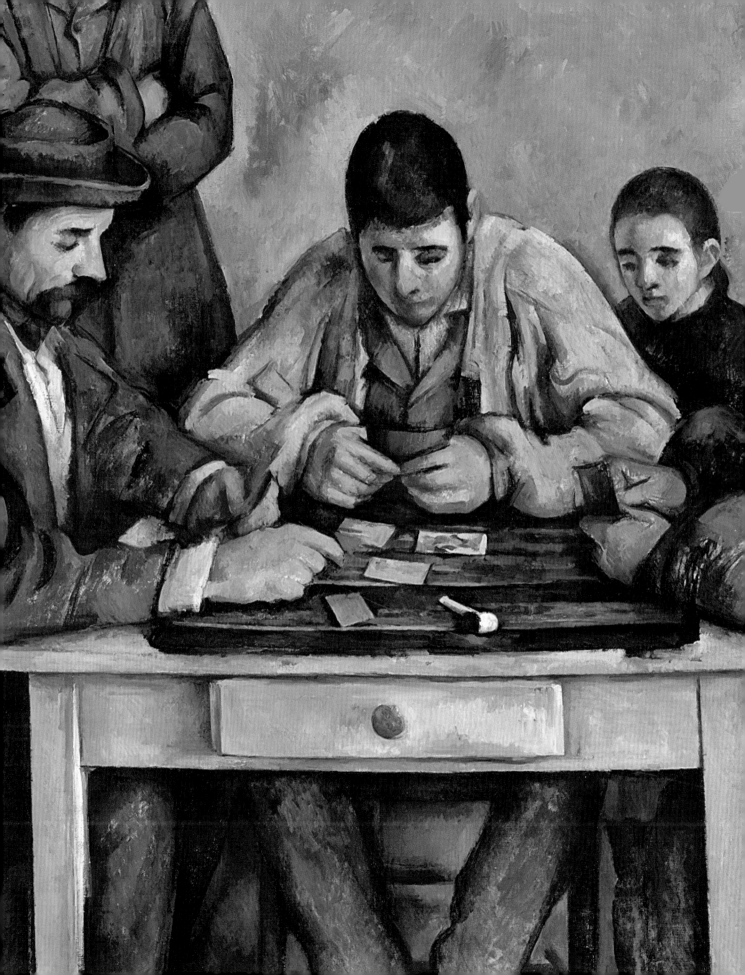

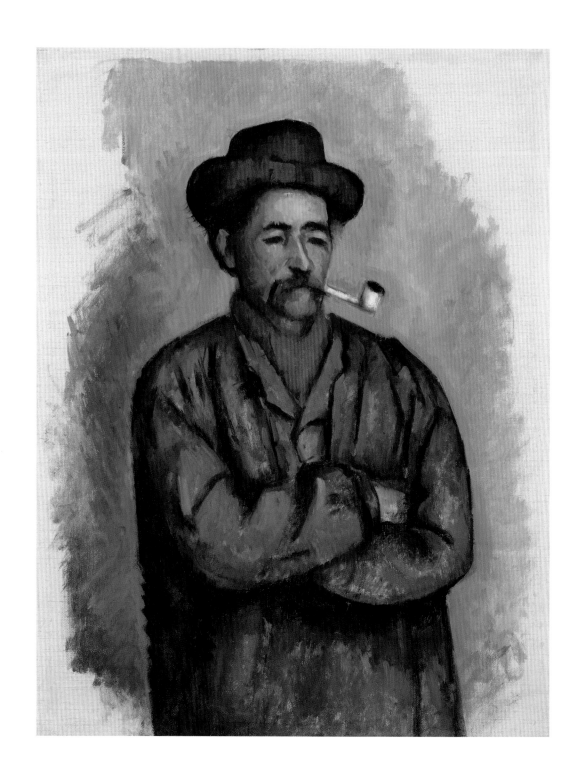

3 Man with a Pipe *c. 1890–92*

Oil on canvas
39 × 30 cm
Rewald 705
Collection of Marion and Henry Bloch, courtesy of The Nelson-Atkins
Museum of Art, Kansas City, Missouri

Cézanne made a number of single-figure oil studies that relate closely to his *Card Players* series (cat. 4, 5 and 15). They are unusual in his practice, for they reveal a marked interest in particular individuals, who each have a distinct physiognomy. With his square shoulders, folded arms and working clothes, this sitter appears as an element in the larger card player arrangements in the Barnes Foundation and Metropolitan Museum canvases (cat. 1 and 2). He was identified by Georges Rivière as *père* Alexandre, a worker from the Jas de Bouffan.[1] His pose is alike in all three images, but the finer details of his body and features differ in each of the versions. This oil study shows how Cézanne's repetition of a theme gave rise to such modifications and refinements. Here, for example, the torso of the model lacks volume, as it does in the Metropolitan painting. In contrast, the smock worn by the standing peasant in the Barnes canvas gives bulk to his form, in a way that appears to anticipate the treatment of the same model in *Man in a Blue Smock* (cat. 23).

If the revised sequence of the *Card Players* proposed here is accepted, it is possible that this study was made after the completion of the Metropolitan canvas, in preparation for the larger composition. In the four-figure picture and

in the present work, the position of the sitter is roughly similar, whereas a slight turn towards the card player on the extreme right is perceptible in the Barnes version. In the Metropolitan work, the forms of the figure's face are faceted and the brushstrokes are far more evident – effects that are tempered in the other depictions. The rendition of the face and clothing here is smoother and more unified; the placement of the man's pipe in his mouth is a fraction higher. These effects are comparable to those visible in the Barnes painting, though it is interesting to note that, in this study, the artist did not choose to resolve the relationship between the pipe and the player's mouth.

This sense of honing in on a motif, making small changes in search of an ideal, is perhaps akin to that noticed in Cézanne's method by Gustave Geffroy at around the time that the artist was working on the *Card Players* scenes. Geffroy described the painter as one "who looks around him, close to him, who feels the intoxication of sight unfurl and who wishes to communicate that feeling of intoxication within the confines of a canvas. He sets to work, and he seeks the means to accomplish this transposition as truthfully as possible."[2]

NI

PROVENANCE

Ambroise Vollard, Paris; Louis Bernand, Paris; Bernheim-Jeune, Paris; Georges Bernheim, Paris; Auguste Pellerin, Paris; René Lecomte and Mme Lecomte, née Pellerin, Paris; private collection; sale, Pellerin collection, Christie's, London, 30 November 1992, lot 16; collection of Marion and Henry Bloch

SELECTED EXHIBITIONS

Paris, 1907, n. n.; Paris, 1954, no. 58

NOTES

1 Rivière 1923, p. 217. A drawing of a man, *Peasant with his Arms Crossed*, c. 1890–94, graphite, 38 × 29 cm, Basel, Kunstmuseum, Chappuis 1061, bears comparison with this figure and might have informed the development of his pose. However, the man in the drawing appears to be wearing a different jacket and may be more closely related to a different peasant painting, such as Rewald: 817.

2 "*C'est un homme qui regarde autour de lui, près de lui, qui ressent une ivresse du spectacle déployé et qui voudrait faire passer la sensation de cette ivresse sur l'espace restreint d'une toile. Il se met au travail, et il cherche le moyen d'accomplir cette transposition aussi véridiquement que possible*": Gustave Geffroy, 'L'art d'aujourd'hui : Paul Cézanne', *Le Journal*, no. 586, Paris, 26 March 1894, p. 1.

4 Study for The Card Players c. 1890–92

Oil on canvas
32 × 35.3 cm
Rewald 708
Worcester Art Museum, Worcester, Massachusetts

This small oil study clearly bears a relationship to the central seated model in the Metropolitan Museum *Card Players* (cat. 1) and may well connect with the equivalent figure in the Barnes Foundation canvas (cat. 2). It shows the sitter in isolation, and may have been made either in preparation for the Metropolitan canvas or subsequently, in the process of developing the larger work. Given the position of the sitter's body – slightly lower, elbows further apart, shoulders rounded forward relative to the Metropolitan canvas – the latter seems a more persuasive suggestion. Though his hat still features in this study, a detail suppressed in the Barnes picture, it is this pose that appears in the five-figure work. As with the Musée d'Orsay oil study (cat. 5), and perhaps *Man with a Pipe* (cat. 3) as well, the artist must have envisaged it as an eventual part of a larger scene. A block of colour to the right of the model's arm might suggest the placement of the standing man in the group compositions.[1] The muted background is also that which appears in the multi-figure canvases.

The composition of the painting appears quite unusual, with the sitter's body dominating the foreground, but the edges were cut at some stage, so this may not always have been the case.[2] Though the canvas appears to be the only one of the known *Card Players* studies that employs a landscape format, no evidence exists to indicate that the artist stretched the canvas in this way, for its outer reaches show no signs of former tacking margins or distortion in the weave. Instead, the edges are uneven and roughly cut, indicating that both paint and ground originally extended on to a larger surface. It is likely, then, that the work is a fragment. In 1931, when the painting entered the Worcester collection, it was already glue-lined.[3] Nonetheless, as an example of Cézanne's technique – the subtle nuances of his palette and his highly distinctive brushstrokes – the canvas is exemplary. The colours of the cards are repeated in highlights across the image, while the angular face, with its straight nose and contoured cheekbones, gives structure to the figure. N I

PROVENANCE

Ambroise Vollard, Paris; Paul Guillaume, Paris; Marie Harriman Gallery, New York; Worcester Art Museum, Massachusetts, 1931

SELECTED EXHIBITIONS

Paris, 1898, no. 14; Paris, 1929, no.16; New York, 1930, no. 2; Detroit, 1931, no. 12; Philadelphia, 1934, no. 33; Detroit, 1954, no. 99; St Petersburg, 1965, no. 76; Tokyo, 1986, no. 32

NOTES

1 See the essay by Aviva Burnstock, Charlotte Hale, Caroline Campbell and Gabriella Macaro in this volume.
2 Louise Dresser, ed., *Worcester Art Museum Catalogue of European Paintings*, vol. 2, Worcester, 1974, pp. 227–28.
3 On 26 April 1969, in an attempted theft of the work, the glass protecting the canvas was broken. Happily, however, the damages incurred (in the upper right-hand corner) did not affect the main part of the image. The thieves then tried, unsuccessfully, to cut the painting from the frame, but the two linear areas of loss that this caused (along the top edge and the right side) were limited to the bare ground and to the corresponding areas of background paint. I am grateful to Rita Albertson, Chief Conservator at the Worcester Art Museum, for providing the technical information communicated in this entry.

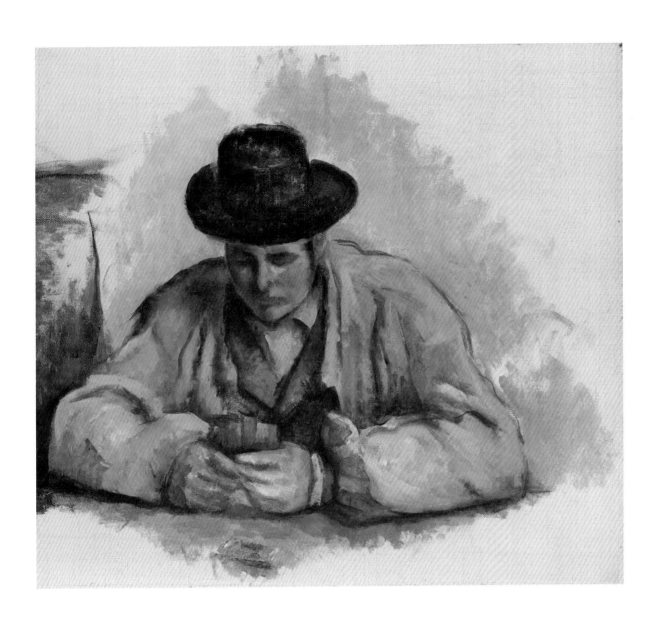

5 The Card Player c. 1890–92

Oil on canvas
50 × 46 cm
Rewald 709
Musée d'Orsay, Paris, Gift of Heinz Berggruen, 1997

Cézanne rarely made oil studies for his paintings; more typically he mapped out his theme in watercolour studies or graphite drawings. But for the *Card Players* series he produced a group of such works, including this study of the farm worker usually identified as Paulin Paulet.[1] He appears against a similar bluish background in the Metropolitan Museum and Barnes Foundation compositions (cat. 1 and 2) but seated on the left-hand side of the table rather than the right, as he is here. The figure is quite fully resolved, as are elements of his surroundings. But the expanse of un-worked blank canvas indicates that Cézanne envisaged the figure as one element of a larger composition and therefore as not requiring further elaboration. Exactly how this canvas functioned as a study for the Metropolitan and Barnes works, given the change in the sitter's position, remains unclear. It is also possible that it might have informed the two-figure *Card Players* scenes in which Paulet also appears, this time on the right-hand side (see cat. 12–14).

The Musée d'Orsay's acquisition of this painting in 1997 was timely, for it coincided with renewed scholarly interest in the issue of the 'finished' and 'unfinished' in Cézanne's work. The un-worked sections of this canvas and the incomplete treatment of the player's hands and cards render the painting unfinished in the conventional sense. However, as a well-known anecdote recounted by Ambroise Vollard makes clear, blank areas could serve the artist as a formal element in their own right. When Cézanne was in the process of painting his portrait, Vollard happened to bring two areas of un-worked canvas to the artist's attention. Cézanne replied that, if his visit to the Louvre went well the next day, he might find "the exact tone to cover up those spots". He even offered a word of warning. "Understand, Monsieur Vollard, that if I put

something there by guesswork, I might have to paint the canvas over, starting from that point".[2] These lines are often cited with irony, but they also reveal the level of consideration he invested into every area of an image, and his acute sensitivity to the harmony of a composition.

The question of 'finished' and 'unfinished' is particularly interesting in relation to figure studies such as this. In most of his semi-finished landscapes in oil, where Cézanne worked across the surface in its entirety, blank spaces seem to provide a sense of balance, stabilising a composition or heightening the interplay of colours. Here, however, Cézanne completed the figure and its immediate surroundings in a fully resolved manner, focusing intensively on the motif, leaving it almost like a fragment. This way of working might be considered in relation to Lawrence Gowing's argument that Cézanne's was more concerned with the ongoing pursuit of his artistic expression than its culmination in a single image.[3] Therefore, even an unfinished study such as this can be seen as part of a painting process in perpetual development. Early Cézanne criticism often tended to see a lack of finish or a blank space in any given work as a failing. In the mid 1890s, for example, Thadée Natanson observed that "yet again" one could accuse him of being "incomplete",[4] while in 1904 Camille Mauclair saw this lack of finish as proof that the artist lacked talent.[5] But as the exhibition *Cézanne Finished-Unfinished*, in 2000, showed, blank spaces might imply a purposeful formal approach rather than abandonment of a work.[6] The lack of finish in this canvas may simply be related to the functional purpose that it served as an oil study. However, its power as an image in its own right lies to some degree in its fragmentary quality and in its evocation of a motif under constant consideration and development. L-CS

PROVENANCE

Ambroise Vollard, Paris; Paul Cassirer, Berlin; Jakob Goldschmidt, Berlin; sale, Goldschmidt collection; Hans W. Lange, Berlin, 25 September 1941, lot 33; Jakob Goldschmidt, New York; Alfred Goldschmidt, New York; sale, Goldschmidt collection, Parke-Bernet, New York, 28 October 1970, lot 17; Mr. and Mrs. Sidney R. Barlow, Beverly Hills; sale, Barlow collection, Christie's, New York, 16 May 1977, lot 7, (bought in); sale, Barlow collection, Sotheby's, London, 2 April 1979, lot 8; Heinz Berggruen; Musée d'Orsay, gift of Heinz Berggruen, 1997

SELECTED EXHIBITIONS

Tokyo, 1974, no. 46; Geneva, 1988, no. 7; Seoul, 2000-01; Lyons, 2005, no. 7; Aix-en-Provence, 2009, no. 43

NOTES

1 See the essay by Nancy Ireson and Barnaby Wright in this volume.
2 Vollard [1914] 1924, p. 79.
3 Lawrence Gowing, *La Logique des sensations organisées*, Paris, 1992, p. 9.
4 Natanson 1895, p. 496.
5 Mauclair 1904, p. 12.
6 Vienna 2000.

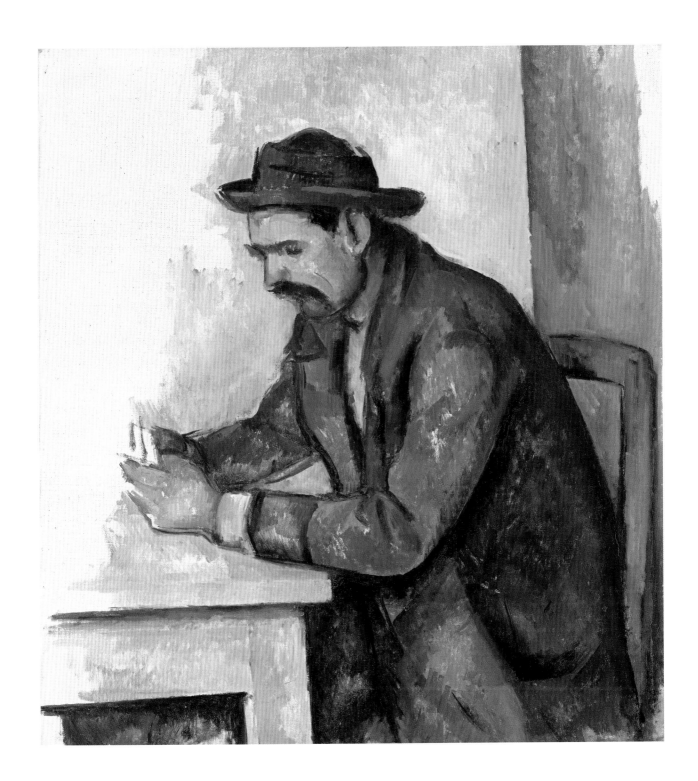

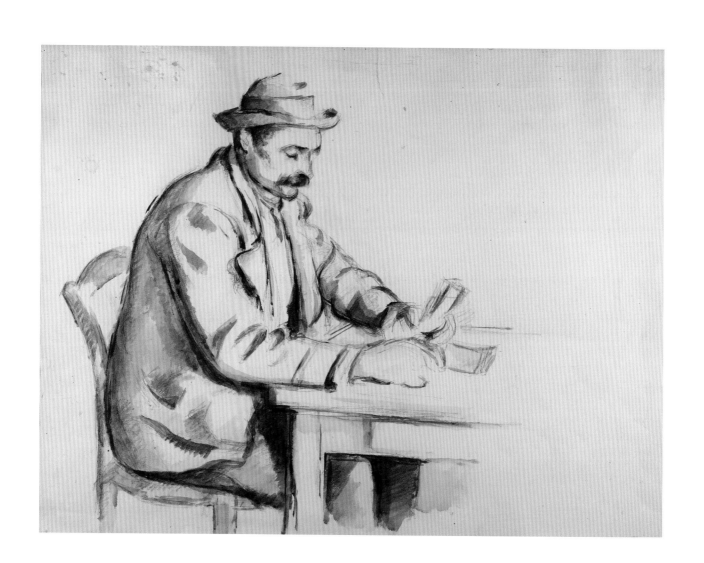

6 A Study for The Card Players *c.* 1890–92

Graphite and watercolour on paper
36.2 × 48.5 cm
Rewald watercolours 377
Private collection, on loan to The Art Institute of Chicago

NEW YORK ONLY

This watercolour – a graphite drawing with colour highlights – is a preparatory study for either the Barnes Foundation or the Metropolitan Museum *Card Players* (cat. 1 and 2) and also relates to the oil study in which the same figure sits on the left-hand side of the table (cat. 5). In this sheet Cézanne pays particular attention to the angle of the body, and there is an evident interest in the placement of shadows and the build-up of solid form. Only deft touches of watercolour are added to the resolved drawing, leaving much of the page blank, revealing the considerable thought and restraint which the artist exercised in his use of colour. That Cézanne was meticulous about the balance of tones in his work is well documented, and it was a feature that was particularly significant for early admirers of his technique. As Renoir once remarked to Gasquet: "How does he do it? He can't lay down two spots of colour unless they'll be perfect."[1] This economy of means might have been precious to the artist but it was a frequent source of confusion for the uninitiated. In 1910, for example, only a few years after the painter's death, three Cézanne lithographs met with a difficult reception in the United States: the customs office in New York was so surprised that the Photo-Secession Gallery intended to exhibit sheets of papers carrying only a few stains of colour, they questioned their entry into the country.[2]

It is true that Cézanne's watercolour technique was highly distinctive, though it shared certain affinities with the practices of his peers.[3] He would often apply colours to sketches that he had made from the motif and, from the 1890s in particular, he seems to have found a way of using this method to work on his construction of an image. The subtleties of watercolour shading here are quite remarkable. The palette is fairly limited, in its range of earth tones and greys, but it brings warmth and depth to the image. The application of paint is economic, but calculated, and not a stroke is out of place. Theodore Reff saw a level of particular exactitude in the rendition of the card-playing gesture, which he suggested was a direct response to that painted by Chardin in his *House of Cards* in the Louvre, which Cézanne would have known (see fig. 36).[4]

If certain Cézanne watercolours from this period are considered, like this one, as studies made in preparation for larger paintings, others appear to stand alone as finished works in their own right. This sheet, in some respects, occupies a kind of middle ground. It reveals the artist's working methods, yet it holds its own as a finished drawing. In all his watercolours, including this one, it is clear that the artist used the white paper in ways that are analogous to his use of patches of blank canvas in certain of his paintings. The attention Cézanne devoted to sheets such as this demonstrates the painstaking effort that he put into each aspect of the development of the *Card Players* series.

L-CS

PROVENANCE

Ambroise Vollard, Paris (?); Jacques Seligmann, Paris and New York; Mr. and Mrs. Chauncey McCormick, Chicago, 1983; private collection, on loan to the Art Institute of Chicago

SELECTED EXHIBITIONS

New York, 1933, no. 6; Philadelphia, 1934, no. 47; Chicago and New York, 1952, no. 78; Paris, London and Philadelphia, 1995–96

NOTES

1 Gasquet 1926, p. 101.
2 H. Seckel, 'Alfred Stieglitz et la Photo-Secession: 291 Fifth Avenue, New York', in *Paris-New York*, exh. cat., Centre National d'art et de culture Georges Pompidou, Paris, 1991, p. 364.
3 Reissner 2008, pp. 49–71.
4 Reff 1980, p. 111.

7 A Card Player c. 1892–96

Graphite on paper
53.3 × 43.1 cm
Chappuis 1093
The Pierpont Morgan Library, New York
Thaw Collection

The sitter who features in this imposing sheet appears to be Paulin Paulet, although, as Joseph Rishel has remarked, the fuller face and body make identification uncertain.[1] The sheet does not connect clearly with any one particular painting. In pose, the drawing might relate to the right-hand figure of the two-figure compositions (cat. 12–14), or alternatively, like the oil study from the Musée d'Orsay (cat. 5), it could present a reversed version of the seated man on the left of the Barnes Foundation and Metropolitan Museum canvases (cat. 1 and 2). The facial expression is quite unlike any seen in the various painted Card Players; but it is comparable to that seen in the study now in the Boijmans Van Beuningen Museum (cat. 17). The jawline is fleshy; the jowls are more pronounced. There is some suggestion of a slightly furrowed brow – a rare indication, in the series, of an emotional involvement with the game. As Walter Feilchenfeldt and others have remarked, more usually the fact that the models have cards in their hands seems of little consequence.[2]

The scale of this work, coupled with its high level of finish, makes it unlikely that it was merely a preparatory study. In many respects it commands the status of a finished work. Details that seem to have troubled the artist in some of the oil studies and in the development of the group compositions are resolved in this image. The cards occupy the hands neatly, the legs are placed squarely beneath the table, and the angle at which the chair is positioned does not compromise its structural integrity within the pictorial space. While some areas show evidence of the artist searching for a line – in the profile of the face, for example, or in the outline of the collar and lapels – others are remarkably confident. The chair back is described in a clean curve, and hatched shading adds a suggestion of depth.

Arguably, of all the highly worked drawings, this is the one that gives the most convincing impression of a figure observed at rest. This is likely to be the result of Cézanne's sureness of execution, achieved after studying the sitter on many previous occasions, rather than of his having made a drawing during an actual card game. We do not know what arrangements Cézanne had with his sitters beyond Léontine Paulet's recollection that her father, Paulin Paulet, received some payment for his time.[3] Nevertheless, Cézanne's peasant models may well have been patient sitters and often available, allowing the artist the time he needed to develop his studies of them carefully. NI

PROVENANCE

Ambroise Vollard; F. Matthiesen, Ltd.; Paul Rosenberg and Co., New York; M. Knoedler and Co., New York (?); Dr. Edward Hanley and Mrs. T. Edward Hanley; E.V. Thaw and Co., New York; Norton Simon Foundation, Los Angeles; E.V. Thaw and Co., New York; The Pierpont Morgan Library, New York (Thaw Collection)

SELECTED EXHIBITIONS

New York, 1975–76; Tübingen, 1978; Paris, London and Philadelphia, 1995–96, no. 135

NOTES

1 Rishel, 'Cardplayer', in Paris, London and Philadelphia 1995–96, pp. 335–41.
2 Feilchenfeldt 2005, p. 210.
3 Ratcliffe 1961, pp. 19–20.

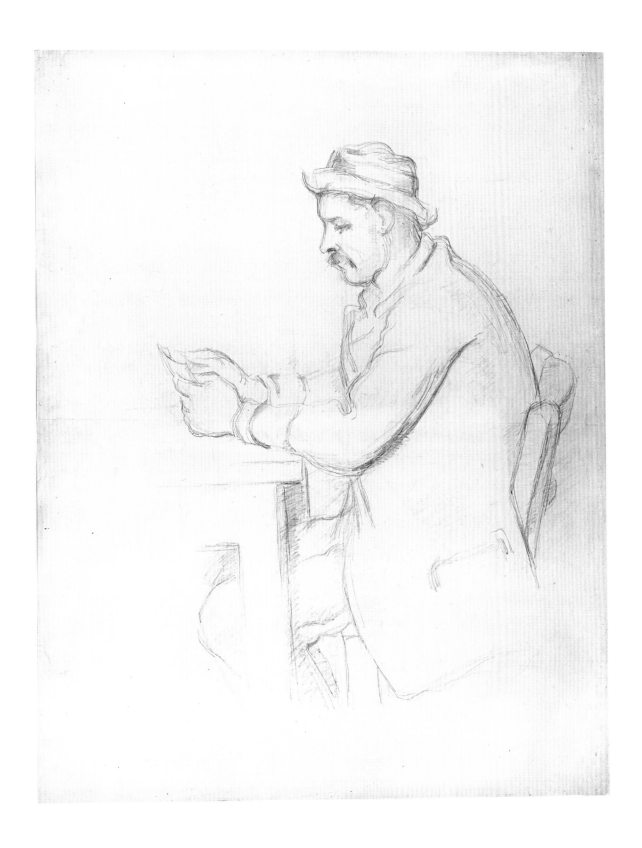

8 A Card Player c. 1892–96

Graphite on laid paper
49 × 40 cm
Chappuis 1092
Honolulu Academy of Arts
NEW YORK ONLY

Listed as "whereabouts unknown" in Chappuis's catalogue raisonné of Cézanne's drawings, this study has attracted relatively little attention, though it was purchased directly from Ambroise Vollard by the Honolulu Academy of Arts in 1937. It has discoloured and shows signs of foxing, but it is impressive nonetheless. Like the watercolour in the Museum of Art at the Rhode Island School of Design (cat. 9), it relates to the figure to the right in the Metropolitan Museum and Barnes Foundation canvases (cat. 1 and 2), and may well have been produced before Cézanne began to paint either of those major works. It may indeed pre-date the Rhode Island watercolour. Some of the details that seem to have troubled the artist here – such as the relationship of the body to the table – are resolved in the other depictions.

Notably, in this drawing the positioning of the left arm and the angle of its hand are particularly awkward. These elements suggest the difficulties of conveying a convincing sense of card play. The rather strange contours of the right sleeve of the blouse, and the apparent struggle to place the hands of the sitter, suggest movement. The arrangement of the smock sleeve in the other depictions of this model is more stylised: in the oil paintings the right sleeve is little more than a diagonal line that leads from the shoulder into a spherical billow before the cuff. Yet it was only at a fairly late stage that Cézanne decided on such an arrangement. X-radiographs of the Metropolitan picture show that in his initial drawing on the canvas the artist had laid in a contour of the right arm very similar to that seen in this study.

These factors suggest that Cézanne used the Honolulu drawing as a guide in the preparation of the paintings, but that he simplified the composition as he worked. Evidently, even if Cézanne relied heavily on his studies at the outset of the painting process, he by no means followed them slavishly. Equally, as works in their own right, the drawings retain a distinct character: here the grain of the paper enhances areas of soft shading, a relatively relaxed form of mark-making, fitting to the subject of the sheet. This sympathetic treatment may be aligned with the way in which, as Philip Conisbee proposed, Cézanne invented his own Provence in his art.[1] It was in seeing the artist's painted depictions of tanned and "robust" resting peasants, "with heavy shoulders, with hands consecrated by the heaviest labours" that Joachim Gasquet claimed to have learnt to know his "race" completely.[2] The physiognomy he described, surely, is akin to that of the timeless type depicted here. NI

PROVENANCE

Ambroise Vollard, Paris; Honolulu Academy of Arts, 1937

NOTES

1 Conisbee 2006, p. 15.
2 "Il y a dans l'atelier du Jas-de-Bouffan quelques toiles où se reposent de leurs travaux de robustes paysans, au teint nourri de soleil, aux puissantes épaules, aux mains sacrées par les plus lourds labeurs … c'est d'eux pourtant que j'ai appris à connaître tout à fait ma race": Gasquet 1898, pp. 379–80.

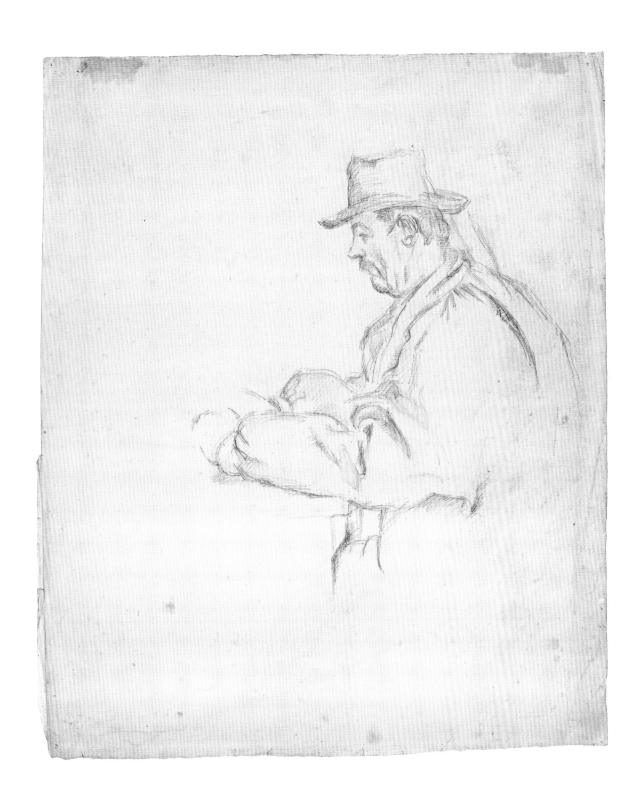

9 Card Player in a Blue Smock c. 1890–92

Graphite and watercolour on white paper
51.5 × 36.9 cm
Rewald watercolours 379
Museum of Art, Rhode Island School of Design, Providence
Gift of Mrs. Murray S. Danforth

This large-scale, highly worked study features the same model as that seen in the Barnes Foundation and the Metropolitan Museum canvases (cat. 1 and 2). Cézanne also depicted the sitter in another resolved drawing, now in the Honolulu Academy of Arts (see cat. 8). Cézanne had a taste for bucolic subjects – Gasquet claimed that he copied Millet's *Sower* around twenty times – and so he must have found this process of revisiting a peasant subject particularly helpful. On each occasion, he introduced subtle variations. In this example (more fully developed than the Honolulu sheet), the presence of the model is more imposing. Rather than end the composition at the waist, here Cézanne extended the view to include the knees, thighs, and considerably more of the table-top. He also added a few careful touches of colour to this watercolour version: highlights that encourage readings of the figure as a hearty rustic type. Hence the brushstrokes around the collar might hint at "the solid blue of blouses" he returned to repeatedly, while the ruddy cheeks of the sitter might suggest a face flushed from drinking (Joachim Gasquet implied that the "mischievous gleam of glasses of Malbec" was another leitmotif for the painter).[1]

Curiously, however, alcohol is absent from this and other *Card Players* studies. The model's heavy hands obscure the game itself; this is far from an image of rural intemperance.[2] Instead, the bulk of the peasant's body projects a sense of *gravitas*, while the suggestion of a curtain behind lends grandeur to the scene. That drapery reinforces the link between this image and the Barnes and Metropolitan Museum canvases, though the face of the sitter here is more characterful than it appears in those works. Arguably, in both the multi-figure compositions, a more general emphasis on the overall shape of the head overtakes any suggestion of skin tone and individual expression. Here, in contrast, the peasant's face seems aged, and he glances down at his hand intently.

The contours of the hat and face are precise, drawn in graphite and enhanced with watercolour, but other areas of the image reveal considerable technical freedom. Loose pencil strokes, which appear to have been made in a casual sweeping motion, emphasise the billowing left sleeve of the blouse. There is evidence of some deliberation surrounding the contour of the upper back, and numerous revisions were made before the painter decided on the definitive curve.

Details such as these have caused considerable speculation as to the placement of the sheet within the series; it was thought to have served as a transitional study, made after the four- and five-figure scenes and before the two-figure compositions.[3] The latest research suggests it may have been made at a moment before the execution of the Metropolitan and Barnes canvases.[4] Some of the difficulties that the artist encountered here are resolved in the finished paintings. NI

PROVENANCE

Ambroise Vollard, Paris; Jacques Seligmann, Paris and New York; Mrs. Murray S. Danforth, Providence, R.I, 1934; Museum of Art, Rhode Island School of Design, Providence 1942 (Gift of Mrs. Murray S. Danforth)

SELECTED EXHIBITIONS

New York, 1933, no. 7; Philadelphia, 1934, no. 48; Buffalo, 1935, no. 124; Boston, 1939, no. 148; Boston, 1945; Cambridge, MA, 1948–49, no. 69; Worcester, 1952, no. 9; Providence, 1954, no. 7; Rotterdam, 1954, no. 7; Paris, 1958–59; New York, 1959, no. 151; Washington, Chicago and Boston, 1971, no. 46; Providence, 1975, no. 5; Paris, London and Philadelphia, 1995–96, no. 132

NOTES

1 "*Constamment il revint à l'étude des paysans, des rustres à foulard rouge, au bleu massif des blouses, à l'éclat gouailleur du vin noir dans les verres*": Gasquet 1926, pp.15–16.
2 See the essay by John House in this volume.
3 *A Handbook of the Museum of Art, Rhode Island School of Design, Providence, Rhode Island*, 1985, p. 259.
4 See the essay by Aviva Burnstock, Charlotte Hale, Caroline Campbell and Gabriella Macaro in this volume.

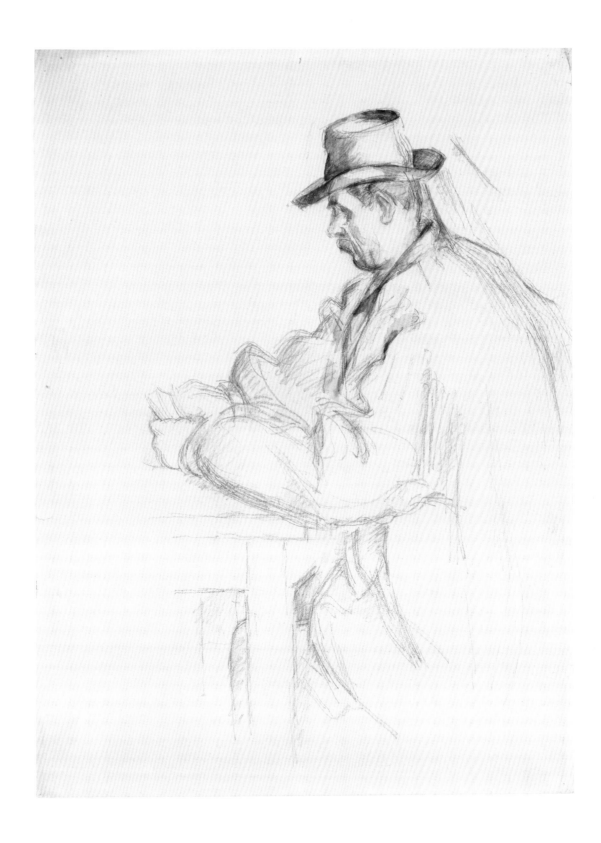

10 Seated Man; Legs of a Bather *c.* 1890?

Graphite on wove paper
18.2 × 11.6 cm
(Sketchbook I, p. 43 verso)
Philadelphia Museum of Art,
Gift of Mr. and Mrs. Walter H. Annenberg, 1987

11 Seated Man *c.* 1892–96

Graphite with traces of watercolour on wove paper
21.6 × 12.7 cm
(Sketchbook II, p. viii verso)
Philadelphia Museum of Art
Gift of Mr. and Mrs. Walter H. Annenberg, 1987

NEW YORK ONLY

These small, informal sketches are of a very different register to the other works in this exhibition. However, particularly in the case of the figure depicted face-on, they appear to connect directly with the *Card Players* series, even if their role remains unclear. It is impossible to know whether the hatless man seen here prompted the central pose found in the Metropolitan Museum and Barnes Foundation paintings (cat. 1 and 2), or whether it served the artist at an intermediate stage between those two works as a means to refine the final arrangement. The drawing style, informal and rapidly done, might indicate that the study provided inspiration at the outset of the series; but the same pyramid-like shape, placed at the centre of the Barnes group, structures that work as a whole. If the five-figure composition initially featured the central figure wearing a hat (as in the Metropolitan canvas), which the artist then chose to eliminate, this small study may have helped to inform the decision. The physiognomy of the model is quite unlike the seated central card player in the four-figure version; with his smooth hair – and his protruding left ear – he bears more resemblance to the sitter in the Barnes picture. The other, less confident, sketch bears no obvious relationship to any particular figure in the series: yet, seated figures in profile being a recurrent theme within the paintings and studies, the exploration of the pose alone invites association with the *Card Players* works.

Both of these pencil studies were originally part of the two Cézanne sketchbooks that were donated to the Philadelphia

Museum by Walter and Leonore Annenberg in 1987.[1] Before the sheets were separated by a previous owner in the 1950s, the complete books had incorporated many different themes. Motifs ranged from a reclining female nude, to a study after a Houdon statue of a flayed man, to a sketch of a bourgeois gentleman wearing a hat. There was no apparent order in their organisation, and it is entirely possible that the artist worked on several different sketchbooks at any given moment. Accordingly, no fixed date has been ascribed to either of these drawings. The *Seated Man; Legs of a Bather* was one of the relatively few sketchbook pages to show Cézanne's writing; the sheet also features an assortment of numbers. But these details reveal nothing more than the artist's casual treatment of the piece. That he noted an address and undertook a mathematical addition in such close proximity to the image must confirm that this was a working drawing, its value to him purely practical. Nor do the legs above offer a clear clue to the year of its execution. They are comparable to studies that the artist made at different stages of his career.

Even if these are the only sheets from the two sketch-books that seem to relate closely to the *Card Players* series, it is important to consider that apparently unrelated drawings in the sketchbooks may also have influenced the *Card Players* works. Studies of the artist's son asleep show a similar interest in the simplified outline of a face, for instance, while more generic figure sketches may have informed the poses of his painted peasants at rest. NI

PROVENANCE

The artist's family; private collection, Lyons; Mr. and Mrs. Ira Haupt, New York; Mr. and Mrs. Walter H. Annenberg, New York; Philadelphia Museum of Art, Gift of Mr. and Mrs. Walter H. Annenberg, 1987

SELECTED EXHIBITIONS

(Cat. 10) Philadelphia, 1989 (2); Philadelphia, 1996
(Cat. 11) Philadelphia, 1989 (2)

NOTE

My thanks to Shelley Langdale and Rich Brooks at The Philadelphia Museum of Art for their assistance.

1 See Reff and Shoemaker 1989.

287
/60
347

My firma
Broquet
vie Poulet, 45

12 The Card Players c. 1892–96

Oil on canvas
47 × 56 cm
Rewald 714
Musée d'Orsay, Paris, Camondo Bequest, 1911

It is generally thought that Cézanne began his series of three paintings depicting two peasants playing cards after completing his multi-figure versions of the subject (see cat. 1 and 2), although the precise dating of the works remains uncertain. In addressing the card-players theme for a second time, Cézanne chose a simpler composition, with two peasants facing each other over a wooden table. He also decided upon a different setting, which may have been a room in the farm house at the Jas de Bouffan, rather than in the main house itself where he usually painted.[1] The background, although not clearly defined, has wooden panelling and perhaps a window or mirror above. It might be thought to evoke a café interior or one of its back rooms of the sort where peasants commonly played cards in Aix as elsewhere. Unlike his two earlier *Card Players* canvases, which with their draped curtains and clear sense of staging are suggestive of interiors from Venetian Renaissance figure scenes, for example, these works are more aligned with the rusticity of a rural genre painting and might almost be observed from everyday life. However, a number of surviving preparatory works in various media (cat. 15–17 and fig. 59) suggest that Cézanne constructed this composition in the same way as his other paintings of card players, by studying the figures individually and bringing them together on the canvas itself.

Later scholars have sometimes celebrated the Musée d'Orsay canvas as Cézanne's most successful distillation of the composition. This judgment underpins the now broadly accepted view that it must have been the final work in the series – the culmination of a gradual process of refinement which saw Cézanne beginning with the largest canvas (cat. 14) and working down in scale, with the Courtauld Gallery painting being an intermediary stage. Meyer Schapiro, for example, was unequivocal that "this little painting is the last and undoubtedly the best; it is the most monumental and also the most refined".[2] Stylistic comparison with the securely dated *Portrait of Gustave Geffroy*, 1895 (fig. 44) has also been made in support of this sequence, with the suggestion that the Orsay painting represents a move towards the freedom of execution and varied brushwork that is characteristic of the last decade of Cézanne's life.[3] However, recent technical research has questioned this chronology.[4] It has revealed the presence of a much greater degree of graphite under-drawing and reworking in this version in comparison to the Courtauld picture and possibly also the largest canvas (which has yet to be examined in this manner). This reopens the possibility that it might in fact have been Cézanne's first attempt at the composition rather than the culmination of the series.

The fact that Cézanne repeated and reworked this almost identical scene in three canvases, something unprecedented

PROVENANCE

Ambroise Vollard, Paris; Baron Denys Cochin, Paris; Durand-Ruel, Paris; Count Isaac de Camondo, Paris; Musée du Louvre, Paris (Camondo Bequest, 1911); transferred to Musée d'Orsay, 1986

SELECTED EXHIBITIONS

Paris, 1945, no. 2 ; Paris, 1947, no. 39?; Aix-en-Provence, 1953, no. 18; Paris, 1954, no. 55; Rome, 1955, no. 9; The Hague, 1956, no. 37; Vienna, 1961, no. 33; Aix-en-Provence, 1961, no. 12; The Hague and Paris, 1966, no. 49 (Paris, no. 51); Paris, 1974, no. 44; Paris, 1978, no. 6; Madrid, 1984, no. 43; Tübingen, 1993, no. 66; Paris, Philadelphia and London,

1995–96, no. 134; St Petersburg, 1998, no. 34; Yokohama and Nagoya, 1999–2000, no. 57; Taipei, 2001–2002; The Hague, 2002; Melbourne, 2004; Washington and Aix-en-Provence, 2006, no. 30; New York, Chicago and Paris, 2006–07, no. 42 (Paris, 2007, no. 30)

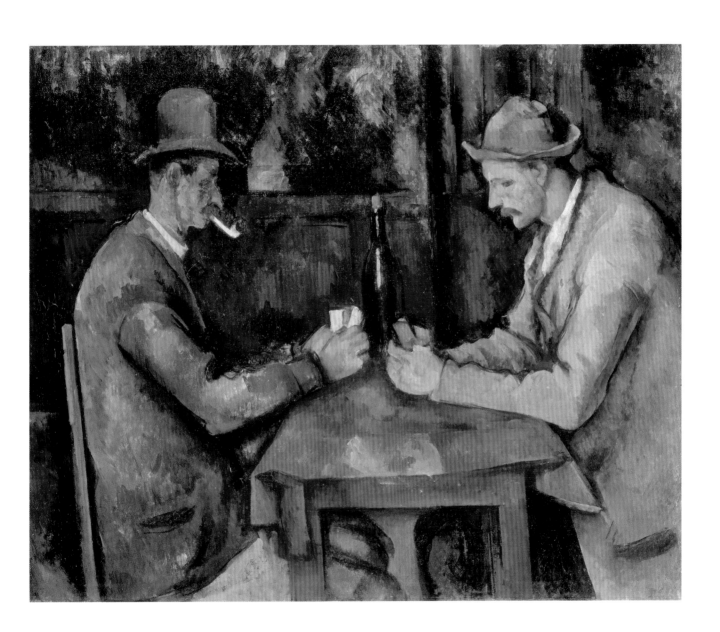

in his oeuvre, is clear evidence of the fascination that it held for him, despite the apparently uncomplicated structure of the composition. Schapiro suggested that it was the blatant simplicity of his broadly symmetrical arrangement of the two figures, either side of the near-central wine bottle, which held the greatest challenge for the artist:

> "Given the symmetry of the two card players looking fixedly at their cards, Cézanne had to surmount the rigidity and obviousness of the pair and yet preserve the gravity of their absorbed attitudes. It is remarkable how thoroughly interesting is this perfectly legible picture, how rich in effective inventions of colour and form."[5]

It is Cézanne's ability to achieve such monumentality without sacrificing the vibrancy of his brushwork and character of the players that has marked out this painting as a masterpiece in the eyes of several later writers – Theodore Reff describing it as "one of the summits of his achievement."[6] Whether these qualities are the result of Cézanne's searching brushwork as he explored the composition for the first time, or the culmination of earlier rehearsals of the subject in different scales, will continue to be debated.
BW

NOTES

1 For a discussion of the settings for these works see the essay by Nancy Ireson and Barnaby Wright in this volume.
2 Schapiro 1952, p. 16.
3 Reff 1977–78, p. 17.
4 See the essay by Aviva Burnstock, Charlotte Hale, Caroline Campbell and Gabriella Macaro in this volume.
5 Schapiro 1952, p. 16.
6 See Reff 1977–78, p. 17.

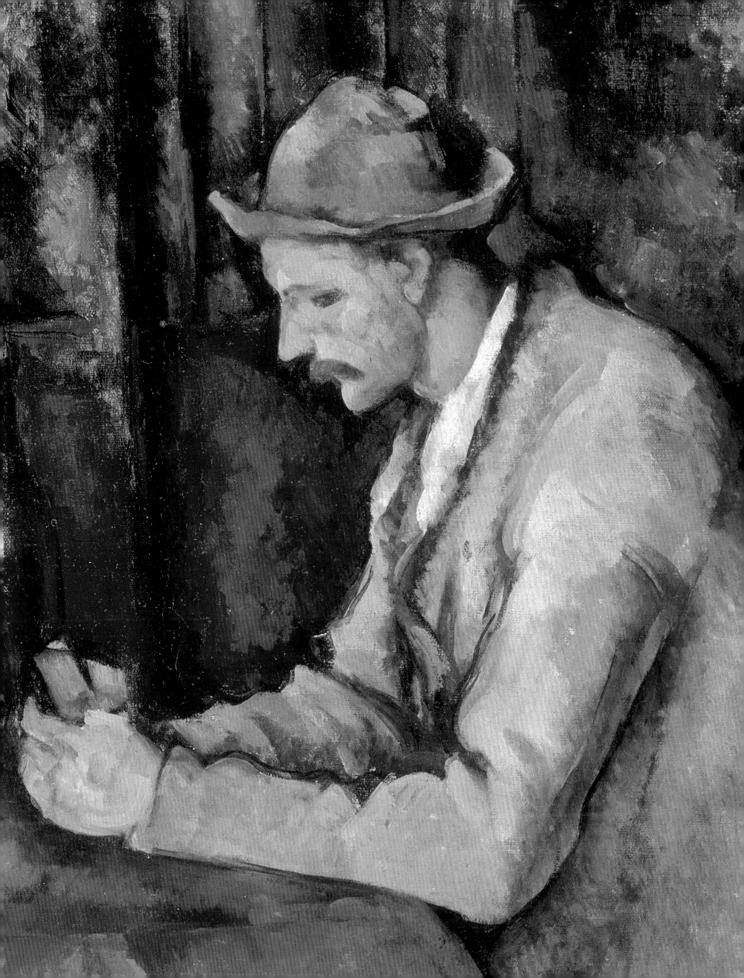

Oil on canvas
60 × 73 cm
Rewald 713
The Courtauld Gallery, London, Samuel Courtauld Trust,
Samuel Courtauld Gift, 1932

As with Cézanne's other card-players scenes, farm workers from the Jas de Bouffan were the models for his two-figure compositions. The man on the right-hand side may be Paulin Paulet, a gardener at the Jas who appears as the left-hand seated figure in the multi-figure compositions (cat. 1 and 2) and in a number of other works (for example, cat. 20 and 21). The other man, who is also the subject of *Man with a Pipe* (cat. 18), is sometimes named as a farmworker known as *peré* Alexandre, although this seems to be incorrect; Alexandre is probably, in fact, the man in a blue smock smoking a pipe in the two earlier *Card Players* compositions (cat. 1 and 2).[1] However, both men would have been well known to Cézanne from the farm and he made detailed head studies of each (cat. 15–17). Whilst they share rather blank expressions, some sense of their individuality is conveyed in the finished paintings by Cézanne's attention to their facial features, carefully modelled with delicate colour accents and fine brushstrokes. Whilst the men are not simply stock types, as was common in nineteenth-century depictions of rural scenes, the overall impression is of peasants engaged in an age-old pastime as part of an unchanging traditional way of life.

This canvas offers the most expanded view of the scene, with the figures revealed more fully than in the other two versions. It is usually considered to be the second work in the group, although recent technical research raises the possibility that it might be the final version.[2] There is little graphite under-drawing on the canvas; instead Cézanne drew loosely and fluently with the brush in ultramarine blue before building up the paint surface in layers to varying degrees in subtly gradated colours. At a late stage he returned to certain forms, such as the men's knees and sleeves, emphasizing them by brushing in dark contouring lines. Areas of the canvas are worked up in different ways and these various types of layering, brushstroke, modelling and line, imbue the work with considerable visual energy. The result is a painting that refuses to cohere as an illusion of reality but rather asserts the process of its construction at every stage.

In striving to achieve his desired arrangement of figures and objects, Cézanne sacrificed anatomical and perspectival accuracy in favour of harmonies of form and tone. The verticals of the table lean to the left, the knees of the smoking figure extend excessively to the right. His body is elongated, distorting the position of his arm and making his head appear a little too small – a feature more exaggerated in the Musée d'Orsay version (cat. 12). These departures from conventional vision seem not to have been preconceived as expressive distortions but rather emerged during the execution of the painting. The work brings to mind Cézanne's often-quoted (perhaps tongue-in-cheek) remark; "I am a primitive, I have a lazy eye. I presented myself twice to the École [des Beaux-Arts], but I couldn't get things in proportion: a head interests me and I make it too big."[3] His comments are, of course, belied by the complexity and inventiveness of this canvas in which distortion in fact plays a sophisticated and subtle role in achieving the work's overall sense of solidity and structure. BW

PROVENANCE

Ambroise Vollard, Paris; Dr. Julius Elias, Berlin; Jorgen Breder Stang, Oslo; Alfred Gold, Berlin; Samuel Courtauld, London; The Courtauld Gallery, London, The Samuel Courtauld Trust, (Samuel Courtauld Gift, 1932)

SELECTED EXHIBITIONS

Berlin, 1904, n. n.; Paris, 1929, no. 8; London, 1932, no. 392; Edinburgh, 1933, no. 142; Sheffield, 1934, no.196; Paris, 1937, no. 256; Birmingham, 1947, n. n.; London, 1948, no. 13; Edinburgh and London, 1954, no. 52; Paris, 1955, no. 11; Arts Council of Great Britain, 1976, no. 10; Tokyo, 1984, no. 11; Cleveland, 1987–88, no. 26; Tübingen, 1993, no. 56; London, 1994, no. 10; Tokyo and Toronto, 1997–98; Stockholm, 2002–03; London, 2006–07

NOTES

1 For a discussion of his identity see the essay by Nancy Ireson and Barnaby Wright in this volume.

2 See the essay by Aviva Burnstock, Charlotte Hale, Caroline Campbell and Gabriella Macaro in this volume.

3 *"Je suis un primitif, j'ai l'œil paresseux. Je me suis présenté deux fois à l'École, mais je ne fais pas l'ensemble: une tête m'intéresse, je la fais trop grosse"*: quoted in Rivière and Schnerb 1907, reprinted in Doran 1978, p. 87.

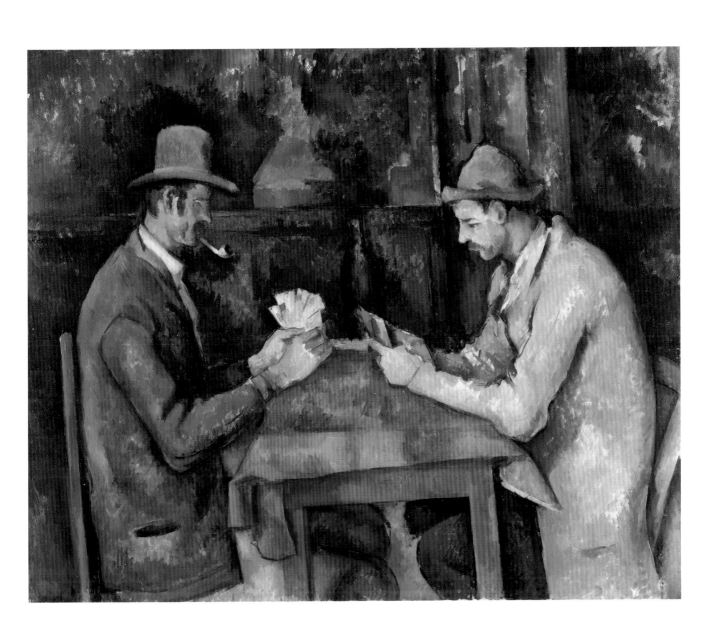

14 The Card Players c. 1892–96

Oil on canvas
97 × 130 cm
Rewald 710
Private collection

NOT EXHIBITED

This canvas is among the largest of Cézanne's paintings and offers the most closely cropped view of the three versions of the composition (see also cat. 12 and 13). It is exceeded in size by his five-figure *Card Players* canvas (cat. 2) and his large *Bathers* series but shares with them an apparent ambition to produce a major work on a scale approaching some of the great museum paintings that he frequently studied in the Louvre. Whereas various sources from the art of the past have been suggested, there are no obvious direct precedents in earlier historical or nineteenth-century figure paintings that compare very closely to the stark symmetry of Cézanne's two-figure card-players compositions. As Theodore Reff has discussed, one has to turn to nineteenth-century caricaturists, admired by Cézanne, such as Honoré Daumier and Paul Gavarni, to find scenes of card players arranged in a comparable manner.[1] For them, the profile view gave visual clarity and immediacy to satirical observation. But Cézanne eliminates anecdotal and narrative detail and instead the stripped-down composition becomes the structure upon which he strives for loftier ambitions, imbuing his card-players scene with qualities of monumentality, gravitas and timelessness. The critic André Pératé, one of the earliest commentators to discuss this painting (in his review of Cézanne's posthumous retrospective at the Salon d'Automne in 1907), responded to the work along precisely these lines, writing: "Instead of a fleeting impression, of an ordinary scene . . . it imposes on our memory by the simplification of detail and the almost eternal sturdiness of matter Wouldn't one think one were looking through an open window into this poor café interior, where the smell of absinthe lingers, where one can make out fly stains on the walls? It must be admitted, this is nature itself."[2]

Similarly other early writers thought the painting harnessed its expression of reality to enduring classical values of form and structure, without compromising either. Gustave Coquiot, for example, described how in the work: "We have here life itself, without exaggeration or theatrical flourish. And it isn't realism, because everything is enhanced by the colour and design. Without extraneous detail, executed in a free and broad manner, these *Card Players* . . . are equal to the most beautiful works of art in the world. It's a moving tribute to the men of the land"[3]

In his influential 1927 monograph, which illustrates this painting, Roger Fry crystallised these ideas in relation to the *Card Players* series as a whole in one of his most eloquent descriptions of Cézanne's works: "It is hard to think of any design since those of the great Italian Primitives – one or two of Rembrandt's later pieces might be cited – which gives us so extraordinary a sense of monumental gravity and resistance – of something that has found its centre and can never be moved, as this does. And yet there is no demonstrative emphasis on such an idea, it emerges quite naturally and inevitably from a perfectly sincere interpretation of a very commonplace situation."[4]

Perhaps of all the *Card Players* paintings it is this work that accords most fully with Cézanne's own reported ambition to create "something solid and durable like the art of the museums".[5] BW

PROVENANCE

Ambroise Vollard, Paris; Bernheim-Jeune, Paris; Auguste Pellerin, Paris; Jean-Victor Pellerin, Paris; private collection

SELECTED EXHIBITIONS

Paris, 1907, no. 14; Paris, 1910, no. 37; Paris, 1926, no. 39; Paris, 1936, no. 87

NOTES

1 Reff 1980, pp. 104–17. Some of Daumier's paintings, such as *Joueurs de Cartes*, c. 1859–62, oil on panel, 27 × 34 cm, formerly in the John Hay Whitney collection, may be compared to Cézanne's two-figure *Card Players*.

2 "*Au lieu d'une impression qui passe, de scène familière . . . il impose a notre mémoire, par la simplification du détail et la robustesse comme éternelle de la matière Ne dirait-on pas que l'on regarde par une fenêtre ouverte dans cette pauvre salle de café, ou traîent des relents d'absinthe, ou l'on devine aux murailles la salissure des mouches ? Il faut le reconnaître, c'est de la nature même*":

André Pératé, 'Le Salon d'Automne', *Gazette des Beaux-Arts*, vol. xxxviii, November 1907, pp. 388–89.

3 "*C'est la vie même, sans emphase, sans accent théâtral. Et ce n'est pas réaliste; car tout est surhaussé par le dessin, par la couleur. Sans détails, d'une exécution large et volontaire, ces Joueurs de cartes . . . égalent la plus belle œuvre qui soit au monde. C'est un émouvant hommage à ceux qui labourent*: Coquiot 1919, pp. 223–24.

4 Fry 1927, p. 72.

5 "*. . . quelque chose de solide et de durable comme l'art des musées*": as quoted by Maurice Denis, 1907, reprinted in Doran 1978, p. 170.

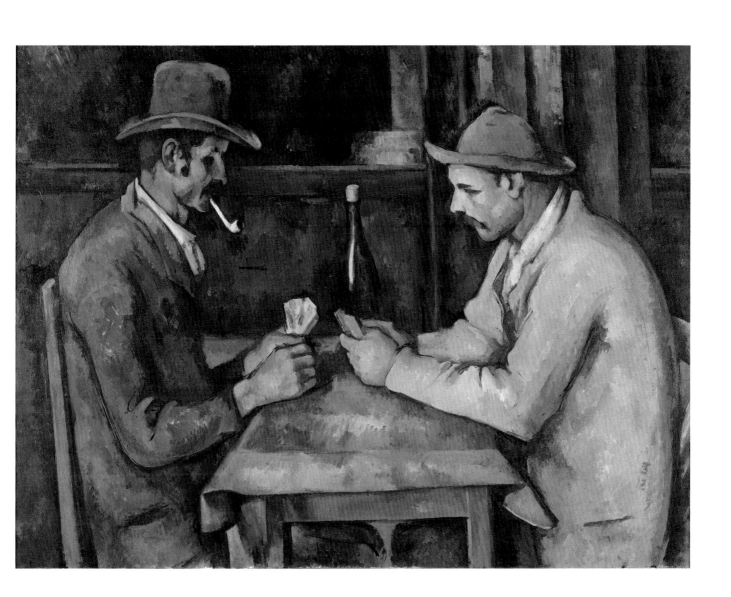

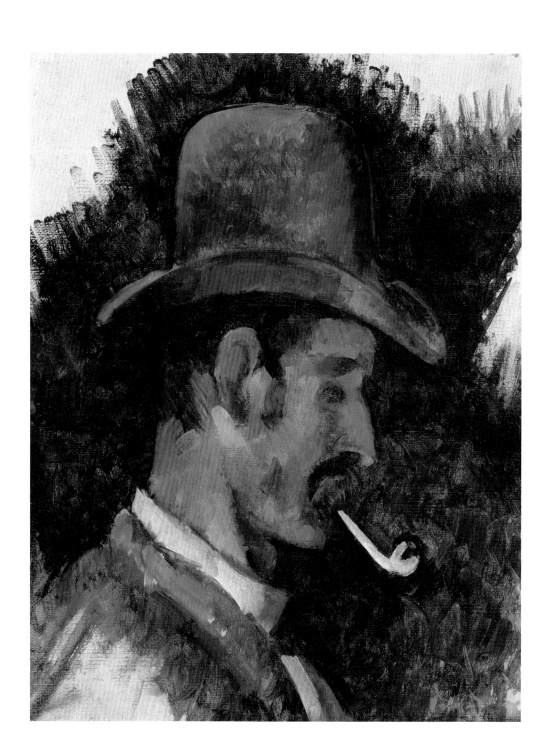

15 Man with a Pipe
(Study for The Card Players) c. 1892–96

Oil on canvas
26 × 20.5 cm
Rewald 711
National Gallery of Art, Washington, DC
Gift of the W. Averell Harriman Foundation in memory of
Marie N. Harriman, 1972

This small oil study of the pipe-smoking card player is difficult to place with certainty in relation to the development of the three two-figure canvases (cat. 12–14). Yet it clearly relates closely to them and demonstrates Cézanne's concern for carefully rendering the complex patchwork of tones of the man's ruddy face with a variety of differently directed brushstrokes. These are also evident in the finished paintings. Whilst tonally it accords with the Musée d'Orsay version (cat. 12), the oil study is a more accurate and defined depiction of the sitter than appears in that work and we might speculate that he produced it in advance of one of the other two canvases where the man's face is more resolved. John Rewald suggested that a life-sized plaster dummy of a man's head, which Cézanne owned (fig. 13), might have been used for this oil study as it has a broadly similar profile.[1] However, even if the peasant model was no longer available to sit when Cézanne made the oil sketch he is likely to have had enough detailed pencil and watercolour studies from which to work (see, for example, cat. 16), unless perhaps the plaster helped him realise a more clearly defined outline of the head in profile. It is possible that the oil study also helped Cézanne to resolve the arrangement of the wooden rail (which runs horizontally just below centre) in relation to the position of the man's head and the placement of his pipe, an area of difficulty in the related watercolour (cat. 16). BW

PROVENANCE

Ambroise Vollard, Paris; Leo and Gertrude Stein, Paris; Gertrude Stein, Paris; Paul Rosenberg, Paris; Marie Harriman Gallery, New York; Mr. and Mrs. W. Averell Harriman, New York; National Gallery of Art, Washington, DC, Gift of the W. Averell Harriman Foundation in memory of Marie N. Harriman, 1972

SELECTED EXHIBITIONS

New York, 1930, no. 3; Detroit, 1931, no. 13; New York, 1932, n. n.; Philadelphia, 1934, no. 36; New York, 1936, no. 3; San Francisco, 1937, no. 28; San Diego, 1937, n. n; New York, 1937, no. 15; New York, 1939, no. 15; Dayton, 1945, n. n.; New York, 1947, no. 47; Cincinnati, 1947, no. 8; New Haven and Baltimore, 1951, no. 5; Munich, 1956, no. 51; Aix-en-Provence, 1956, no. 45; Washington, 1961, n. n.; New York, 1970–71, n. n.; Cincinnati, 1981, n. n.; Milan, 1989

NOTES

1 Rewald 1996, no. 711.

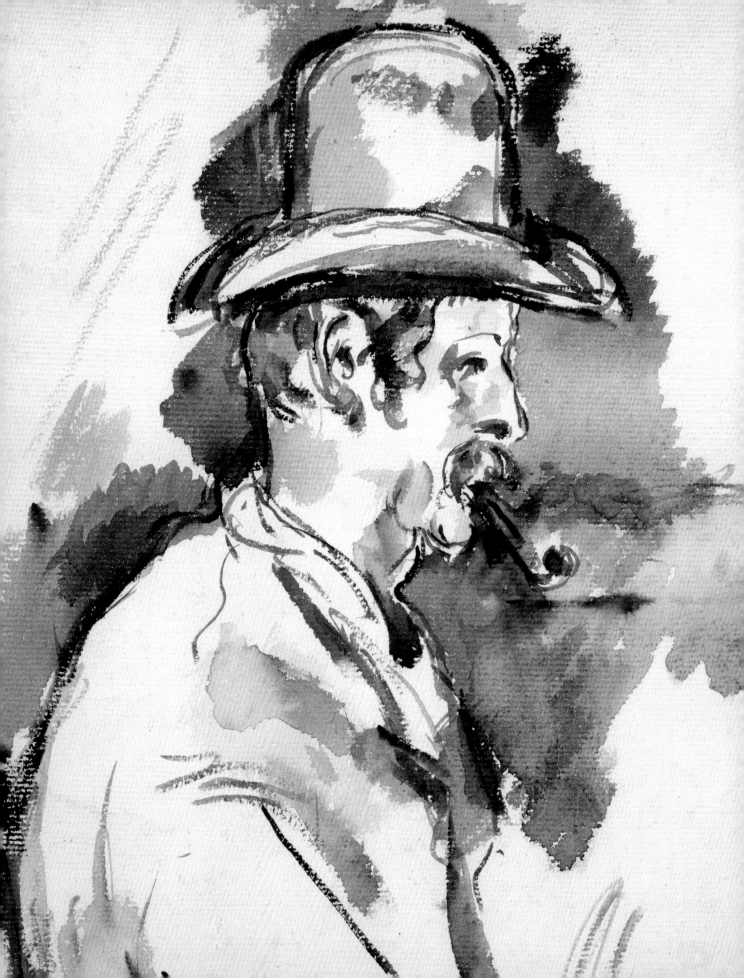

16 Man with a Pipe (Study for The Card Players)
recto, c. 1892–96

Watercolour on paper
51 × 32 cm
Rewald watercolours 378
Private collection, courtesy of Thomas Gibson Fine Art, London

LONDON ONLY

Study of a Man's Head
verso, c. 1892–96

Graphite
Chappuis 1095

Four studies on paper for Cézanne's two-figure *Card Players* scenes are known. They were probably made from life with the models posing for him separately in his studio or in one of the rooms on the farm at the Jas de Bouffan. They are a head study in pencil and a fuller length study in watercolour of each player. The two studies for the left-hand figure form the recto and verso of this sheet (see also cat. 17 and fig. 59). However, the rather pleasing symmetry of the two figures studied in the same way should not be taken as evidence of a systematic approach on Cézanne's part, as there are likely to have been other preparatory sheets that he destroyed or which are lost. The works attest to the range of different types of preparatory studies Cézanne made for the *Card Players* series.

We might speculate that Cézanne was more likely to have made the pencil sketch first and then turned the sheet to produce the watercolour on the other side. The head study is closely observed and pays particular attention to the contours of the man's face, with Cézanne making numerous fine adjustments to his features; most noticeably to his chin, mouth, moustache, nose and ear. He also uses the drawing to explore the volume of the man's hat, which he establishes with hatched shading of varied densities. It is interesting to note the absence of the clay pipe in this sketch, which is such a defining feature of Cézanne's other depictions of this sitter, including the head study in oil (cat. 15) and the watercolour on the other side of this sheet.

The watercolour is more loosely worked than the head study and was probably produced fairly swiftly. It can be assumed to represent a relatively early stage in the development of the composition as Cézanne appears troubled by the position of the panelling in the background, the rail of which intersects with the man's mouth and pipe. The area is worked over several times. In the finished paintings he raises the height of the panelling altogether so that the pipe breaks the line of the rail and gives a clearer sense of depth. There is no evidence of pencil underdrawing and Cézanne simply drew directly with the brush in black, adding salient patches of colour to help establish form and to explore tone and highlights. In places, such as the area below the right arm, the coloured wash has become dirtied by contact with the black line giving a gradation of shading, perhaps a fortuitous consequence of a moment's impatient brushwork.

John Rewald discussed a change in the character of Cézanne's watercolours in the 1890s. At this stage, the artist began to use the medium with far less reliance upon detailed pencil underdrawing and sometimes completely independently, as seen in this work.[1] In this case his use of watercolour correlates closely with his approach to the resultant canvases where he also drew loosely with the brush before applying patches of colour. Tellingly, several of the coloured areas of the watercolour sketch, such as the bluish patch to the left of the sitter's sleeve and the orange highlight by his temple, find a similar place in the Musée d'Orsay canvas, to which the study seems most closely related. It is likely that this watercolour (and perhaps others) played its part in emboldening Cézanne to work in oil on his *Card Players* with increased inventiveness and vibrancy, creating new relationships between the roles of drawing and painting. BW

PROVENANCE

Ambroise Vollard, Paris; Adrien Chappuis, Paris; Paul Rosenberg, Paris; Paul Cassirer, Amsterdam; Franz Koenigs, Haarlem; private collection, Holland; Heinz Berggruen, Switzerland; E.V. Thaw Inc., New York; private collection, Switzerland; private collection

SELECTED EXHIBITIONS

Amsterdam, 1938, no. 12; London, 1939, no. 27; Paris and Amsterdam, 1964, no. 203; Tübingen and Zürich, 1982, no. 98; Arts Council of Great Britain, 1986, no. 12; Geneva, 1988; New York, 1999

NOTE

1 Rewald 1983, p. 31.

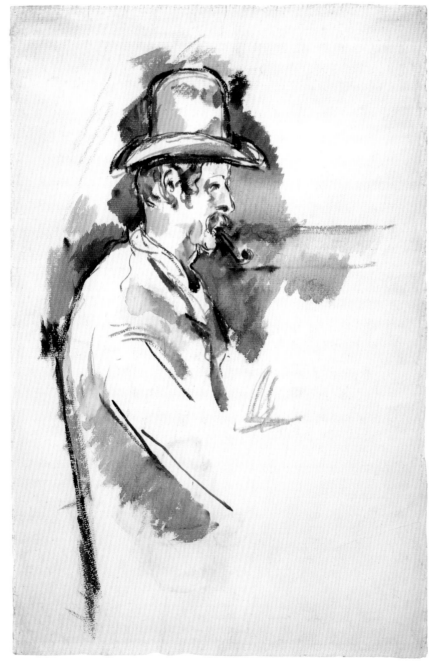

16 recto

16 verso (reproduced inverted relative to the recto)

17 Man Smoking (Study for The Card Players) *c.* 1892–96

Graphite on laid paper
50 × 32 cm
Chappuis 1094
Boijmans Van Beuningen Museum, Rotterdam
Koenigs collection

This head study is for the peasant seated on the right in Cézanne's two-figure *Card Players* canvases (cat. 12 and 13), where the same figure appears without the pipe that is partially sketched in this drawing. Subtle and more obvious differences between the drawing and the sitter's realisation in paint show that the artist continued to make numerous adjustments to the man's features with each subsequent iteration. This is evident in the sketch itself, where the contours of the chin and the area of the mouth are redrawn several times.

The sheet perhaps relates more closely to the Musée d'Orsay canvas (cat. 12) than to the other two works; notable here is the careful attention Cézanne pays to the undulations of the brim of the man's hat in the drawing, some of which are retained (although narrowed) in the Orsay work but largely flattened-out in the other paintings. However, his face is significantly thinner in the Orsay painting and the tilt of his head altered slightly, making it impossible to claim definitive connections. Indeed, to expect to find exact parallels between Cézanne's drawings and paintings is to misunderstand his way of working, especially during this period, when the role of a drawing such as this was to give him the visual information needed to recreate the figure on the canvas rather than to make a literal transcription.

A large watercolour depicting the seated man more fully is also documented, although currently untraced and known only from a black and white photograph and John Rewald's description (fig. 59).[1] As with the watercolour study of the left-hand figure (cat. 16), in this instance, Cézanne evidently worked entirely with the brush, drawing in the contours in dark pigment and accenting with colour. Both the pencil head study and the watercolour bear comparison with the large-scale pencil drawing from the Morgan Library (cat. 7), which is sometimes considered to be a further preparatory work for this composition. However, the absence of a

Fig. 59
A Card Player, c. 1892–96
Watercolour on paper, 61 × 42 cm
Rewald watercolours 380
Present whereabouts unknown

tablecloth or any indication of wooden panelling behind, together with the fact that his shirt sleeve is visible, all suggest that the Morgan drawing is in fact the figure who appears, inverted, on the left-hand side of the Barnes Foundation and Metropolitan Museum versions (cat. 1 and 2). However, the drawing could have played some part in informing the development of the two-figure compositions, along with these two sheets and no doubt others that are lost. BW

PROVENANCE

S. Meller, Munich; P. Cassirer; F. Koenigs, Haarlem; D. G. van Beuningen; Museum Boijmans Foundation, Rotterdam, 1940 (Gift of D.G. van Beuningen).

SELECTED EXHIBITIONS

Rotterdam, 1934, no. 8; Basel, 1935, no. 180; Basel, 1936, no. 140; Amsterdam, 1938, no. 24; Amsterdam, 1946, no. 16; Paris, 1952, no. 143; The Hague, 1956, no. 125; Zurich, 1956, no. 188; Munich, 1956, no. 143; Paris and Amsterdam, 1964, no. 204

NOTE

1 Rewald 1983, no. 380.

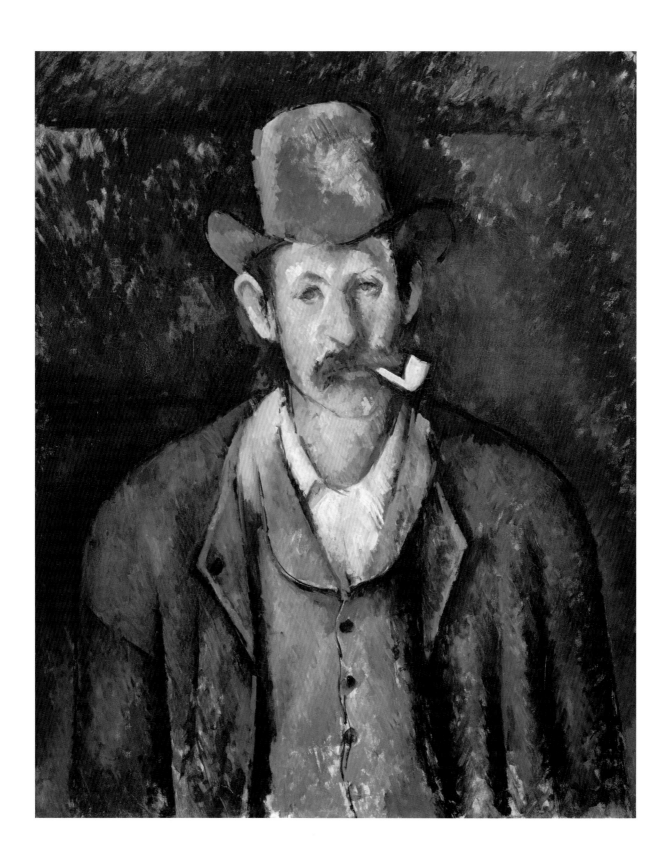

18 Man with a Pipe c. 1892–96

Oil on canvas
73 × 60 cm
Rewald 712
The Courtauld Gallery, London, Samuel Courtauld Trust,
Samuel Courtauld Gift 1932

This painting is one of a group of related canvases from the first half of the 1890s that depict single peasants often smoking clay pipes (see, for example, cat. 20–22). They have long been recognised as part of the same body of work as Cézanne's *Card Players* series. Several of the single peasant sitters also appear in his *Card Players* compositions, including this man, who is unmistakable as the left-hand player in the two-figure versions and appears in a number of preparatory works (cat. 12–16). The handling, palette and background of this canvas are closely comparable to that series and it is reasonable to assume that it was produced at a similar date.

Perhaps the germ of the idea for this stripped-down and assertively frontal composition came from Cézanne's pipe-smoking peasant in a blue smock, who appears in the background of his multi-figure scenes (cat. 1 and 2) and as a single figure in an oil study (cat. 3). However, several of his portraits of his wife from the late 1880s and early 1890s feature similarly austere compositions and it is important to consider his peasant 'portraits' in the broader context of his figure paintings at this time (see, for example, fig. 60). Indeed, this canvas blurs the boundaries between portraiture and peasant genre painting and resists straightforward categorization as either – the figure here is both an individual and a stand-in for a stoical rural type. Although he has sometimes been identified as *père* Alexandre, a farm worker from the Jas de Bouffan, this seems to be a confusion in the literature with the man who appears in a blue smock smoking a pipe in the background of the two multi-figure compositions (cat. 1 and 2).[1]

As with his two-figure *Card Players* works, the challenge of this painting for Cézanne must have been to breathe life into the potentially deadening flatness of the arrangement, accentuated by the relentless brown colouring of both the background and the man's clothes. Cézanne directs attention towards the face, which he composes of successions of diagonal strokes, animating the surface of the flesh. These marks are set off by two broader strokes of red along the ridge of his nose, which were added at a late stage. The varied warm hues of his weathered face are thrown into greater relief by the subdued tones used elsewhere, which are nevertheless enlivened by subtle swathes of cooler and warmer colours. Different levels of surface finish, from exposed patches of primed canvas to carefully built-up modelling, give the painting as a whole visual and intellectual complexity. Certain passages seem provisional and searching, such at the alternative positions of the lines marking the overlap of his buttoned waistcoat. By contrast, the fluent contouring line that defines the brim of his hat appears more resolute. Yet here too the form created is fragile and contingent upon our willingness to accept that the curved line marking the right-hand side of the brim is sufficient to distinguish the underside of the hat from the background, when in reality they are clearly one and the same.

The focused intensity of Cézanne's rendering of this humble peasant is remarkable and sets the work apart from some of his other peasant paintings. The canvas invites comparison with works by Cézanne's artistic forebears, most notably perhaps with Rembrandt's portraits, which similarly exude luminosity from the darkness of their surroundings and in which the complex painted construction of the face is paramount.[2] The frontal pose of Cézanne's peasant, the blankness of the setting and the solemnity of his expression are qualities shared with religious icons and in a broad sense this work might be thought to aspire to a similar degree of visual intensity. BW

PROVENANCE

Paul Gallimard, Paris; Louis Hodebert, Paris; Galerie E. Bignou, Paris; Reid and Lefevre, London; Samuel Courtauld, London; The Courtauld Gallery, London, the Samuel Courtauld Trust (Samuel Courtauld Gift 1932)

SELECTED EXHIBITIONS

Brussels, 1904, n. n.; Paris, 1929, no. 9; London, 1948, no. 14; London, 1954, no. 51; Paris, 1955, no. 12; Zurich, 1956, no. 67; Aix-en-Provence, 1956, no. 46; The Hague, 1956, no. 38; London, 1976, no. 101; London, 1975, no.11; Tokyo, 1984, no. 12; Cleveland, 1987–88, no. 27; London, 1994, no. 11; Tokyo and Toronto, 1997–98; Essen, 2004–05; London, 2006–07; Aix-en-Provence, 2009

NOTE

1 See the essay by Nancy Ireson and Barnaby Wright in this volume.
2 For a discussion of possible parallels between Cézanne and Rembrandt, see Carpenter 1951, pp. 174–86.

19 Peasant c. 1890–92

Oil on canvas
55 × 46 cm
Rewald 704
Private collection

Although not directly related to the multi-figure Card Players scenes (cat. 1 and 2), in its treatment of an isolated peasant figure this canvas is comparable to certain studies for those works (see, for example, cat. 3 and 4). Its peasant sitter, in wrapt concentration, appears before a similarly muted bluish background. It is easy to imagine that the figure posed in the same setting that served for the Metropolitan Museum and Barnes Foundation versions of the subject, perhaps a room in the farmhouse at the Jas de Bouffan or in the main house itself.[1]

The image raises important questions as to the status of its sitter. Though the figure depicted is undoubtedly an individual – as suggested by his high hairline and his surprisingly delicate, almost feminine, features – it may be that the artist's interest lay more readily in ideas of a type. Images of the peasant as a simple character, essential to the well-being of the nation, prevailed not only in painting but also in contemporary social studies. The historian Jules Michelet, whose book Le Peuple was standard school reading in France throughout the second half of the nineteenth century, described how a love of the land was ingrained into this section of the population. Even on a Sunday walk, dressed in his best clothes, Michelet's peasant would worry about the well-being of his crop: 'he crosses his arms and stops, he looks, grave, anxious. He looks for a long time, a very long time, and seems to forget himself. At last, if he thinks himself watched, if he notices a passer-by, he slowly steps away. Thirty paces further on, he stops, turns, and throws a last look at his earth, a profound and gloomy look;

but for he who knows how to see these things, this look is completely impassioned, heartfelt, full of devotion'.[2] Perhaps contemporary viewers might have read similar sentiment in Cézanne's peasant, whose eyes are downcast, potentially filled with that same compassion for his charge.

In its critical history, this canvas has indeed been read as one that depicts a generic peasant figure. In 1926, Pierre Courthion described the picture in particularly vivid terms: "Voluminous, rendered so simply, the young countryman has that somewhat dazed expression common to those who eat bacon and beetroot every day. The planes of the face are well determined, carved in wood but lively nonetheless. What a marvel, the passage at the temple, to the left in the background! On well-placed foundations, the mix is distributed widely, in a definitive layer. What we see of the clothes is hardly overlooked (a body lies beneath). Ah, the frankness of this head accentuated by none-other than nature herself. You can almost smell the potatoes and the hay."[3]

In viewing the peasant as representative of country folk generally, Courthion touched on a sentiment that, broadly, may have been in line with the artist's own approach. Cézanne's peasant works are certainly open to such readings. More recently, the sombre and reflective qualities of the artist's peasant pictures of the 1890s have been seen in the context of contemporaneous Provençal farming troubles.[4] However, even if this were part of his intent, the artist would have been engaging once more with a stock character rather than with a distinct personality. N I

PROVENANCE

Ambroise Vollard, Paris; Arthur and Hedy Hahnloser-Bühler, Minterthur; Hans R. Hahnloser, Bern; private collection

SELECTED EXHIBITIONS

Basel, 1936, no. 149; Paris, 1938, no.9; Lucerne, 1940, no. 25; Zurich, 1956, no. 66; Munich, 1956, no. 48; Cologne, 1956–57, no. 24; Tübingen, 1993, no. 64

NOTES

1 See the essay by Nancy Ireson and Barnaby Wright in this volume.

2 "... il croise ses bras et s'arrête, regarde, sérieux, soucieux. Il regarde longtemps, très longtemps, et semble s'oublier. A la fin, s'il croit observé, s'il aperçoit un passant, il s'éloigne à pas lents. A trente pas encore, il s'arrête, se retourne, et jette sur sa terre un dernier regard, regard profond et sombre ; mais pour qui sait bien voir, il est tout passionné, ce regard, tout de cœur, plein de dévotion": Jules Michelet, Le Peuple, Paris, 1974, p. 79.

3 "Très en volume, fort simplement traité, le jeune campagnard a cette expression un peu hébété des gens qui mangent tous les jours du lards et des betteraves. Les plans de son visage sont bien

déterminés, taillés dans du bois et cependant vivants. Quelle merveille que ce passage de la tempe, à gauche sur le fond ! Après des dessous bien établis la pâte est largement distribuée, en un coulée définitive. Ce que l'on ne voit de l'habit n'est point négligé (il y a un corps dessous). Ah, la franchise de cette tête accentuée par la seule nature. Cela sent la pomme de terre et les foins." Pierre Courthion, 'La Collection Arthur Hahnhoser', L'Amour de l'Art, 1926, vol. vii, p. 62. For another response to the work during this period, see the essay by Nancy Ireson and Barnaby Wright in this volume.

4 Athanassoglou-Kallmyer 2003, pp. 207–20.

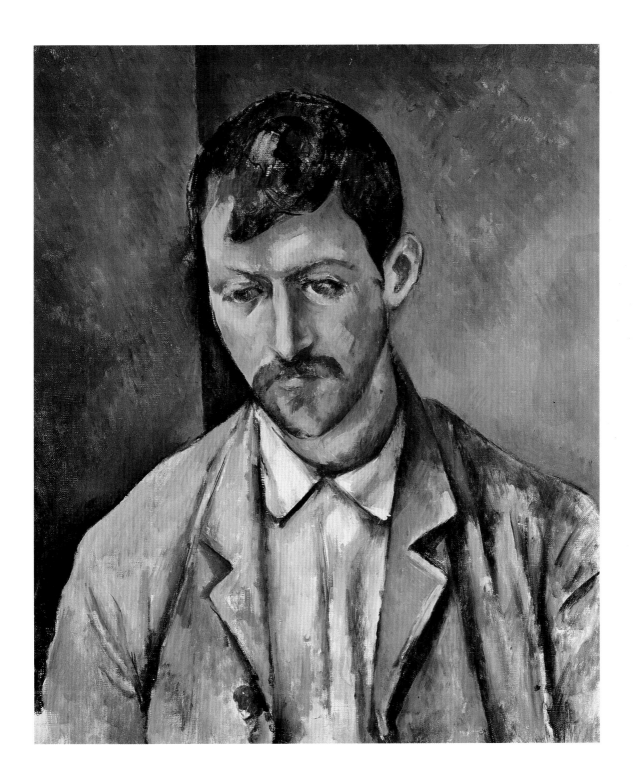

20 The Smoker c. 1890–91

Oil on canvas
92 × 73 cm
Rewald 756
Städtische Kunsthalle, Mannheim

This is one of three related canvases depicting a peasant smoking a clay pipe and resting his head upon his arm (see cat. 21–22). The sitter here is thought to be Paulin Paulet, a gardener who worked for the Cézanne family at the Jas de Bouffan and who appears in all the versions of the *Card Players* series. The canvas is likely to have been one of the paintings that Cézanne gave to the writer Paul Alexis in 1891.[1] Alexis had travelled to the artist's studio that year and a letter he wrote to Émile Zola during the visit is the first recorded account of Cézanne working on his peasant subjects.[2] The painting is most closely related to the version now in the State Hermitage Museum (cat. 21), where the same sitter appears in a near-identical pose, and both works may have been based upon a preparatory watercolour made from life (fig. 59). It is plausible that Cézanne worked on the two paintings concurrently, exploring the different possibilities afforded by repeating the motif and varying the settings. In contrast to the Hermitage version, with its complex interplay of the figure and the depiction of other paintings within the studio, in this composition Cézanne's sets the peasant within simple surroundings. The austerity of the room, with nothing more than a table covered with a patterned cloth and a stove in the background, gives greater prominence to the figure, whose frontal pose and gaze bring him into direct relationship with the viewer.

The painting is arguably the most psychologically intense of the three related canvases. One early critic considered the work to be a vision of "mental idleness" and noted that such works depicted "untroubled and untroubling types, sitting for the most part solid and serene".[3] Others, however, have found a more complex set of concerns at work in these paintings that move beyond the idea that Cézanne's peasant sitters were simply passive objects to be painted. Lionello Venturi, for example, maintained that "The peasant as painted by Cézanne is individual like a portrait, universal like an idea, majestic like a movement and as sound as a clear conscience".[4]

Of the three related canvases, this work is arguably the most conventional. Its plain, rustic surroundings are broadly

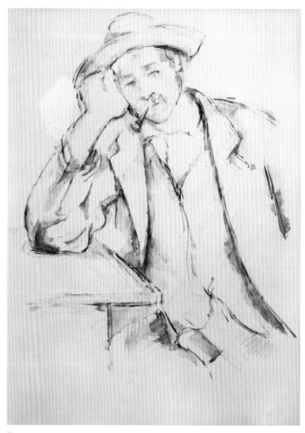

Fig. 59
The Smoker, c. 1890–91
Graphite and watercolour on paper, 47 × 33.5 cm
The Barnes Foundation,
Merion, Pennsylvania

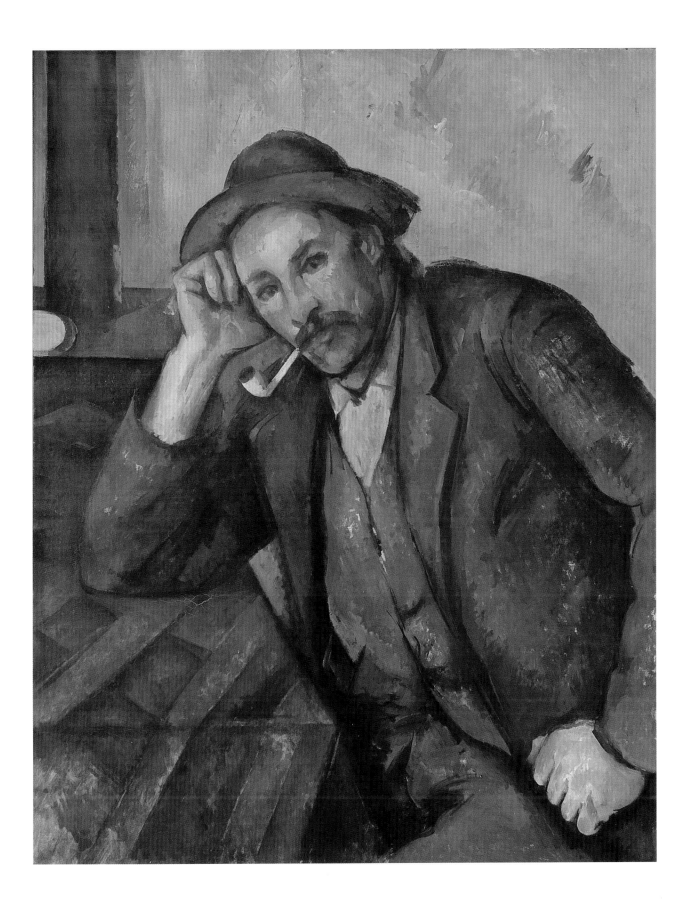

in line with the norms of nineteenth-century rural genre painting and might be considered an 'authentic' rural space, unlike the explicitly studio-based settings of the other two. In this regard the work can be compared to the two-figure *Card Players* canvases (cat. 12–14), which are suggestive of a rural scene observed from life. Exactly how Cézanne's individual peasant paintings relate to the *Card Players* series remains uncertain. They undoubtedly informed each other in various ways and it is clear that studying his peasant sitters individually was central to Cézanne's approach to the whole body of work. At the same time the lone peasant paintings are independent works in their own right and allowed Cézanne to explore a further set of pictorial possibilities beyond those of the *Card Players* compositions. They also extended the conventional approach to their subject-matter by bringing together the traditional categories of rural genre painting and portraiture. L-CS

PROVENANCE

Paul Alexis, Paris; Ambroise Vollard, Paris; Paul Cassirer, Berlin; Städtische Kunsthalle, Mannheim, purchased 1913

SELECTED EXHIBITIONS

Berlin, 1912, no. 11; Frankfurt a. M., 1931, no. 29; Brussels, 1935, no. 3; Paris, 1936, no. 94; Basel, 1936. no. 53; Berlin, 1946, no. 59; Paris, 1951, no. 7; Paris, Philadelphia and London, 1995–96, no. 136; Humlebaek, 2008, no. 34

NOTES

1 Rewald 1996, no. 756.
2 Paul Alexis, letter to Émile Zola, February 1891, in *Correspondance* 1978, p. 235.
3 Anonymous [W. H. Wright], 'Art at home and abroad', *New York Times,* 6 July 1913, section V, p. 15, quoted in John Rewald , *Cézanne and America*, Princeton and London, 1989, p. 219.
4 Lionello Venturi, *Da Manet a Lautrec*, Florence, 1950, p. 19.

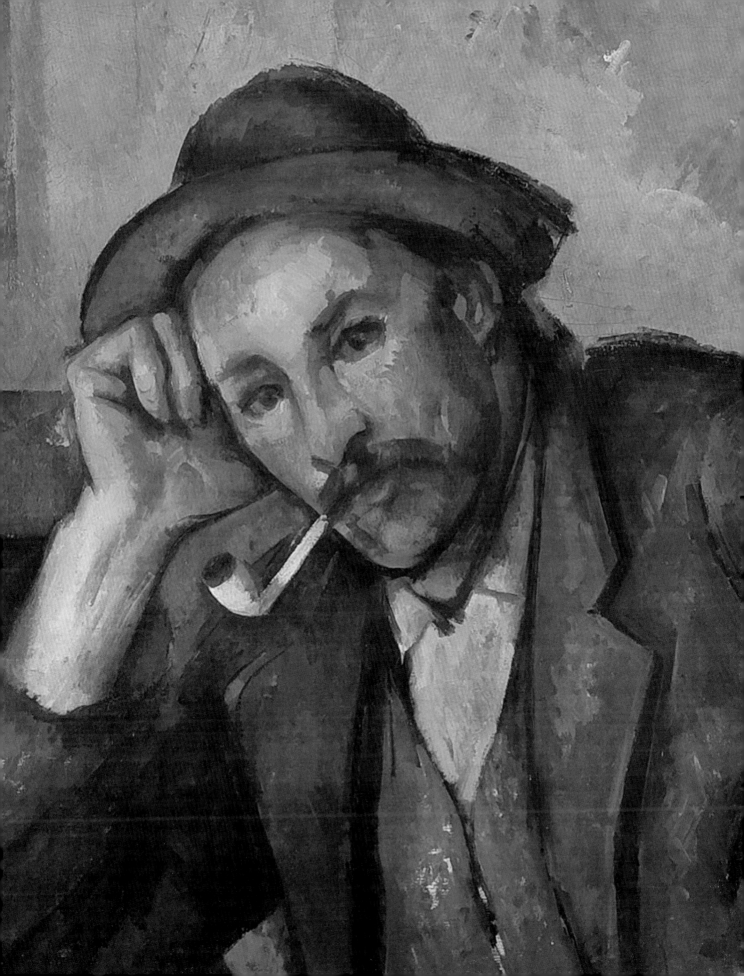

21 The Smoker c. 1890–92

Oil on canvas
91 × 72 cm
Rewald 757
The State Hermitage Museum, St Petersburg

This painting is closely related to the version in the Städtische Kunsthalle, Mannheim (cat. 20), and also to that in the Pushkin Museum, Moscow (cat. 22). Like the latter work, this peasant sitter is clearly set in one of Cézanne's studios, as suggested by the presence of several of his unstretched canvases pinned to the wall behind. Most prominent is one of the artist's early still-life paintings (now in the Nationalgalerie, Berlin), which gives the effect of a trompe l'oeil in appearing at first glance to be real bottles and fruit on the table. The placement of the bottle is reminiscent of that in his two-figure Card Players compositions and the table at which he sits may be the same used for those works. Above this still-life is the lower edge of another work, identified as one of Cézanne's 1890s Bathers compositions, with a further, unidentified, painting in the top left-hand corner.[1] His decision to set the peasant sitter within this studio context, with its play of artifice and reality, was highly unconventional and worked against the norms of rural genre painting. In one sense it lends the work an air of informality, like a captured moment in the studio. However, the painting's explicit staging of the various elements of the composition and its introduction of pictures-within-the-picture dramatizes the act of painting itself.

The figure is a near-repetition of the Mannheim version and may have been based upon the same preparatory drawing (fig. 59), but that painting has a far less complex setting and the figure's pose is subtly altered. The two renderings of the sitter share a contemplative attitude, although the more frontal gaze of the Mannheim figure and the austere surroundings imbue that work with greater psychological intensity. The Hermitage peasant is somewhat more akin to an object for contemplation – like the still-life against which he is shown – and he does not return the viewer's gaze.[2]

The comparison of these two works suggests that Cézanne was interested in exploring the different expressive possibilities afforded by varying his theme. Although by repeating the figure so closely he may have also wanted to refine and improve his depiction of the model – the human form being a subject that Cézanne continually struggled to master.[3] With the Smoker paintings, then, Cézanne appears not to have been producing a series in the more conventional sense of trying to capture a comprehensive vision of a chosen motif under different conditions, such as Claude Monet's serial approach to the Gare St-Lazare, for example. It is very unlikely that Cézanne gave thought to showing his peasants together, as Monet had done with his series paintings from the 1870s onwards. Rather, Cézanne seems to have revisited his peasant motif in order to refine and perfect the construction of his work over time. As Theodore Reff noted, Cézanne's incorporation of his own earlier paintings within a number of his compositions of the 1890s perhaps speaks to his increased awareness of the long duration over which his work had developed.[4] The appearance here of the still life from twenty years earlier suggests a sense of continuity with the art of his own past. L-CS

PROVENANCE

Ambroise Vollard, Paris ; Ivan Morosov, Moscow; The State Hermitage Museum, St Petersburg, 1931

SELECTED EXHIBITIONS

Paris, 1904, no. 1; Moscow, 1926, no. 18; Hermitage, 1956, n. n.; Leningrad, 1956 (2), no. 18; Bordeaux, 1965, no. 56; Tokyo and Kyoto, 1971; no. 53; Otterlo, 1972, no.2; Washington, 1973, no. 4; Leningrad, 1974, no. 53; Le Havre, 1978, no. 3; Lugano, 1983, no. 7; Venice and Rome, 1985, no. 8; Tokyo, 1986, no. 33; St-Paul, 1989, no. 4; Essen, 1993–94, no. 30; Kasama, 1997; Roma, 1999–2000; New York 2006–07; Philadelphia, 2009, n. n.

NOTES

1 The works in question have been identified as Still Life, c. 1869–70, oil on canvas, 64 × 80 cm, Rewald 138, Nationalgalerie, Berlin, and Bathers, c. 1890–91, oil on canvas, 54 × 65 cm, Rewald 748, State Hermitage Museum, St Petersburg.

2 For the French novelist Philippe Claudel, the Hermitage figure appeared to have "absent eyes". He described him as: "Nothing at all but a human being propped on a restaurant table to keep up the illusion of still being a little caught up in humanity's warm bosom": Philippe Claudel, 'Cézanne, the Pipe's Smoker', Queen's Quarterly, June 2006.

3 Bernard 1921, pp. 51–52.

4 Reff 1977–78, pp. 18–20.

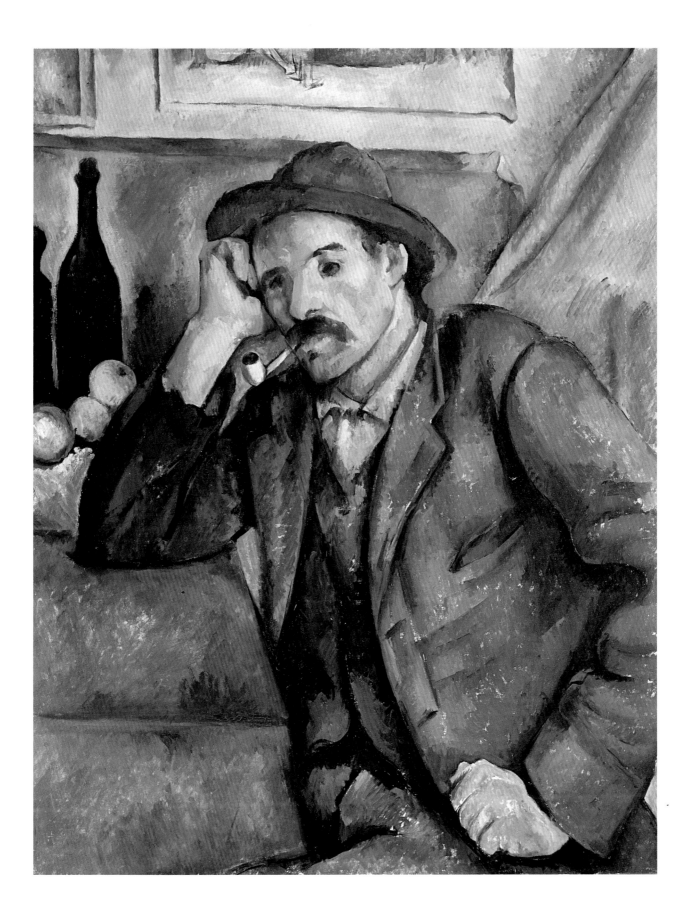

22 Man Smoking a Pipe c. 1893–96

Oil on canvas
91 × 72 cm
Rewald 790
The State Pushkin Museum of Fine Arts, Moscow
LONDON ONLY

Although closely related to the two peasant paintings now in the Städtische Kunsthalle, Mannheim, and the State Hermitage Museum, St Petersburg (cat. 20–21), this canvas is sometimes thought to be a slightly later work and a further development of the theme. However, its dating has long been problematic (see below). Unlike those two works, it depicts the figure in a three-quarter-length view but there are striking similarities of pose and composition. The sitter rests his head in the same fashion and, like the Hermitage work, he is clearly set within Cézanne's studio with part of an unstretched canvas visible pinned to the wall behind and peeling at its lower edge. This has been identified as the *Portrait of Madame Cézanne*, c. 1886 (fig. 60).[1] By adopting a broader viewpoint, Cézanne alters the overall balance of the composition and creates a somewhat disorienting space in which the depth and structure of the room are difficult to comprehend clearly. This rejection of conventional perspective is a feature of many of his works from the early 1890s and indicates the development of his fascination with the fundamental tenets of painting itself.

As well as being comparable to the Hermitage and Mannheim paintings, this painting has various connections with Cézanne's other portraits from this period, prompting debate as to its dating. There are, for example, similarities with the four versions of the *Boy in the Red Waistcoat*, especially that in the Bührle Collection, usually thought to date from 1888–90. Cézanne's inclusion of the *Portrait of Madame Cézanne* in the composition – the curve of her arm echoing that of the peasant – offers a point of connection between this work and his late 1880s portraits. However, John Rewald and others have grouped it with a number of later portraits including the securely dated 1895–96 *Portrait of Gustave Geffroy* (fig. 44).[2]

Fig. 60
Portrait of Madame Cézanne, c. 1886
Oil on canvas,
126.4 × 104.8 cm
Detroit Institute of Arts, Bequest of Robert H. Tannahill

The possibility of an earlier date, perhaps even before the Mannheim and Hermitage canvases, would reinforce the idea that Cézanne's variations on his peasant theme were a process of refinement and distillation; moving from the broader, more complex composition of this work to the greater simplification of the Mannheim work, for example. But Cézanne's practice may not have been so programmatic, and new technical research on the *Card Players* has called into question the idea that they were an exercise in compositional simplification.[3] If a later date for this work is equally plausible then its expanded format and the complexity of its composition is a further indication of the range of the artist's formal experimentation in the 1890s. L-CS

PROVENANCE

Ambroise Vollard, Paris; Sergei Shchukin, Moscow; The State Pushkin Museum of Fine Arts, Moscow

SELECTED EXHIBITIONS

Moscow, 1926, no. 17; Moscow, 1955, n. n.; Leningrad, 1956 (1), n. n.; Leningrad, 1956 (2), no. 19; Bordeaux, 1965, no. 56; Paris, 1978, no. 5; Madrid, 1984, no. 45; Essen, 1993–94, no. 31

NOTES

1 For a discussion of these 'pictures within the picture' see Reff 1977–78.
2 Rewald 1996, no. 791.
3 See the essay by Aviva Burnstock, Charlotte Hale, Caroline Campbell and Gabriella Macaro in this volume.

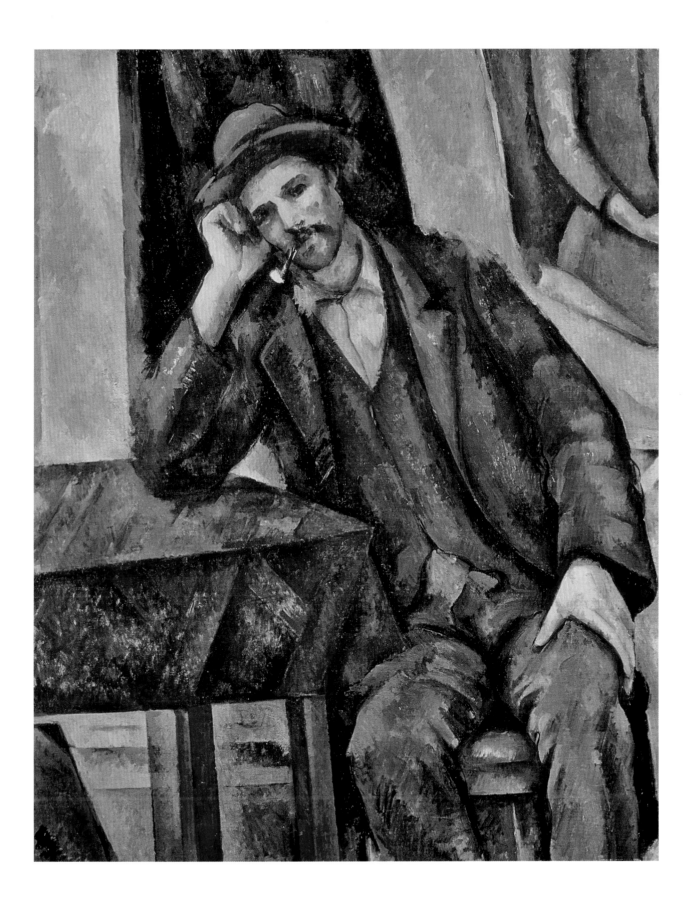

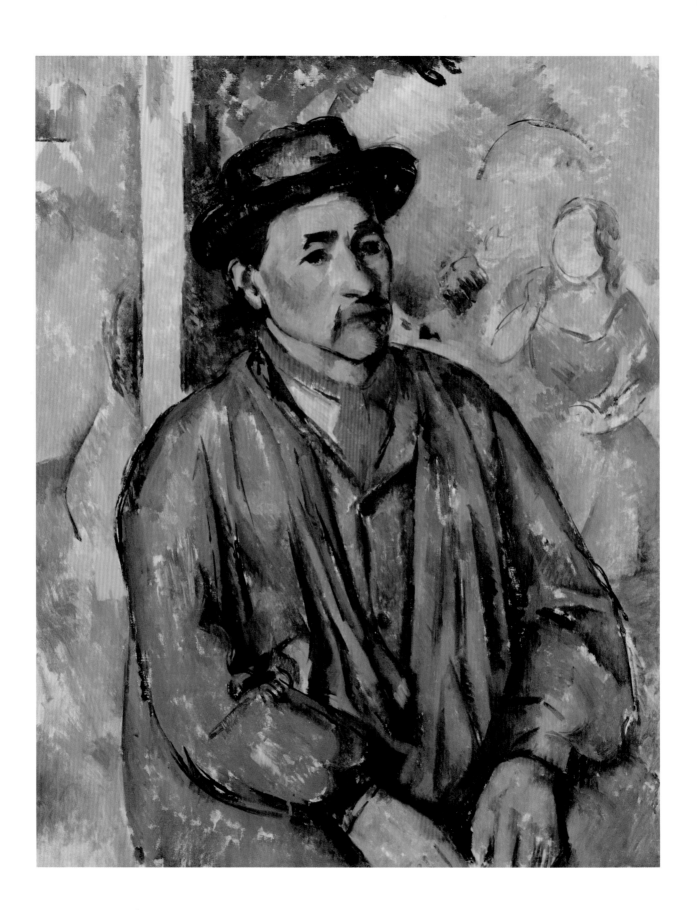

23 Man in a Blue Smock c. 1892–97

Oil on canvas
81 × 65 cm
Rewald 826
Kimbell Art Museum, Fort Worth, Texas
Acquired in memory of Richard F. Brown

This painting depicts the same man who appears as the pipe smoking spectator in both the Metropolitan Museum and Barnes Foundation *Card Players* (cat. 1 and 2), probably père Alexandre, a farm worker from the Jas de Bouffan. It is likely to have been the canvas seen by Joachim Gasquet in Cézanne's studio at the Jas at some point before the spring of 1898. There it was one of a number of scenes depicting peasants at rest, and he described the work in the regionalist review *Les Mois Dorés*. His words cast its male figure as a key player in an equation of Cézanne's painting with Provence. For Gasquet, this peasant appeared as an embodiment of the land, one who, "in his blue smock, adorned with his red neckerchief, arms dangling, is impressive in his roughness, like the conception of a patch of earth that has suddenly taken form in coarse and magnificent flesh, sun-baked and whipped by the wind".[1]

With his simple clothing, tanned skin and broad hands, the *Peasant in a Blue Smock* certainly lent himself to the discourses favoured by the regionalist *Félibrige* poets with whom Cézanne associated in his youth. The solidity of the body seems reassuring, immovable; the colours of his jacket echo those of his surroundings, as if to suggest a kind of synchronicity. Furthermore, the screen design sketched in the background of the canvas – a pastiche of the eighteenth-century painter Nicolas Lancret that the artist produced in his youth – supports another idea that Gasquet expounds in his text. In her glorious history, Provence had seen her "spring", but now she could await her magnificent "summer". In Cézanne's oeuvre, too, the artist's present and future works would outshine his past achievements, a juxtaposition that is staged in this image, as it harks back to the painter's artistic beginnings, even while it seems to anticipate the formal innovations of his later career. Indeed, the reading may reach further still. Recent research has suggested that the artist did not paint the decorative screen in its entirety, but rather added figure groupings to a pre-existing item of regional furniture purchased by his father, the combination of which might present a meeting of Provençal and personal history.[2]

It is little wonder that, with the added encouragement of Gasquet's comments, there is a strong temptation to read the *Peasant in a Blue Smock* in terms of land, heritage, and continuity – though as several authors have noted, the poet had his own agenda.[3] It is worth remembering, however, that Gasquet's interest in this peasant rendered by Cézanne as an expression of the Provençal race was also shaped by his knowledge of the theories of the influential art historian Hippolyte Taine, whose writings were widely known. Taine believed that artists who shared the racial make-up of their subjects could capture the essence of places where they were born, a theory he applied to themes as diverse as Greek relief sculpture and seventeenth-century Flemish painting.[4] It is logical that educated late nineteenth-century viewers would have extended this theory to their own time. NI

PROVENANCE

Ambroise Vollard, Paris; Auguste Pellerin, Paris; Bernheim-Jeune, Paris; Ambroise Vollard, Paris; Paul Cassirer, Berlin; Gottlieb Friedrich Reber, Lausanne; Paul Rosenberg, Paris; A. Conger Goodyear, New York; Mrs. Mary G. Kenefick, Buffalo; sale, Sotheby's, London, 25 November 1959, lot 17; Henry Ford II, Detroit; sale, Ford collection, Christie's, New York, 13 May 1980, lot 3; Kimbell Art Museum, Fort Worth, acquired in memory of Richard F. Brown, the Kimbell Art Museum's first Director, by the Kimbell Board of Trustees, assisted by the gifts of many friends

SELECTED EXHIBITIONS

Cologne, 1912, no. 146; Berlin, 1912, no. 8; Cologne, 1912, no. 146; Berlin, 1912, no. 8; Berlin, 1913, no. 13; Darmstadt, 1913, no. 28; Dresden, 1914, no. 4; London, 1926, no. 4; Chicago, 1926, n. n.; Toronto, 1927, no. 11; New York, 1928, no. 21; Buffalo, 1928, no. 3; Cambridge, MA, 1929, no. 7; Cleveland, 1929–30, n. n.; Chicago, 1933, no. 313; Philadelphia, 1934, no. 37; Paris, 1936, no. 88; New York, 1942, no. 20; Buffalo, 1951, n. n.; Buffalo, 1958, no. 20; Buffalo, 1966, n. n.; Paris, 1978, no. 5; Paris, London and Philadelphia, 1995–96, no. 137; Los Angeles, 1998, n. n.; St Petersburg and Moscow, 1998, no. 30; Zurich, 2000, no. 30; Washington, 2006; Aix-en-Provence, 2006; Madrid and Fort Worth, 2007; Philadelphia, 2009

NOTES

1 "*Un surtout, dans sa blouse bleue, décorée de son foulard rouge, les bras ballants, est admirable dans sa rudesse comme la pensée d'un coin de terre qui se serait soudain incarnée dans cette chair grossière et magnifique, cuite par le soleil et fouéttée par le vent*": Gasquet 1898, p. 379.
2 Theodore Reff, 'Cézanne's Early Paravent and the Jas de Bouffan', in *Jas de Bouffan* 2004, pp. 57–67.
3 For example, Françoise Cachin, 'Peasant in a Blue Smock', in Paris, London and Philadelphia 1995–96, p. 345.
4 See Hippolyte Taine, *Philosophie de l'art* [1881] Paris, 1964, notably pp. 47–48.

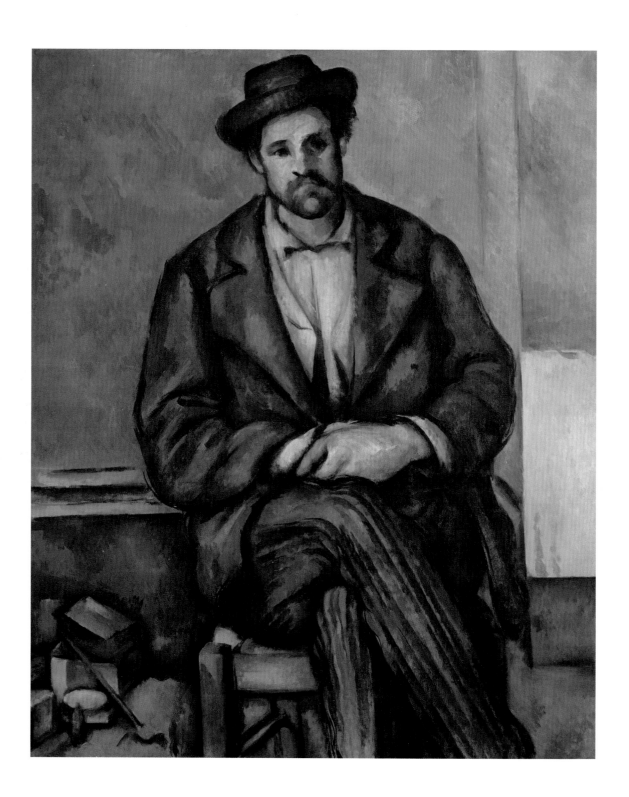

24 Seated Peasant c. 1892–96

Oil on canvas
54.6 × 45 cm
Rewald 827
The Metropolitan Museum of Art, New York
The Walter H. and Leonore Annenberg Collection
Gift of Walter H. and Leonore Annenberg, 1997
Bequest of Walter H. Annenberg, 2002

NEW YORK ONLY

Although this sitter does not appear in the *Card Players* canvases, the work clearly relates to them in terms of its character and handling. The man seems to be set in the same room at the Jas de Bouffan as the Barnes Foundation and Metropolitan Museum compositions (cat. 1 and 2), with its bluish wall and distinctive decorative red line at skirting-board height. He is probably the same individual who posed, apparently again in this room, for one of the few full-length peasant paintings (fig. 61) and also for a less resolved seated portrait now in the Hiroshima Museum of Art.[1] As with these other two works, here Cézanne uses the horizontal and vertical lines of the room's few architectural features to frame and balance the figure as part of the overall composition. This sense of linear structure is contrasted, to some extent, with the clutter of boxes and other objects in the lower-left corner. In common with several of Cézanne's other paintings of individual peasants, the setting of this work defies simple categorization, especially in terms of conventional nineteenth-century genres. In one sense this peasant is profoundly out of place; removed from a recognisably rural setting, where contemporary viewers might have expected him to be depicted, and portrayed instead in a non-descript room that does not even announce itself clearly as a studio. It is tempting to read the painting as an image of displacement, with the peasant's distant, even melancholic, expression echoed by his sparse surroundings. Nina Maria Athanassoglou-Kallmyer has established an historical context in which one might read the work as being associated with contemporary fears that Provence was losing

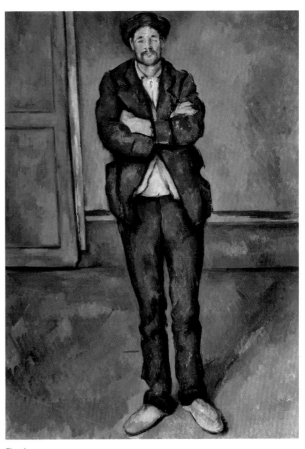

Fig. 61
Standing Peasant with Crossed Arms, c. 1895
Oil on canvas, 80 × 52 cm
The Barnes Foundation,
Merion, Pennsylvania

PROVENANCE

Probably Ambroise Vollard, Paris; Josse Hessel, Paris; Christian and Charlotte Mustad, Oslo; Wildenstein Galleries, New York; Enid A. Haupt; Walter H. and Leonore Annenberg, California; The Metropolitan Museum of Art, New York, Gift of Walter H. and Leonore Annenberg, 1997; Bequest of Walter H. Annenberg, 2002

SELECTED EXHIBITIONS

Kristiana (Oslo), 1918, no. 10; Stockholm, 1935, no. 4; Philadelphia 1989 (1), n. n.

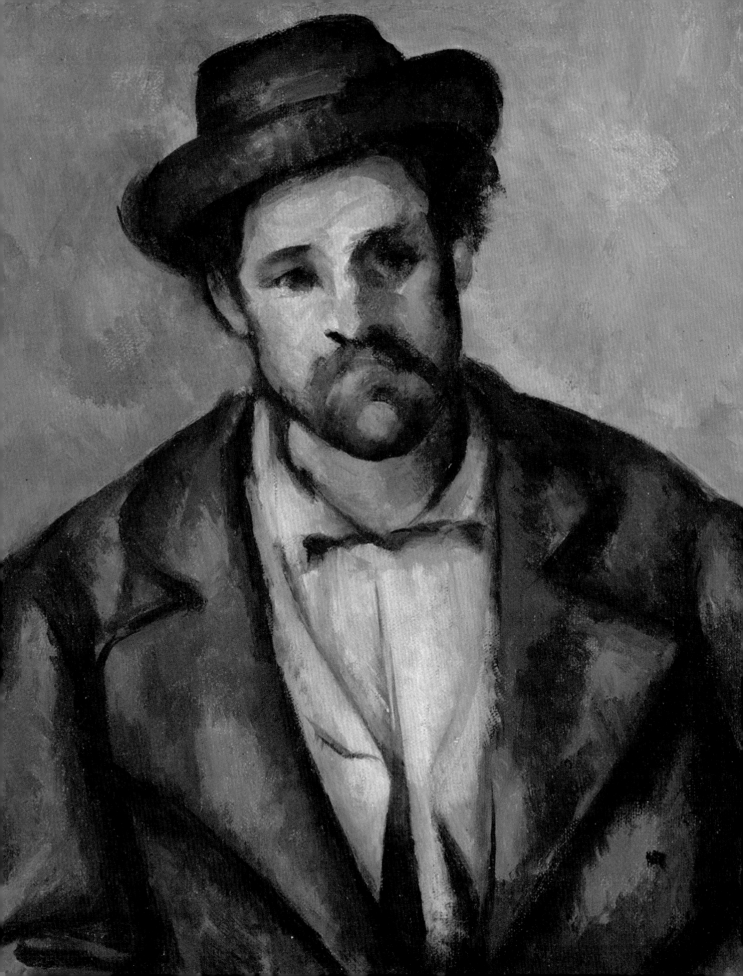

its rural way of life and its regional identity in the face of an ongoing agricultural crisis and mass migration to the cities.[2] Whilst Cézanne may well have shared these concerns, the work remains aloof from direct engagement with such socio-political themes.

The painting can also be understood in relation to Cézanne's broader interest in portraiture during this period. We know from Gustave Geffroy's and Ambroise Vollard's accounts of sitting for Cézanne at this time that the process was protracted and fraught with difficulty for the artist.[3] There are comparisons to be made with the Vollard portrait (fig. 6), in particular, both in terms of the similar poses adopted and their shared range of colours and tones. Cézanne is reported to have abandoned his portrait of Vollard and whilst Seated Peasant is perhaps more resolved, it too clearly has a searching quality with various painted lines repositioned and left visible as he worked to establish the contours of the man's form. Cézanne also appears to have struggled with the peasant's hands, which are over-sized and inaccurately rendered. However, it is possible that their role in centring and balancing the composition as a whole was more important to the artist than their descriptive detail. Seen in the wider context of Cézanne's ongoing interest in the challenges of figure painting, regardless of the identity of an individual sitter, the work's specific associations with its peasant subject become less amplified. As with his other peasant paintings of 1890s, this work is as much about the concerns and possibilities of painting itself as it is about the status of its sitter. Seated Peasant anticipates Cézanne's group of paintings of the gardener Vallier, produced in the last years of the artist's life, where this duality would find its final expression (see, for example, fig. 3). BW

NOTES

1 Seated Peasant, c. 1897, oil on canvas, 55 × 46 cm, Rewald: 817, Hiroshima Museum of Art.
2 Athanassoglou-Kallmyer 2003, pp. 207–15.
3 For a discussion of these portraits see Paris, London and Philadelphia 1995–96, pp. 410–12 and 422–23.

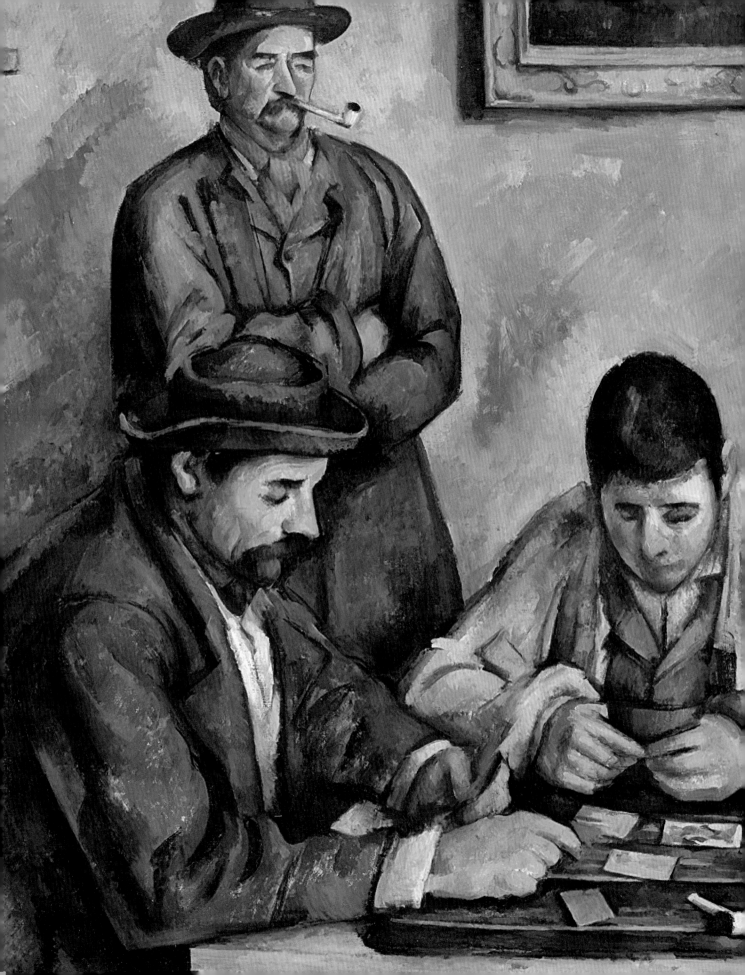

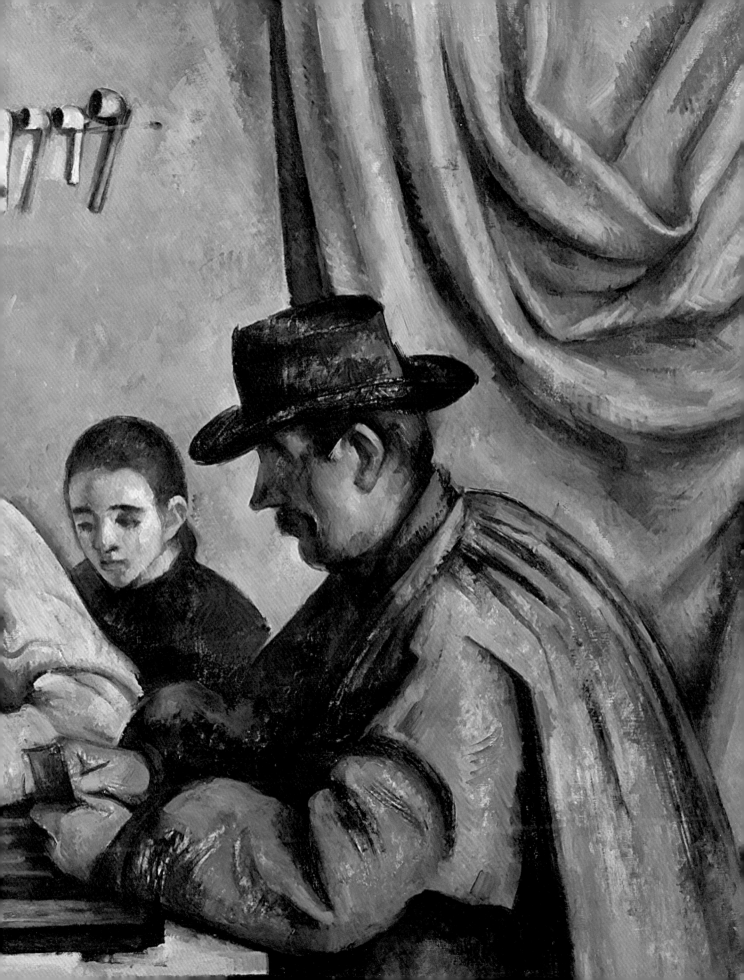

SELECTED BIBLIOGRAPHY

A list of the principal publications cited in this catalogue

ATHANASSOGLOU-KALLMYER 2003
Nina Maria Athanassoglou-Kallmyer, Cézanne
and Provence: The Painter in His Culture, Chicago:
University of Chicago Press, 2003

ATHANASSOGLOU-KALLMYER 2004
Nina Maria Athanassoglou-Kallmyer, 'Cézanne
and his friends at Jas de Bouffan', in Jas de Bouffan
2004, pp. 49–55

BADT 1965
Kurt Badt, The Art of Cézanne, London: Faber
and Faber, 1965 (German edn 1956)

BARNES AND DE MAZIA 1939
Albert C. Barnes and Violette de Mazia, The Art
of Cézanne, New York: Harcourt, Brace, 1939

BERNARD 1921
Émile Bernard, Souvenirs sur Paul Cézanne,
3rd edn, Paris: La Rénovation Esthétique, 1921

BERNARD 1924 (1)
Émile Bernard, 'Le Dessin de Cézanne', L'Amour
de l'Art, January 1924, p. 37

BERNARD 1924 (2)
Émile Bernard, 'Les Aquarelles de Cézanne',
L'Amour de l'Art, February 1924, pp. 33–36

CARPENTER 1951
James M. Carpenter, 'Cézanne and Tradition',
The Art Bulletin, no. 33, September 1951

CORRESPONDANCE 1978
Paul Cézanne, Correspondance, ed. John Rewald,
Paris: Grasset, 1978

CHAPPUIS 1973
Adrien Chappuis, The Drawings of Paul Cézanne.
A Catalogue Raisonné, 2 vols., Greenwich, Conn.,
and London: New York Graphic Society, 1973

CONISBEE 2006
Philip Conisbee, 'Cézanne's Provence', in Cézanne
in Provence, exh. cat., National Gallery of Art,
Washington and Musée Granet, Aix-en-Provence,
2006

COOPER 1954 (1)
Douglas Cooper, 'Two Cézanne Exhibitions',
Burlington Magazine, vol. 96, 1954, pp. 378–83

COOPER 1954 (2)
Douglas Cooper, The Courtauld Collection.
A Catalogue and Introduction, London, 1954

COQUIOT 1919
Gustave Coquiot, Paul Cézanne, Paris:
Ollendorf, 1919

DENIS 1907
Maurice Denis, 'Cézanne', L'Occident, vol. 12,
September 1907, pp. 118–33

DENIS 1910
Maurice Denis, 'Cézanne', trans. Roger Fry,
Burlington Magazine, vol. 16, January–February
1910, pp. 207–19, 275–80

DORAN 1978
Michael Doran, ed., Conversations avec Cézanne,
Paris: Macula, 1978

DORIVAL 1948
Bernard Dorival, Cézanne, New York:
Continental Book Center, 1948

DURET 1906
Théodore Duret, Histoire des peintres impression-
nistes, Paris: Floury, 1906

FEILCHENFELDT 2005
Walter Feilchenfeldt, By Appointment Only:
Cézanne, Van Gogh and Some Secrets of Art Dealing,
London: Thames and Hudson, 2005

FRAISSET 2006
Michel Fraisset, L'Atelier Cézanne,
Aix-en-Provence, 2006

FRY 1927
Roger Fry, Cézanne: A Study of His Development,
London: Leonard and Virginia Woolf at the
Hogarth Press, 1927

GASQUET 1898
Joachim Gasquet, 'Le sang provençal', Les Mois
Dorés, Paris, March–April 1898, pp. 379–80

GASQUET 1921
Joachim Gasquet, Cézanne, Paris: Bernheim-
Jeune, 1921

GASQUET 1926
Joachim Gasquet, Cézanne, Paris: Bernheim-
Jeune, 1926

GOWING 1956
Lawrence Gowing, 'Notes on the Development
of Cézanne', Burlington Magazine, vol. 98, no. 639,
June 1956, pp. 185–92

GEFFROY 1894
Gustave Geffroy, 'L'art d'aujourd'hui: Paul
Cézanne', Le Journal, no. 586, 26 March 1894, p. 1

GEFFROY 1892–1903
Gustave Geffroy, La vie artistique, 8 vols., Paris:
Dentu (vols. 1–4); Paris: Floury (vols. 5–8),
1892–1903

JAS DE BOUFFAN 2004
Jas de Bouffan: Cézanne, Aix-en-Provence:
Société Paul Cézanne, 2004

KEAR 2001
Jon Kear, Cézanne and Genre: Readings in the
Oeuvre of Paul Cézanne, c. 1859–1906, PhD thesis,
The Courtauld Institute of Art, London, 2001

KRUMRINE 1997
Mary Louise Krumrine, 'Les Joueurs de cartes de
Cézanne: un jeu de la vie', in Françoise Cachin,
Henri Loyrette and Stéphane Guégan, Cézanne
aujourd'hui, Paris: Réunion des Musées
Nationaux, 1997, pp. 65–74

MAUCLAIR 1904
Camille Mauclair, L'Impressionnisme. Son histoire,
son esthétique, ses maîtres, Paris, 1904

NATANSON 1895
Thadée Natanson, "Paul Cézanne," La Revue
Blanche, vol. 9, 1 December 1895, p. 496

RATCLIFFE 1961
Robert Ratcliffe, 'Cézanne's Working Methods
and their Theoretical Background', PhD,
The Courtauld Institute of Art, University of
London, 1961

REFF 1977–78
Theodore Reff, 'Painting and Theory in the
Final Decade', in *Cézanne: The Late Work*, ed.
W. Rubin, exh. cat., Museum of Modern Art,
New York, and Museum of Fine Arts, Houston,
1977–78, pp. 13–53

REFF 1980
Theodore Reff, 'Cézanne's "Cardplayers" and
Their Sources', *Arts Magazine*, November 1980,
pp. 104–17

REFF AND SHOEMAKER 1989
Theodore Reff and Innis Howe Shoemaker,
Paul Cézanne: Two Sketchbooks, Philadelphia
Museum of Art, 1989

REISSNER 2008
Elisabeth Reissner, 'Transparency of means:
'Drawing' and Colour in Cézanne's Watercolours
and Oil Paintings in the Courtauld Gallery',
exh. cat., *The Courtauld Cézannes*, London, 2008

REWALD / REWALD 1996
John Rewald with Walter Feilchenfeldt and
Jayne Warman, *The Paintings of Paul Cézanne:
A Catalogue Raisonné*, New York: Harry N. Abrams,
and London: Thames and Hudson, 1996

REWALD WATERCOLOURS / REWALD 1983
John Rewald, *Paul Cézanne. The Watercolors.
A Catalogue Raisonné*, Boston: Little, Brown, 1983

REWALD 1937
John Rewald, 'A propos du catalogue raisonné
de l'œuvre de Paul Cézanne et de la chronologie
de cette œuvre', *Renaissance de l'art Français*, Paris,
March–April 1937, pp. 53–54

REWALD 1948
John Rewald, *Paul Cézanne*, New York, 1948

RISHEL 1993
Joseph J. Rishel, 'Paul Cézanne: The Card
Players', in Richard J. Wattenmaker and Anne
Distel, eds., *Great French Paintings from the Barnes
Collection*, New York: Alfred A. Knopf, 1993

RIVIÈRE 1923
Georges Rivière, *Le Maître Paul Cézanne*, Paris:
Floury, 1923

RIVIÈRE 1936
Georges Rivière, *Paul Cézanne. Le peintre solitaire*,
Paris: Floury, 1936 (1st edn 1933)

SCHAPIRO 1952 / 1988
Meyer Schapiro, *Paul Cézanne*, New York: Abrams,
1952; reprinted New York: Abrams, 1988

SEMMER 2004
Laure-Caroline Semmer, *Cézanne au XXe siècle,
une histoire de la réception critique de Paul Cézanne*,
PhD, Université Paris 1, Panthéon-Sorbonne,
2004

SHIFF 1984
Richard Shiff, *Cézanne and the End of
Impressionism: A Study of the Theory, Technique, and
Critical Evaluation of Modern Art*, Chicago and
London: University of Chicago Press, 1984

VALABRÈGUE 1936
Antony Valabrègue, *Les Frères Le Nain*, Paris:
Librairie de l'art ancien et moderne, 1904

VENTURI 1936
Lionello Venturi, *Cézanne. Son art, son œuvre*,
2 vols., Paris: Paul Rosenberg, 1936

VOLLARD 1914 / 1924
Ambroise Vollard, *Paul Cézanne*, Paris, 1914;
Ambroise Vollard, trans. H.L. Van Doren,
Paul Cézanne: His Life and Art, London: 1924

VOLLARD 1938 / 2008
Ambroise Vollard, *En écoutant Cézanne, Degas,
Renoir*, Paris: Grasset, 2008 (1st edn 1938)

SELECTED EXHIBITIONS

PARIS 1898
Exposition Cézanne, Galerie Vollard, Paris 1898

BERLIN 1904
Paul Cassirer, Berlin, 1904

BRUSSELS 1904
Peintres Impressionnistes, La Libre Esthétique, Brussels, 1904

PARIS 1904
Salon d'Automne, Petit Palais, Paris, 1904

PARIS 1907
Rétrospective d'œuvres de Cézanne, Salon d'Automne, Grand Palais, Paris, 1907

PARIS 1910
Cézanne, Galerie Bernheim-Jeune, Paris, 1910

BERLIN 1912
Group Exhibition, VIII, Paul Cassirer, Berlin, 1912

COLOGNE 1912
Sonderbund, Städtische Ausstellungshalle, Cologne, 1912

BERLIN 1913
Sammlung Reber, Paul Cassirer, Berlin, 1913

DARMSTADT 1913
Sammlung G.F. Reber, Mathildenhöhe, Darmstadt, 1913

DRESDEN 1914
Französische Malerei des XIX. Jahrhunderts, Galerie Ernst Arnold, Dresden, 1914

LONDON 1914
Art français, Exposition d'art decoratif contemporain 1800–1885, Grosvenor Gallery, London, 1914

PARIS 1917
Peinture moderne, Galerie Bernheim-Jeune, Paris, 1917

ZURICH 1917
Französische Kunst des XIX. und XX. Jahrhunderts, Kunsthaus, Zurich, 1917

KRISTIANA (OSLO) 1918
Den franske Ultilling, Kunstnerforbundet, Kristiana (Oslo), 1918

PARIS 1920
Cézanne, Galerie Bernheim-Jeune, Paris, 1920

LONDON 1926
Great Masters of the French XIXth Century [Rosenberg collection], French Gallery, London, 1926

PARIS 1926
Rétrospective Paul Cézanne, Galerie Bernheim-Jeune, Paris, 1926

MOSCOW 1926
Paul Cézanne – Vincent Van Gogh, Museum of Modern Western Art, Moscow, 1926

CHICAGO 1926
Cézanne, Art Institute, Chicago 1926

TORONTO 1927
Portraits, Art Gallery of Toronto, Toronto, 1927

BERLIN 1927
Erste Sonderausstellung, Galerie Thannhauser, Berlin, 1927

NEW YORK 1928
Paul Cézanne, Wildenstein Galleries, New York 1928

BUFFALO 1928
[Goodyear collection], Buffalo Fine Arts Academy, 1928

BERLIN 1928
Seit Cezanne in Paris, Galerie Alfred Flechtheim, Berlin, 1928

BERLIN 1929–30
Ein Jahrhundert französischer Zeichnungen, Galerie Paul Cassirer, Berlin, 1929–30

PARIS 1929
Cézanne, Galerie Pigalle, Paris, 1929

CAMBRIDGE, MA, 1929
French Painting of the XIXth and XXth Centuries, Fogg Art Museum, Cambridge, Mass., 1929

CLEVELAND 1929–30
French Art, Cleveland Museum of Art, Cleveland, 1929–30

PARIS 1930
Cents Ans de peinture française, Galerie G. Petit, Paris, 1930

NEW YORK 1930
[Opening exhibition], Marie Harriman Gallery, New York, 1930

NEW YORK 1930
Summer Exhibition, Museum of Modern Art, New York, 1930

DETROIT 1931
Modern French Painting, Detroit Institute of Arts, Detroit, 1931

FRANKFURT AM MAIN 1931
Vom Abbild zum Sinnbild, Staedelsches Kunstinstitut, Frankfurt am Main, 1931

LONDON 1932
French Art, Royal Academy of Arts, London, 1932

NEW YORK 1932
French Paintings, Marie Harriman Gallery, New York, 1932

CHICAGO 1933
A Century of Progress, Art Institute Chicago, Chicago, 1933

NEW YORK 1933
Watercolours by Cézanne, Jacques Seligmann Gallery, New York, 1933

ROTTERDAM 1933–34
Teekeningen van Ingres tot Seurat, Museum Boijmans, Rotterdam, 1933–34

BERN 1934
Französische Meister des 19. Jahrhunderts und van Gogh, Kunstmuseum, Bern 1934

SAN FRANCISCO 1934
French Painting from the XVth Century to the Present, California Palace of the Legion of Honor, San Francisco, 1934

NEW YORK 1934
Modern Works of Art, Museum of Modern Art, New York, 1934

NEW YORK 1934–35
Fifth Anniversary Exhibition, Museum of
Modern Art, New York, 1934–35

PHILADELPHIA 1934
Cézanne, Pennsylvania Museum of Art,
Philadelphia, 1934

ROTTERDAM 1934
Cézanne, Boijmans Museum, Rotterdam, 1934

STOCKHOLM 1935
Mästerverk i Fransk 1800 – Talskonst, Svensk-
Franska Konstgalleriet., Stockholm. 1935

BRUSSELS 1935
L'Impressionnisme, Palais des Beaux-Arts,
Brussels, 1935

BUFFALO 1935
Master Drawings, Albright Art Gallery,
Buffalo, 1935

BASEL 1936
Paul Cézanne, Kunsthalle, Basel 1936

PARIS 1936
Cézanne, Orangerie, Paris, 1936

NEW YORK 1936
Cézanne, Derain and Others, Marie Harriman
Gallery, New York, 1936

PARIS 1937
Chefs-d'œuvre de l'art français (World's Fair),
Palais National des Arts, Paris, 1937

SAN FRANCISCO 1937
Paul Cézanne, San Francisco Museum of Art,
San Francisco, 1937

AMSTERDAM 1938
Fransche Meesters uit de XIX eeuw, Paul Cassirer,
Amsterdam, 1938

NEW YORK 1938
Cézanne, Durand-Ruel, New York, 1938

PARIS 1938
La Peinture française du XIXe siècle en Suisse,
Galerie de la Gazette des Beaux-Arts, Paris, 1938

BOSTON 1939
Paintings, Drawings, Prints from Private
Collections in New England, Museum of Fine
Arts, Boston, 1939

LONDON 1939
Paul Cézanne – Watercolours, Paul Cassirer,
London 1939

NEW YORK 1939
Art in Our Time, Museum of Modern Art,
New York, 1939

NEW YORK 1939
Cézanne – Centennial Exhibition, Marie Harriman
Gallery, New York, 1939

LUCERNE 1940
La Collection Hahnloser, Kunstmuseum,
Lucerne, 1940

NEW YORK 1940
New York World's Fair, New York, 1940

NEW YORK 1940
Modern Masters from European and American
Collections, Museum of Modern Art,
New York, 1940

SAN FRANCISCO 1940
Master Drawings, Palace of Fine Arts,
San Francisco, 1940

NEW YORK 1942
Paintings by Cézanne, Paul Rosenberg,
New York, 1942

NEW YORK 1944
Art in Progress, Museum of Modern Art,
New York, 1944

BOSTON 1945
100 Modern Pictures, Institute of Modern Art,
Boston, 1945

DAYTON 1945
The Little Show, Dayton Art Institute, Dayton, 1945

AMSTERDAM 1946
Fransche Meesters 1800–1900, Stedelijk Museum,
Amsterdam, 1946

BERLIN 1946
Moderne Französische Malerei, Château Imperial,
Berlin, 1946

NEW YORK 1946
Paintings from the Stephen C. Clark Collection,
Century Association, New York, 1946

CINCINNATI 1947
Paintings by Paul Cézanne, Cincinnati Art
Museum, Cincinnati, 1947

NEW YORK 1947
Cézanne, Wildenstein Galleries, New York, 1947

BIRMINGHAM 1947
French Art, Birmingham, City Art Gallery 1947

PARIS 1947
Chefs-d'œuvre de la peinture (Les Impressionistes,
leurs precurseurs contemporains), Jeu de Paume,
Paris, 1947

LONDON 1948
Samuel Courtauld Memorial Exhibition,
Tate Gallery, London, 1948

CAMBRIDGE, MA, 1948–49
Seventy Master Drawings, Fogg Art Museum,
Harvard University, Cambridge, MA, 1948–49

NEW HAVEN AND BALTIMORE 1951
Pictures for a Picture, of Gertrude Stein as a Collector
and Writer on Art and Artists, Yale University Art
Gallery, New Haven, and Baltimore Musem
of Art, 1951

PARIS 1951
Impressionistes et romantiques français dans les
musées allemands, Orangerie, Paris, 1951

BUFFALO 1951 and 1958
Cézanne, Albright-Knox Art Gallery, Buffalo 1951
and 1958

CHICAGO AND NEW YORK 1952
Cézanne, Art Institute, Chicago, and Metropolitan
Museum of Art, New York, 1952

PARIS 1952
Cézanne, Bibliothèque nationale, Paris, 1952

WORCESTER 1952
The Practise of Drawing, Worcester Art Museum,
1952

AIX-EN-PROVENCE 1953
Cézanne, Peintures, Aquarelles, Dessins, Musée
Granet, Aix-en-Provence, 1953

NEW YORK 1953
French Art Around 1900 – From Van Gogh to Matisse,
Fine Arts Associates, New York, 1953

DETROIT 1954
Two Sides of the Medal, Detroit Institute of Art,
Detroit, 1954

EDINBURGH AND LONDON 1954
Paintings by Cézanne, Royal Scottish Academy,
Edinburgh, and Tate Gallery, London, 1954

NEW YORK 1954
A Collector's Taste, Knoedler Galleries,
New York, 1954

PARIS 1954
Hommage à Cézanne, Orangerie, Paris, 1954

PROVIDENCE 1954
Cézanne, Rhode Island School of Design,
Providence, 1954

MOSCOW 1955
Cézanne, Pushkin Museum, Moscow 1955

PARIS 1955
Impressionistes de la Collection de Courtauld
de Londres, Orangerie, Paris, 1955

NEW YORK 1955
Paintings from Private Collections, 25th Anniversary
Exhibition, Museum of Modern Art, New York,
1955

ROME 1955
Capolavori dell'Ottocento francese, Palazzo delle
Esposizioni, Rome, 1955

AIX-EN-PROVENCE 1956
Exposition pour commemorer le cinquantenaire
de la mort de Cezanne, Pavillon de Vendôme,
Aix-en-Provence, 1956

NEW HAVEN 1956
Pictures Collected by Yale Alumni, Yale University
Art Gallery, New Haven, 1956

MUNICH 1956
Paul Cézanne, Haus der Kunst, Munich, 1956

THE HAGUE 1956
Paul Cézanne, Gemeentemuseum,
The Hague, 1956

WASHINGTON 1956
The Marie and Averell Harriman Collection,
National Art Gallery, Washington, DC, 1956

LENINGRAD 1956 (1)
French Art from the Twelfth to the Twentieth Century,
Hermitage, Leningrad, 1956

LENINGRAD 1956 (2)
Paul Cezanne: 50 Years since His Death,
Hermitage, Leningrad, 1956

ZURICH 1956
Paul Cézanne, Kunsthaus, Zurich 1956

COLOGNE 1956-57
Cézanne, Ausstellung zum Gedenken an sein 50.
Todesjahr, Wallraf-Richartz-Museum, Cologne,
1956-57

NEW YORK 1958
Summer Loan Exhibition, Metropolitan Museum
of Art, New York, 1958

ROTTERDAM 1958
Van Clouet tot Matisse, Museum Boijmans,
Rotterdam, 1958

PARIS 1958-59
De Clouet à Matisse, Orangerie, Paris, 1958-59

NEW YORK 1959
French Drawings from American Collections,
Metropolitan Museum of Art, New York, 1959

VIENNA 1961
Paul Cézanne, Belvedere, Vienna, 1961

PARIS AND AMSTERDAM 1964
Le Dessin français dans les collections hollandaises,
Institut Néerlandais, Paris, and Rijksmuseum,
Amsterdam, 1964

ST PETERSBURG 1965
Inaugural Exhibition, Museum of Fine Arts,
St Petersburg, 1965

AIX-EN-PROVENCE 1965
Exposition, Tableaux–Aquarelles–Dessins,
Aix-en-Provence, 1965

BORDEAUX 1965
La peinture française dans les Musées de l'Ermitage
et de Moscou, Bordeaux, 1965

BUFFALO 1966
A. Conger Goodyear Collects, Albright-Knox Art
Gallery, Buffalo, 1966

THE HAGUE 1966
In het licht van Vermeer, Mauritshuis,
The Hague, 1966

PARIS 1966
Dans la lumière de Vermeer, Orangerie, Paris, 1966

NEW YORK 1970-71
Four Americans in Paris – The Collections of Gertrude
Stein and Her Family, Museum of Modern Art,
New York, 1970-71

WASHINGTON, CHICAGO AND
BOSTON 1971
Cezanne: An Exhibition in Honour of the Fiftieth
Anniversary of the Phillips Collection, Phillips
Collection, Washington; Art Institute, Chicago,
and Museum of Fine Arts, Boston, 1971

TOKYO AND KYOTO 1971
100 Masterpieces of Paintings from Soviet Museums,
Tokyo and Kyoto, 1971

OTTERLO 1972
From Van Gogh to Picasso, Rijksmuseum
Kröller-Müller, Otterlo, 1972

WASHINGTON 1973
Impressionist and Post-Impressionist Paintings
from the U.S.S.R., National Gallery of Art,
Washington DC, 1973

LENINGRAD 1974
Peinture des Impressionistes à l'occasion du
centenaire de la première exposition, en 1874,
Hermitage, Leningrad, 1974

TOKYO 1974
Cézanne, National Museum of Western Art,
Tokyo, and travelling, 1974

PARIS 1974
Cézanne dans les Musées nationaux, Orangerie,
Paris, 1974

PROVIDENCE 1975
French Watercolors and Drawings from the
Museum's Collection, c.1800–1910, Rhode Island
School of Design, Providence, 1975

NEW YORK 1975-76
Thaw I: Drawings from the Collection of
Mr. and Mrs. Eugene V. Thaw, The Morgan
Library and Museum, New York, 1975-76

LONDON 1976
Samuel Courtauld's Collection of French 19th
Century Paintings and Drawings, Arts Council
of Great Britain, 1976

NEW YORK AND HOUSTON 1977-78
Cézanne: The Late Work, Museum of Modern Art,
New York, and Museum of Fine Arts, Houston,
1977-78

PARIS 1978
Cézanne, les dernières années, Grand Palais,
Paris, 1978

LE HAVRE 1978
La Peinture impressioniste et post-impressioniste
au Musée de l'Ermitage, Musée des Beaux-Arts
d'André Malraux, Le Havre, 1978

TÜBINGEN 1978
Paul Cézanne, das zeichnerische Werk, Kunsthalle,
Tübingen, 1978

CINCINNATI 1981
Small Paintings from Famous Collections, Taft
Museum, Cincinnati, 1981

TÜBINGEN AND ZÜRICH 1982
Cézanne Aquarelle, Kunsthalle, Tübingen, and
Kunsthaus, Zurich

LUGANO 1983
Capolavori impressionisti e postimpressionisti dai
musei sovietici, Villa Favorita, Lugano, 1983

MADRID 1984
Paul Cézanne, Museo Español de Arte
Contemporaneo, Madrid, 1984

TOKYO 1984
The Impressionists and the Post-Impressionists from
the Courtauld Collection, Takashimaya, Tokyo, 1984

VENICE AND ROME 1985
Cézanne, Monet, Renoir, Museo Correr Ala
Napoleonica, Venice, and Museo Capitolino,
Rome, 1985

ARTS COUNCIL OF GREAT BRITAIN 1986
Impressionists Drawings, Arts Council of Great
Britain, 1986

TOKYO 1986
Cézanne, Isetan Museum of Art, Tokyo 1986

CLEVELAND 1987-88
Impressionist and Post-Impressionist Masterpieces:
The Courtauld Collection, Cleveland Museum
of Art, Cleveland, 1987-88

GENEVA 1988
Berggruen Collection, Musée d'art et d'histoire,
Geneva, 1988

MOSCOW 1988
From Delacroix to Matisse, Pushkin State Museum
of Fine Arts, Moscow, 1988

VENICE AND MILAN 1989
Impressionisti della National Gallery of Art di Washington, Ala Napoleonica Museo Correr, Venice, and Palazzo Reale, Milan, 1989

PHILADELPHIA 1989 (1)
Masterpieces of Impressionism and Post-Impressionism, Philadelphia Museum of Art, Philadelphia, 1989

PHILADELPHIA 1989 (2)
Paul Cézanne: Two Sketchbooks, Philadelphia Museum of Art, Philadelphia, 1989

ST-PAUL 1989
Cézanne, Fondation Maeght, St-Paul, 1989

TÜBINGEN 1993
Cézanne Gemälde, Kunsthalle, Tübingen, 1993

ESSEN 1993–94
Morozov and Shchukin – The Russian Collectors, Museum Folkwang, Essen, 1993–94

NEW YORK AND PARIS 1993–94
French Master Drawings from the Pierpont Morgan Library, The Morgan Library and Museum, New York, and Musée du Louvre, Paris 1993–94

WASHINGTON 1993–96
Great French Paintings from the Barnes Foundation, National Gallery of Art, Washington, DC, and travelling, 1993–96

LONDON 1994
Impressionism for England, Courtauld Institute Galleries, London, 1994

PARIS 1995–96
Impressionisme, les origins, Grand Palais, Paris, 1995–96

PARIS, LONDON AND PHILADELPHIA 1995–96
Paul Cézanne: Une Rétrospective, Grand Palais, Paris, 1995–96; Cézanne, Tate Gallery, London, and Philadelphia Museum of Art, 1996

PHILADELPHIA 1996
Paul Cézanne: The Philadelphia Sketchbooks, Philadelphia Museum of Art, 1996

KASAMA 1997
Kasama Nichido Museum of Art, Kasama, 1997

TOKYO AND TORONTO 1997–98
The Courtauld Collection, Takashimaya, Tokyo, Osaka and Kyoto, and Art Gallery of Ontario, Toronto, 1997–98

ST PETERSBURG 1998
Paul Cézanne and the Russian Avant-Garde since the beginning of the Twentieth Century, State Hermitage Museum, St Petersburg, 1998

ST PETERSBURG AND MOSCOW 1998
French Master Drawings from the Pierpont Morgan Library, State Hermitage Museum, St Petersburg, and State Pushkin Museum of Fine Arts, Moscow, 1998

NEW YORK 1999
Cézanne Watercolours, Acquavella Galleries, New York, 1999

ROME 1999
I cento capolavori dell'Ermitage. Impressionisti e Avanguardie alle Scuderie Papali al Quirinale, Scuderie Papali al Quirinale, Roma 1999

AICHI AND YOKOHAMA 1999–2000
Cézanne and Japan, Aichi Prefectural Museum and Yokohama Museum of Art, 2000

VIENNA AND ZURICH 2000
Cézanne: Vollendet – Unvollendet, Kunstforum, Vienna, and Kunsthaus, Zurich, 2000

SEOUL 2000–01
Impressionism and Modern Art, Toksu Palace (Annex to the Museum of Modern Art), Seoul, 2000–01

TAIPEI 2001–02
From Poussin to Cézanne, 300 Years of French Painting, National Palace Museum, Taipei, 2001–02

THE HAGUE 2002
Le Temps de Degas, Haags Gemeentemuseum, The Hague 2002

STOCKHOLM 2003
Impressionism, Post-Impressionism and Nordic Culture, Nationalmuseum Stockholm, 2003

MELBOURNE 2004
The Impressionists – Masterpieces from the Musée d'Orsay, National Gallery of Victoria, Melbourne 2004

ESSEN 2004–05
Cézanne – Aufbruch in die Moderne, Museum Folkwang, Essen, 2004–05

LYONS 2005
Impressionnisme et la naissance du Cinématographe, Musée des Beaux-Arts, Lyons, 2005

WILLIAMSTOWN 2006
The Clark Brothers Collect: Impressionist and Early Modern Paintings, Sterling and Francine Clark Art Institute, Williamstown, MA, 2006 (travelling to New York, Metropolitan Museum of Art, 2007)

WASHINGTON AND AIX-EN-PROVENCE 2006
Cézanne in Provence, National Gallery of Art, Washington, DC, and Musée Granet, Aix-en-Provence, 2006

LONDON 2006–07
Cézanne in Britain, National Gallery, London, 2006–07

NEW YORK, CHICAGO AND PARIS 2006–07
Cézanne to Picasso, Ambroise Vollard, Patron of the Avant-Garde, Metropolitan Museum of Art, New York, and The Art Institute of Chicago; De Cézanne à Picasso, chefs-d'oeuvre de la galerie Vollard, Musée d'Orsay, Paris, 2006–07

MADRID AND FORT WORTH 2007
The Mirror and the Mask. Portraiture in the Age of Picasso, Museo Thyssen-Bornemisza, Madrid, and Kimbell Art Museum, Fort Worth, Texas 2007

HOUSTON 2007
The Masterpieces of French Painting from The Metropolitan Museum of Art: 1800–1920, Museum of Fine Arts, Houston, 2007

LONDON 2008
The Courtauld Cézannes, The Courtauld Gallery, Somerset House, London, 2008

HUMLEBAEK 2008
Cézanne and Giacometti – Paths of Doubt, Louisiana Museum of Modern Art, Humlebaek, 2008

AIX-EN-PROVENCE 2009
Picasso – Cézanne, le soleil en face, Musée Granet, Aix-en-Provence, 2009

PHILADELPHIA 2009
Cézanne and Beyond, Philadelphia Museum of Art, Philadelphia, 2009

All images as credited in the captions with the exception
of the following: